To Lori,

Happy Birthday!

You are an awesome nurse! Keep up the good work and

God Bless you!

Love

Emily Cochran
2/3/16

TRUE FAITH, TRUE LIGHT

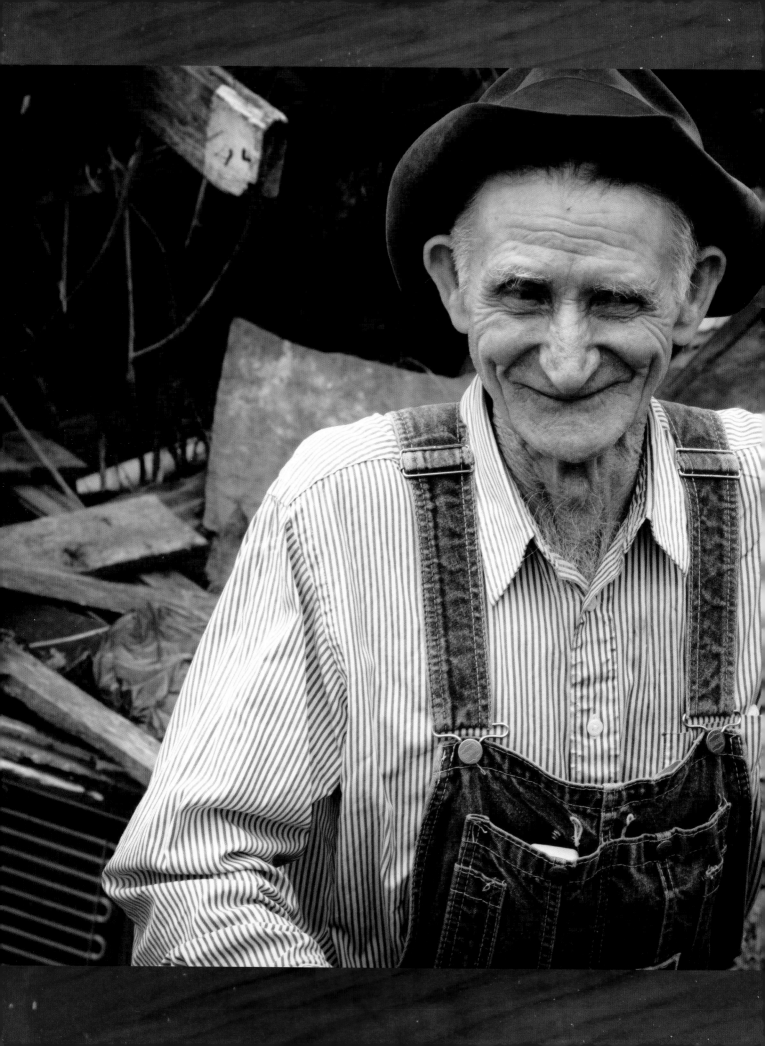

TRUE FAITH
TRUE LIGHT

The Devotional Art of Ed Stilley

KELLY MULHOLLAN

**PHOTOGRAPHS BY
KIRK LANIER**

**ADDITIONAL PHOTOGRAPHS BY
FLIP PUTTHOFF AND RUSSELL COTHREN**

The University of Arkansas Press
Fayetteville
2015

Copyright © 2015 by The University of Arkansas Press

All rights reserved

Printed in Korea

978-1-55728-681-9 (cloth)
978-1-61075-570-2 (e-book)

19 18 17 16 15 5 4 3 2 1

Designed by Liz Lester

♾ The paper used in this publication meets the minimum requirements
of the American National Standard for Permanence of Paper for Printed
Library Materials Z39.48-1984.

Library of Congress Control Number: 2015938418

This project was supported in part by the Center for Arkansas and Regional
Studies of the J. William Fulbright College of Arts and Sciences at the
University of Arkansas and the David and Barbara Pryor Center for
Arkansas Oral and Visual History.

Frontispiece photograph by Russell Cothren.

CONTENTS

ACKNOWLEDGMENTS

I want to thank a few people who made huge contributions to the making of this book. First, there is my dear wife, Donna, who has been right here working with me on the entire project. She is the silent coauthor of this book. Next is my friend and "front-line editor" and advisor, Budhi Kling (known today as Dreama Phoenix). Honestly, I could not have done this without her. Kirk Lanier immersed himself in taking the pictures that grace these pages. His eye and expertise make the book shine. All photographs are by Kirk Lanier unless another credit is given. Professor Robert Cochran realized the significance of Ed Stilley's life and work and made sure the project made it to the University of Arkansas Press.

I am thankful for the wonderful images provided by Flip Putthoff and Russell Cothren, which enable us to see Ed working at his Hogscald Holler homestead. Ed's story would not be complete without these precious photographs. Dr. Dennis Warren of Generations Chiropractic generously provided the X-ray photographs that allow us to view inside the instruments. A special thanks to the Walton Arts Center and Brian Hembree of the Fayetteville Roots Festival for the opportunity for Donna and me to curate a month-long exhibit of Ed's life and work in the Joy Pratt Markham Gallery in 2013. (This was the exhibit, *True Faith, True Light: The Folk Instruments of Ed Stilley*, which initially caught Robert Cochran's eye.) And to Thomas Lavoie for his steady guidance as we maneuvered through this whole process.

And of course, Ed and his family are the warp and the weft of the fabric of *True Faith, True Light*. I'm grateful to Eliza Stilley, Ed's wife, for her loving support over the years (and all the wonderful meals she has cooked for Donna and me). Stephen, Ed's son, helped me with documentation, as have Malinda Miller Fitch, Mary Jane Prickett Rohr, and David Rohr. I appreciate Darren McCullough and all the other owners trusting us with their precious instruments for the photo shoots and exhibition. It has been a wonderful experience working with all of you.

ARTIST TO ARTIST TO ARTIST

Tranquilizing with this jewel
The torments of confusion
—WALLACE STEVENS

How It Begins

Open in darkness. Picture a desperate man at wits' end, cornered, all avenues closed and every resource exhausted. Desperation row, bottom of the well. Suddenly there's help from on high. God speaks, commands and promises. Burdens lift, a clear path opens. The bowed man rises, moves to busy, fruitful labor. This would be a psychological approach, straightforwardly chronological, true to Mr. Stilley's experience.

Or begin instead in light, in the time-stopping panorama of a visitor's initial glimpse of not one but perhaps thirty-five of Stilley's creations mounted on a gallery wall. There they stand, unclamorous, their material presence incontrovertible, serene as a cohort of Buddhas or Easter Island monoliths huge on their hillside. But also sharply unclassifiable, singular, somehow both less and more than the guitars, fiddles, and dulcimers they most resemble. In the moment, perceived as novel hybrids, at once both musical instruments and wood/metal statuary, they simultaneously draw attention and impose a barrier, challenge the puzzled mind. The visitor moves closer, caught and held. This approach reverses chronology, focuses not on Mr. Stilley's out-of-time visionary experience but on the viewer's analogously out-of-time encounter with the durable results of the industry it prompted.

Joined, the two trace an archetypal tale, commedia's upward curve, arduous climb or instantaneous rapture from dark to light. From Mr. Stilley's vantage, which is spiritual, redemption arrives in the miraculous moment of God's command. Once was lost but now I'm found. The Lord's imperative, however, obeyed on earthly ground, is enacted as a covenant over time, so that from the gallery visitor's perspective, which is aesthetic, salvation manifests itself in the devoted work of decades, in the some two hundred instruments Stilley created in obedience to divine directive. Gathered on the wall, presented as a visual gift, they carry forward Mr. Stilley's many gestures of bestowal to a larger and more remote audience.

Theophany

Over the years, responding to inquiries of friends and supporters whose interest he understands as every bit as heaven directed as his own, Mr. Stilley constructed several narrative frames for the presentation of his theophany. These responses, despite their different surfaces and narrative strategies, never vary at their core. In every instance Stilley, a savvy

interlocutor, provides an answer adroitly directed to the questioner's purposes without violating either his own needs for privacy or the essential truth of his experience. For musicians and storytellers Donna and Kelly Mulhollan, in 1995, he elaborated a narrative centered on medical crisis leading to an animal-tale vision. Knocked to his knees by sharp chest pains, he envisioned himself as a swimming turtle caught in surging waters with his family clinging to his shell. In this extremity the Lord promised immediate aid in return for an ongoing labor that would itself provide an enduring sense of right livelihood. (The covenant was thus in essence a double gift, God commanding once and blessing twice.)

From this account the Mulhollans fashioned a song, "Take Me to the Other Side," which they perform regularly, accompanying themselves on instruments made by Stilley.[1] It seems clear, doesn't it, that he responded to them as an artist speaking to other artists, both responding to their queries and providing an occasion for the exercise of their own talents? The Mulhollans, as it turned out, would develop a two-decade commitment to Stilley and his work. More than any others, they would be responsible for that work's wider appreciation.

Two years later, in 1997, newspaper writer and photographer Flip Putthoff, at Kelly Mulhollan's urging, prepared a newspaper feature focused on Stilley's instruments. Interviewed by Putthoff, Stilley trimmed his account to a journalist's bare-bones need for who, what, where, when, and why: "A deeply religious man, the 66-year-old said he was called by God in 1979 to build stringed instruments and give them away to children."[2]

In subsequent conversations and interviews with the Mulhollans and others, Stilley's narrative focused not on heart attacks or swimming turtles but on petition-bearing preachers from outside the area with allegations of children inadequately cared for by a lunatic, religion-crazed father. Finally, in 2014, he provided the gallery visitor with a terse, elliptical summary: "I was pushed where I didn't want to go," he said. "No way out." He described himself as waiting at home for a resolution he regarded as both terrible and inevitable when, as he waked and dozed, the saving instructions arrived. Stilley would craft musical instruments and give them to children; God would provide. Cast thy burden upon the Lord, and he shall sustain thee. "I woke up," he said. "Put the gun on the shelf."[3]

In these later interviews, responding to queries focused not on the Lord's saving intervention but upon the immediate threat that called it forth, Mr. Stilley, guarding his privacy by oblique presentation and omission of detail, provided over time a relatively straightforward secular narrative. But here, exactly as in the tale crafted for the Mulhollans, threat to family holds the center. Spouses and parents expect to deal with life's day-to-day pressures, working alone or in partnership to shelter, feed, and clothe themselves and their children. This is adult life's standard portion. But when these fundamental ties are imperiled or destroyed, when the loss of partner or children is threatened, a burden beyond bearing is imposed. Where do I go but to the Lord?

Prologue

Prior to his encounter with the Mulhollans, Stilley had been celebrated in the 1950s as a singer of folk songs and in the 1970s as the head of a family practicing "a traditional and lightly-mechanized farm life."[4] The earlier of the two brushes with recognition took place

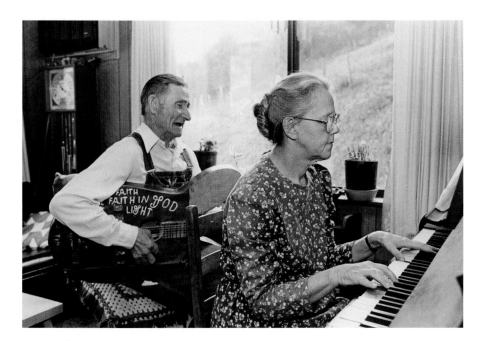

Ed and Eliza Stilley, Hogscald Hollow, Arkansas, 1997. Photograph by Flip Putthoff. ©Kelly Mulhollan. Used by permission.

in 1958, when Springfield, Missouri, folksong collector Max Hunter recorded Stilley's singing of eight songs. Stilley was at this time pushing thirty, unmarried, still living at Hogscald Hollow, south of Eureka Springs, in the home of Fannie Prickett (Hunter describes him as "a young man that Aunt Fannie raised"). He performs a mix of sacred and secular pieces, accompanying himself on a store-bought guitar.[5] In a photograph from that period he looks every bit a young man on the rise, dressed for the occasion in a shirt and tie, hair combed and trousers pressed, guitar in hand, perched on his own truck. He's already preaching—his call came to him at nineteen—and soon a beautiful young woman named Eliza Miller will hear him at a service in nearby Clifty.

The second notice came just over a decade later, in the early 1970s, when California-based photographer Roger Minick, an Arkansas native, returned to the Ozarks to complete a photographic evocation of the world he'd known as a youngster. In the Stilley family—Ed and Eliza were by this time married and busy raising five children—he found what he was looking for. *Hills of Home: The Rural Ozarks of Arkansas*, the book Minick produced with the help of his wife (introduction), his father (writings), and artist friend Leonard Sussman (drawings and etchings), is dedicated to them. A photograph of Ed plowing with a two-horse team serves as its frontispiece; the front cover shows daughters Martha and Janie bringing in cows; son Nathan walks upon home-made stilts on the back cover. Stilleys appear in twelve other photographs in the book itself, inhabiting its emotional center as embodiments of a venerable and fast-disappearing traditional Ozark lifestyle. A framing introductory essay ends with an anxious rearview-mirror glimpse as the visitors return to California. The authorities are at that very moment shutting down the Stilleys' milk business (their farm lacks a required refrigeration unit), and Ed "has begun working part-time at a sawmill." As the children mature, the essay guesses, "there will likely be difficult choices to make," and their departing admirers "can only wish them well and hope that they remain, in some way, close to their hills of home."[6]

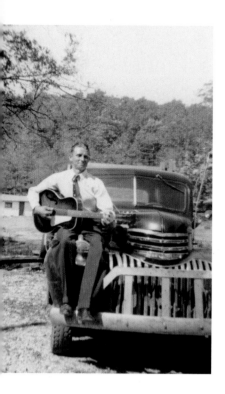

Ed Stilley, Hogscald Hollow, Arkansas, c. 1955. Photograph by Lucy Prickett. ©Mary Jane Prickett Rohr. Used by permission.

The tone of this might be taken as problematic—a whole family is fixed in amber, urged to perseverance in a disappearing lifestyle on the margins of contemporary life even as their exhorters decamp for the center—but at the level of fact the essay is notable for its prescient acumen. Times were hard and getting harder. Five years later, more or less, the Lord appeared to a desperate Ed Stilley.

Discovery

By the time the Mulhollans arrived, introduced by friends who were neighbors to the Stilleys, Ed had been making instruments for fifteen years. Putthoff's one-page feature appeared early in 1997 as the first published account of his mission. Putthoff printed five photographs with his essay, but he made nearly one hundred images, saved the negatives, and gave them to Kelly Mulhollan. Then, as the Mulhollans pushed their work to a finished manuscript, they were crucially aided by Kirk Lanier, a Fayetteville friend and fellow musician who brought to the project his striking skills as a portrait photographer. He also knew (and had previously photographed) the Stilleys themselves. With Kelly and Donna Mulhollan, Lanier is the crucial third party in the long saga leading to Mr. Stilley's wider recognition.[7] (Before Lanier came on board, the Mulhollans were aided in assembling a wonderful gallery exhibit in celebration of Stilley's work by Springfield, Missouri, photographer Tim Hawley. It was Hawley who contributed the brilliant idea of creating X-ray photographs to better capture the interior design of Stilley's instruments.) Artist to artist to artist.

These combined efforts, demanding of both time and money, were inspired and sustained over time by a bedrock appreciation of Stilley's work and by a growing admiration for the Stilleys themselves. Mr. and Mrs. Stilley gradually emerged as archetypal Ozark hill folks. Devoted to each other and deeply rooted in family life, firm in their faith, stoic in the face of trial, and adept in the many skills required to wrest a hardscrabble living from their spectacularly beautiful mountain home, they appeared to younger admirers, as to Roger Minick decades earlier, as embodiments of authenticity.

If Lanier's photographic artistry is apparent at a glance as an indispensable element in an appreciation of Stilley's creations, it is no less true that Kelly Mulhollan emerges in retrospection as a perfectly situated initial appreciator of Stilley's achievement. Himself both a musician and a journeyman-level carpenter, he brought with him an intimate understanding of the obstacles Ed Stilley faced when in obedience to the Lord's command he first stood at his workbench with his bare-bones toolkit ("a hacksaw and a handsaw," by his report) and in his head not the first inkling of the luthier's art. Like Stilley, who built his own house two decades before turning to musical instruments, Mulhollan had experience with woodworking projects small and large—he routinely makes repairs to his own instruments (and to Stilley's), and has worked both building and restoring houses. His experience ranged from designing and building on the one hand a three-ton water wheel for War Eagle Mill's working gristmill, and on the other a delicately intricate moving-parts chandelier for his wife. (It hangs over the dining room table in their home—picture a miniature puppet merry-go-round with a light at its center.)

The Mulhollans and Lanier, then—musicians, carpenter, photographer—constituted

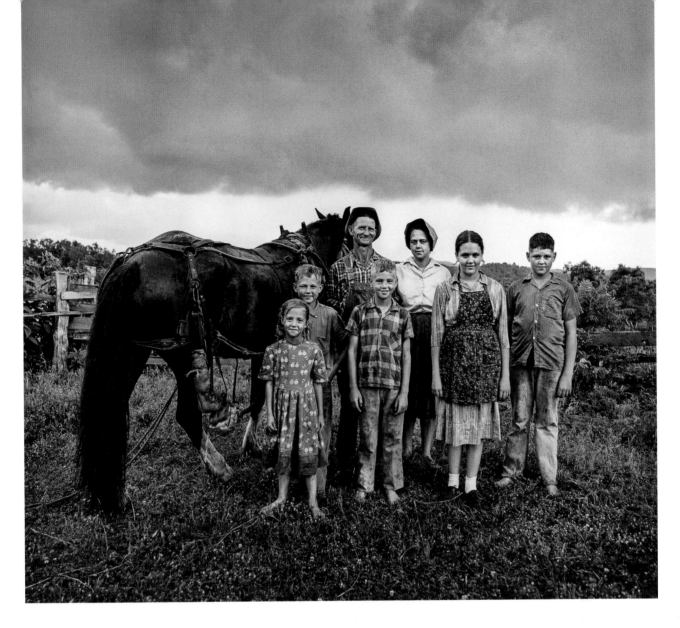

a perfect team for the documentation, restoration, and presentation of Stilley's art. In tandem they possessed in generous measure every requisite skill. Mr. Stilley, for his part, is volubly pleased and grateful for every attention, but his understanding of every step has been secure from the beginning. The eye of his God, overseeing every sparrow, has not failed to direct the interest of the musicians, the journalist, the photographers, and finally the gallery visitor. Each arrives in turn, in Mr. Stilley's view, to serve a purpose wholly known only on high. In the first months of 2014, in our second meeting, he chose a private moment at his kitchen table to fix me in his gaze and phrase what was a question only at the grammatical level: "You're here at the Lord's will," he said. "You know that, don't you?" "Yes, sir," I replied, "I do tonight."[8]

This volume, pooling these labors, is produced by the University of Arkansas Press as volume one in the Arkansas Character series jointly sponsored by the David and Barbara Pryor Center for Arkansas Oral and Visual History and Fulbright College's Center for Arkansas and Regional Studies. Our ad hoc publication board (Randy Dixon, Scott Lunsford, Robert Cochran) is grateful to Bill and Judy Schwab for arranging and

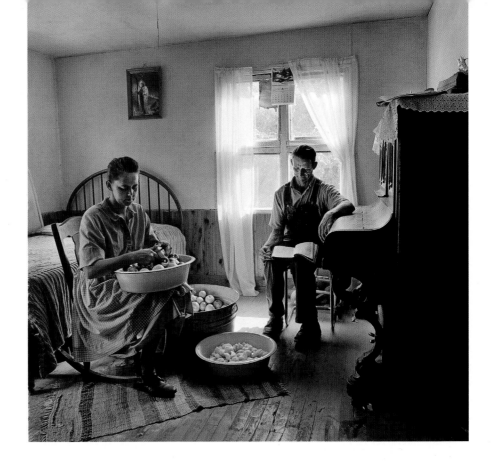

Eliza and Ed Stilley, Hogscald Hollow, Arkansas, c. 1971. Photograph by Roger Minick. ©Roger Minick. Used by permission.

superintending the collaborative union of our two centers, and to Todd Shields and Lynda Coon, dean and associate dean of Fulbright College, for continuing encouragement and support. We have high hopes for this series, and we're proud to lead it off with this celebration of Stilley's art.

Where's the Hurt?

You say the poor. But who else would saints appear to?
Do saints and angels appear to bank presidents?
—DON DELILLO

Ed Stilley, of course, was far from alone in turning to a life of making art (or what others will call art) at the Lord's command. The Most High, if testimonials of artists the world over are credited, is a connoisseur of wide-ranging tastes. Artisan of all, God is also the ultimate patron of the arts. Artists in their millions, over several millennia, have turned to their work backed by a sense of divine commission. And turned gratefully, for the Lord's orders in the art market seem not to be randomly distributed between the fortunate and the afflicted, the well-heeled and the impoverished, the mainstream and the marginal, but overrepresented among the latter groups. The Divine, in keeping with what seems standard practice (a man "of a slow tongue" called to public oration, a woman of ninety, "well stricken in age," made suddenly capable of childbearing), manifests divinity by favoring the unlikely, concentrating support where it is most needed.[9] Again and again, crossing all borders, appearing to the afflicted of all creeds (and of no creed), the gods and goddesses

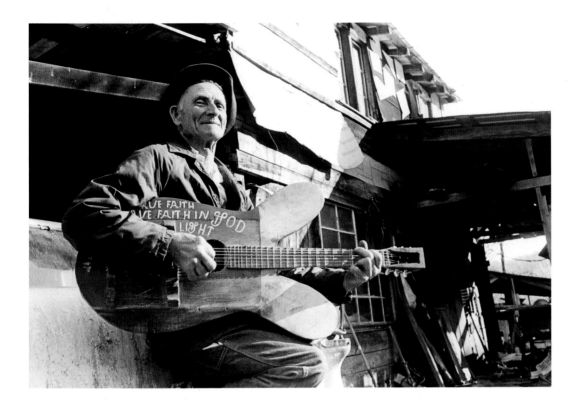

arrive, compassionate and merciful. "I give you hands," they say. "And a world around. Use the former to shape the latter in My service. Find your peace in this sanctified labor."[10]

Some examples, ranged across space and time and form: the apex painter Domenikos Theotokopoulos, known in museums as El Greco, got his start as a painter of icons, "a creator of holy images whose every movement of the brush had been an act of prayer," before going on to the large-scale Adorations and Ascensions (often for the interior of churches) that took his name to the world.[11] "My work is a prayer," agrees Haripada Pal, a Bangladeshi maker of clay *murtis*, devotional images of Hindu deities used in public and private worship. "It is a part of my devotion to God, and it is a benefit to the people. It is a goodness." Ahmet Şahin, a famed Turkish *çinici*, ceramic artist, is no less succinct: "God says, 'Tell everyone what you know. Wish for no pay.'" It's the same with music, adds Fermanagh musician Peter Flanagan: "you could save them people by that music in the early stages of life from goin astray and adoptin the wrong way of life. . . . Aye, he's a child of God, surely, the person who does that. . . . If ye accomplish that, and if ye carry that on to the end of your lifetime, there's no danger."[12]

From a single widely shared moment of origin, then, obedience takes a galaxy of forms. The landscape is dotted coast to coast with the productions of artists who turned to large-scale installations like James Hampton's *The Throne of the Third Heaven of the Nations' Millennium General Assembly*, a rented garage in Washington, DC, refurnished as a reception room for the risen Christ, or, across the continent in the Mojave Desert's searing heat, Leonard Knight's brightly painted *Salvation Mountain*, erected on an abandoned bombing range near Niland, California. Very different in form but identical in initiating impulse would be the heartland "grotto" complexes of Paul Dobberstein (*Grotto of the Redemption*, in West Bend, Iowa) and Joseph Zoettl (*Ave Maria Grotto*, in Cullman,

Alabama), or Joe Minter's *African Village in America* near Birmingham. More than 450 such monuments are listed in "A Global Tour of Sites" in *Self-Made Worlds: Visionary Folk Art Environments*.[13]

Other artists, working closer to Stilley's practice, have produced smaller artifacts— the wood carvings of Ulysses Davis and Elijah Pierce, the stone sculptures of Raymond Coins and William Edmondson, Annie Hooper's doll tableaux, the vivid oils of Myrtice West. A collection of this work, large and small, centered on southern practitioners, is *Coming Home: Self-Taught Artists, the Bible and the American South*.[14]

Stilley's creations were crafted and presented to recipients, as Kelly Mulhollan carefully demonstrates, as musical instruments, and over the years their creator worked diligently to improve them as such. But from the beginning Mr. Stilley clearly intended more. Children who received them may or may not have attempted to play, but they surely sensed a message in the giving, a reminder of the Lord's care, an urging to joyful noise. (It must be observed, too, that despite the specificity of God's commands, many instruments are not in any obvious way reduced in size with the needs of children in mind, and were often in fact given to adults.) Emblems of their maker's obedience to divine command and clearly understood as a facet of his ministry, inscribed with pastorly exhortation and encouragement, they were bestowed at least in part as charms, as amulets or talismans, Saint Christopher medals, or "What Would Jesus Do?" bracelets writ large.

Charms and amulets, terms generally reserved for exotic contexts, have little contemporary currency and less authority; they sound in the mind as either obsolete or applying to less knowing others. That's too bad, as we all, rube and sophisticate, stand as awed under vast heavens as any australopithecine, as likely as our remotest ancestor to kneel before a shrine offering succor or protection. Yet another term characterizing such immanent power is "mana," as recently deployed by furniture artist Peter Korn to articulate an "ancient materialism" ascribing to physical objects a "miraculous power to provide spiritual sustenance." Korn's instances are refreshingly contemporary and close to home: "We enshrine the original manuscript of the Declaration of Independence because it has mana; we revere hallowed paintings in museums because they have mana; we make pilgrimages to the Shroud of Turin because it has mana."[15]

How It Ends

> *The earlier culture will become a heap of rubble and finally*
> *a heap of ashes, but spirits will hover over the ashes.*
> —LUDWIG WITTGENSTEIN

A strikingly close parallel to the life and work of Ed and Eliza Stilley is found in the career of Vicksburg, Mississippi, storekeeper evangelists H. D. and Margaret Rogers Dennis, as lovingly chronicled by Bruce West's photographic collection, *The True Gospel Preached Here*. Like Stilley, Reverend Dennis grew up without a mother (she died at his birth), was directly ordained by God to undertake his ministry, and accomplished his mission in the lifelong company of his wife. Dennis built a roadside evangelical park, not musical instruments. Marry me, he urged Margaret Rogers, a widow who operated

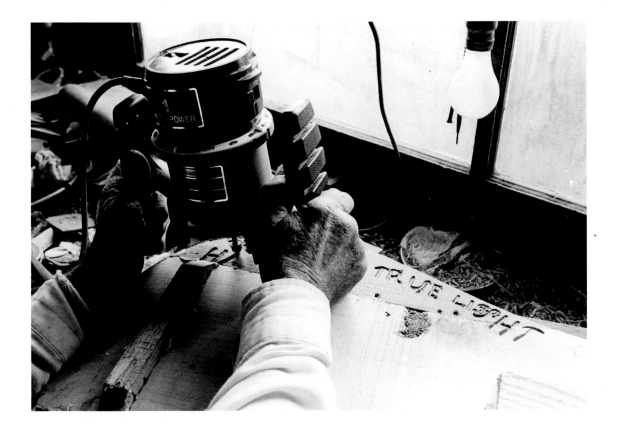

Ed Stilley, Hogscald Hollow,
Arkansas, 1997. Photograph by
Flip Putthoff. ©Kelly Mulhollan.
Used by permission.

a neighborhood grocery, and I'll make it a palace. At once true to his word and obedi-
ent to the Lord, Dennis spent the next two decades working with brick and cinder block
and paint to transform the store, all the while preaching energetically to any passerby
lured within range by the flamboyant assemblage. A particular virtue of West's work
is his diligent tracing of the whole arc of the Dennises' shared ministry, from its begin-
nings at their marriage in 1984 to its end (Margaret died in 2009 at ninety-four and
H. D. followed in 2012 at ninety-six). His photographs are for the most part chronolog-
ically arranged, allowing the viewer to see *Margaret's Grocery & Market: The Home of the
Doubleheaded Eagle* at its most splendid, newly painted, shining brightly in the morning
sun, and to encounter its makers healthy and happy together, she gently smiling, holding
their door open in welcome, he posing proudly at the entrance, leading tours, and preach-
ing vigorously.[16] By the volume's close, however, not only have both Margaret and H. D.
died, but their roadside temple complex has fallen to ruin, its altars and shrines desecrated
and stolen, its welcoming signboards weathered and askew. The volume's starkest image, a
photograph labeled "Mrs. Margaret Dennis' Grave, 2011," appears as a patch of browned
grass speckled with a thin scattering of fallen leaves. There is no marker, no mound of bare
earth. The facing page is blank, a shining, empty white. Here is the triumph of entropy at
the domestic level—the family perished, their home an empty ruin, their devoted labors
undone.

The effect of having this whole narrative available, open to close, is to highlight, here
and in other instances, the contribution of those most moved by the artists' creations, the
audiences/congregations who act to rescue and preserve, to collect and restore, to document
and photograph. Alert to the presence of mana, they act to pass it on. For Reverend and

Mrs. Dennis the most devoted chronicler was West, who visited again and again for eighteen years, became more than a friend (Margaret wrote in 2008 that she and her husband considered him "our white son"), and finally persevered to produce and publish his tribute volume. This is what Kelly and Donna Mulhollan, with the central aid of Kirk Lanier and the peripheral assistance of many others, have done for Ed and Eliza Stilley. In 2014, as they completed work on their own celebratory book, Ed and Eliza had been gone from their beloved Hogscald Hollow farmstead for a decade. The hand-built home where they raised their children, the workshop where Ed fashioned his God-commissioned instruments—both were fallen into a disrepair matching that of Margaret and H. D. Dennis's roadside sanctuary. Ed's last instrument was finished just before the move, though the Stilleys carry on their ministry as they can, welcoming visitors and handing out tape cassettes of Ed's sermons and musical performances. Ed was confined to a wheelchair for the opening of the Fayetteville exhibit celebrating his work, but both Stilleys were able to attend what was an overwhelmingly joyous occasion for all concerned. Voices were raised in song.

Whence Cometh My Help

What's most insistently communicated, then, by Mr. Stilley's creations, to the viewer encountering them on the gallery wall, to the child or adult hefting one just given into her or his lap? Drawing close, focusing for the moment on a single instrument, the initial impression is of struggle, protracted effort against odds. The guitar appears unfinished, a facsimile or prototype assembled from scraps of bulky wood, only half painted, its upper frets preposterously spaced. It presents itself frankly, unguardedly but with no trace of abashment, as an artifact wrested from recalcitrant materials with inadequate tools by a remarkably determined if untrained artisan. The overall effect is strangely reminiscent of the engineless wood-and-palm-frond airplanes and tanks constructed by World War II–era Melanesian "cargo cults" to summon return of the C-46s and C-54s that delivered unprecedented wealth from the sky in support of Allied troop operations. Here too are objects that beggar category, manifesting themselves as at once insistently present and tenaciously opaque. Planes that do not fly and tanks that fire no shells, they stand most powerfully as offerings, ritual instruments of propitiation and invocation. For all their flimsiness, they are accoutrements of worship and prayer, assembled as missives to heaven. They too are rich in mana.[17]

The incomplete finish of Stilley's instruments, in contrast with the varnished sheen, dark or bright, of more polished violins and guitars, foregrounds their sheer materiality even as it subordinates form. Their power, undeniable as it is, lacks all connection to assured display of skill, of technical mastery. "I took lots of work. I wasn't easy," the instrument says. "Devoted industry brought me to you. I am rough looking and rude, but I am solid. Made to last." The most enduring impression is of an urgent beauty, nature's wood and culture's metal joined, bent to unity by dogged energy and unyielding will. Picked up, cradled for performance, the gift is heavy in the hand; its strings strummed or plucked, it produces a sound tied more tightly to its metallic innards than its wooden exterior. To the ear, as to the eye and hand, it seems meant for ends in addition to music. By its every rough-hewn mark and tinny sound it carries its maker's signature, testament to

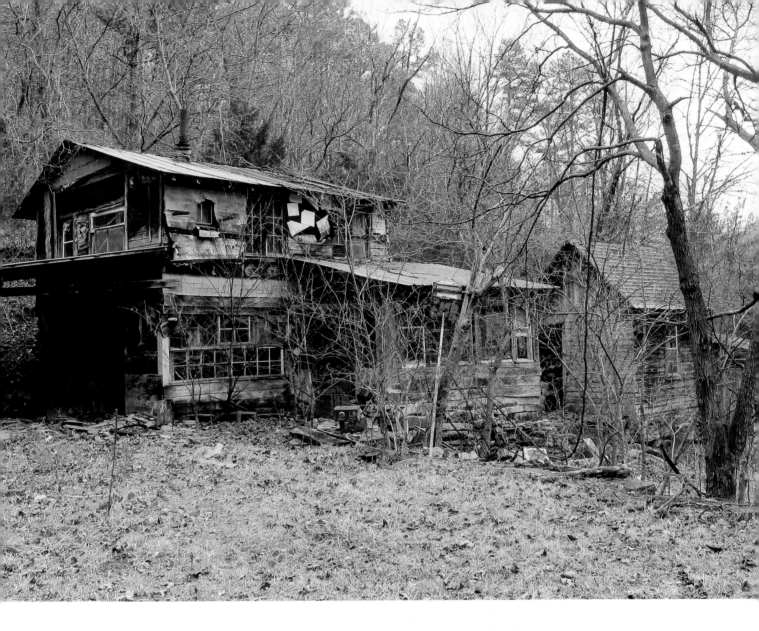

his persistent obedience, reaching against the limits imposed by throwaway materials and rudimentary tool kit. (Stilley may be the first luthier on record to see a router as essential equipment!)[18]

And here, in this reach, this effort, in the years upon years of what William Morris called "the blessing of labor," is the heart of Stilley's gift, his devotion's true sign and art's surest marker, trumping even technique as the supra-utilitarian passional element that lifts craft to art. Here, and not in culturally variable hierarchies of media or distinctions between mainstream and outsider practitioners, is the root of art's power, the source of all mana. The best of art, everywhere and at all times, is made where making merges with veneration, where the thing made, of whatever form in whatever material, is among other things an offering, an oblation, and where the artist at last reaches past capability to leave the work inscribed with linked signs of devotional aspiration and executive shortfall.[19] Melville put it plainly: "I love all men who *dive*."[20]

James Hampton, as he worked upon *The Throne of the Third Heaven of the Nations' Millennium General Assembly*, made for his own appropriate vestment a small crown

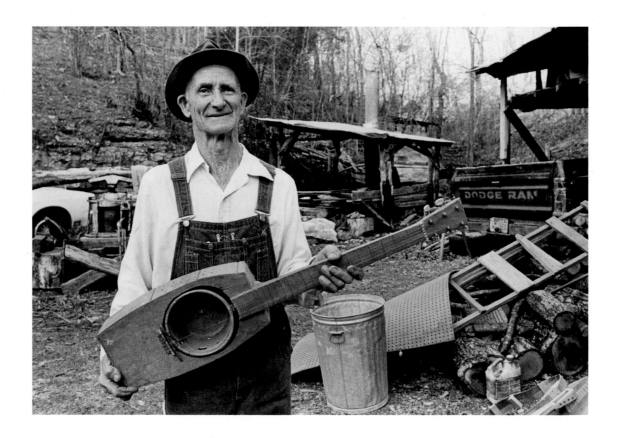

from the same castoff materials. Ed Stilley, as he told Tim Hawley, "left my name out of it." But he, no less than Hampton, knew himself as called to serve the Lord's inscrutable purposes. His creations are sanctified musical instruments, psalms in metal and wood. Each one is a timbrel for Ozark Miriam, that she might lead women in dancing, a harp for Arkansas David, that Saul might be refreshed.[21] He asked for no pay, but his creations brought peace in their making and confer blessing in their giving. They are Ed Stilley's crowns; they are a goodness.

Stilley, the Mulhollans, Lanier. Artist to artist to artist. Now they're yours.

ROBERT COCHRAN

Center for Arkansas and Regional Studies,
Fulbright College of Arts and Sciences
University of Arkansas

NOTES

Epigraphs are from Wallace Stevens's poem, "Homunculus et La Belle Étoile," Don DeLillo's short story, "The Angel Esmeralda," and Ludwig Wittgenstein's *Culture and Value*.

1. The Mulhollans appear professionally as Still on the Hill. Their performance of "Take Me to the Other Side," filmed by Tim Hawley, may be seen online at http://www.youtube.com/watch?v=Y2roCkzK2ys.

2. Flip Putthoff, "Making Music in the Hollow," *The Morning News of Northwest Arkansas*, January 19, 1997.

3. Ed Stilley, in unrecorded conversation at his home, March 18, 2014. The scriptural reference is to Psalm 55:22.

4. Joyce Minick, "A Word Before," in Roger Minick, Bob Minick, and Leonard Sussman, *The Hills of Home: The Rural Ozarks of Arkansas* (San Francisco: Scrimshaw Press, 1975), unpaginated [8].

5. Stilley performed at two sessions—the first on February 5, 1958, the second on May 1 of the same year. The first session's two numbers, in order of performance, are "My Mother's Bible" (catalogued by Hunter as #0045) and "When the Morning Comes" (#0046), with introductory remarks by Hunter for the former. The second session's six numbers, in order of performance are "Girl in the Blue Velvet Band" (#0091), "Wildwood Flower" (#0092), "Something Got Hold of Me" (#0093), "In the Pines" (0094), "Tattler's Wagon" (#0095), and "Mama and Daddy Don't Cry" (#0096). There's also a separate track labeled "Introduction to Ed Stilley" following the fourth number—it lists the titles of the first four performances and introduces "Tattler's Wagon." The guitar accompaniment for two of Fannie Prickett's four performances, "At the Feast of Belshazzer" (#0313) and "Behold the Wayward Boy" (#0314), both recorded on February 11, 1959, may also be provided by Stilley. Hunter also recorded, as "Hogscald Hollow Story," a striking anecdote with Stilley at its center. Crossing a stream on a footbridge following a nighttime recording session at Ed and Aunt Fannie Prickett's home, Hunter and a friend hear a frog croaking in an unusual way ("sound like it was in a barrel"). Inquiry is addressed to Ed. "A snake is swallowing the frog," he tells them, "and the frog is croaking down in the snake. He's not got it all swallowed yet." A quick return for a flashlight and a brief search of the creek bed confirms Ed in every detail. Think on this—one nocturnal sound mixed with others, out of the night, read so promptly, so exactly. Stilley, already preaching, already singing, playing guitar, piano, and harmonica, soon to marry, build a home, work in a sawmill, operate a farm, raise a family—he appears, doesn't he, as a remarkably perceptive and resourceful young man, knowingly at home in his world? It's not so surprising, after all, that twenty years later he'll move so inventively, so energetically, to obey the Lord's directive.

6. Minick, "A Word Before," unpaginated [10].

7. A vivid portfolio of Lanier's work is available online at http://kbass9.wix.com/lanierphotography.

8. That's what I said, happily channeling "Walking in Memphis." Thanks, Mr. Cohn.

9. The man "of a slow tongue" (Moses) is from Exodus 4:10; the woman "well stricken in age" (Sarah) is from Genesis 18:11.

10. I'm not forgetful of Mr. Stilley's fervent Christianity, even as my purpose here is to suggest his experience's cross-cultural reach. The oblique references to Islamic and Hindu traditions are purposeful—one English version of the *Mahabharata* closes upon strikingly ecumenical assertion: "whoever calls Him by any name, by that name does He come." (*Mahabharata*, "retold" by William Buck [Berkeley: University of California Press, 1973], 411.) I've long admired this line, though searches through my dual-language edition for a Sanskrit original have thus far proved unsuccessful, and it may be that Buck was flying pretty free when he coined it. Good for him. My imagined collective divine imperative is stolen from the first half of Ruskin's formulation: "that the law of human life may be Effort" (from "The Nature of Gothic," *The Stones of Venice*, 2.6).

11. Ingrid D. Rowland, "Irresistible El Greco," *The New York Review of Books*, June 19, 2014.

12. I've learned most about traditional or folk art from Henry Glassie. I thank him here by selecting three practitioners of artistic labor understood as divinely directed, of creation as worship,

from his work. The first is from *Art and Life in Bangladesh* (Bloomington: Indiana University Press, 1997), 349; the second is from *Turkish Traditional Art Today* (Bloomington: Indiana University Press, 1993), 482; the third is from *The Stars of Ballymenone* (Bloomington: Indiana University Press, 2006), 173–74. Glassie links all three as "completely realized artists" on pages 181–82 of *The Stars of Ballymenone.*

13. I've been a devotee of such environments for a long time (and have visited many), but my understanding of outsider art owes most to Greg Bottoms's *The Colorful Apocalypse: Journeys in Outsider Art* (Chicago: University of Chicago Press, 2007) and *Spiritual American Trash* (Berkeley, CA: Counterpoint, 2013), the latter with its first chapter dedicated to James Hampton (and his *Throne* on the cover). I first encountered Bottoms's writing in "St. James," a 1999 piece on Hampton published in the wonderful *Gadfly*, a now-defunct magazine I much admired (and occasionally wrote for). *Self-Made Worlds: Visionary Folk Art Environments* was edited by Roger Manley and Mark Sloan (New York: Aperture, 1997). Dobberstein (pages 18–19), Zoettl (pages 44–45), Hooper (pages 48–49, 103), and Knight (front cover, pages 78–79) are featured, along with Manley's warmly appreciative essay, "Strangers among Us" (pages 102–11). For Minter see Carol Brown, ed., *Coming Home: Self-Taught Artists, the Bible and the American South* (Jackson: University Press of Mississippi, 2004), 29, 47, 50–52, 72, 144). Nomenclature has long been a vexed issue—what is art and what is craft and what labels best characterize the productions of artists who turn madly or merrily to their painting and drawing, building and sewing, cutting and pasting, sculpting and wire bending with little or no formal instruction and at best a passing acquaintance with mainstream traditions? Many have been tried—"environmental," "folk," "grassroots," "naive," "outsider," "primitive," "self-taught," "traditional," "vernacular," "visionary"—and mostly found wanting. *Art brut* was an early and influential French coinage (from the pioneering work of Jean Dubuffet). What seems clear is that each term works well to describe some works but that none works well for all, that hierarchies rooted in genre or medium or academic certifications are at bottom arbitrary impositions rooted in nationalist, class, and professional agendas. "Devotional" works nicely for Mr. Stilley. (It is at the heart of this essay's purposes to suggest the label's redundant character—the artist is by definition devoted; a dispassionate creator, no matter how skilled, is at last better described as a virtuoso, a prestidigitator, a marketer.)

14. For Davis see Susan Mitchell Crawley, *The Treasure of Ulysses Davis: Sculpture from a Savannah Barbershop* (Jackson: University Press of Mississippi, 2008). For Pierce see *Elijah Pierce: Woodcarver* (Seattle: University of Washington Press, 1992). Brown's *Coming Home* includes a brief bio of Coins (pages 186–87) and prints two of his carvings (page 113); Edmondson's bio appears on page 187, with additional commentary (pages 17, 29, 79, 82) and two prints of limestone carvings (page 118); West is treated in considerable detail—her bio is on page 195, with prints of her paintings and additional commentary on pages 27, 30, 36, 179–82.

15. Peter Korn, *Why We Make Things and Why It Matters: The Education of a Craftsman* (Boston: David R. Godine, 2013), 59. Korn's essay centers on his secular quest for a good life; at its heart is a lovely meditation on "thinking with things" (the title of his sixth chapter, where mana is mentioned). The term comes from Pacific languages; it's found in both Hawaiian and Maori, where reference is to forces inhering in the physical world. Korn's pivotal assumption is that these natural powers are focused and concentrated by skilled human shaping. Robert Plant Armstrong's influential notion of "affecting presence," elaborated in the study of Yoruba art, is nicely analogous to Korn's use of mana. Armstrong's thornier prose reflects his greater analytic ambition and rigor—see Robert Plant Armstrong, *The Affecting Presence: An Essay in Humanistic Anthropology* (Urbana: University of Illinois Press, 1971).

16. Bruce West, *The True Gospel Preached Here* (Jackson: University Press of Mississippi, 2014). Other accounts of the Dennises' ministry include Stephen Young, "'All of world-kind have been right here': The Theology and Architecture of Rev. H. D. Dennis," *Southern Quarterly*, 39, no. 1–2 (2000–2001): 100–111 and Cynthia Elyce Rubin, "Margaret's Grocery & Mkt & Bible Class: Mississippi's Grassroots Temple of Prayer," *Raw Vision* 15 (Summer, 1996): 52–53. Reverend Dennis also appeared in films: see *Ghost Trip* (2000), a short black and white feature directed by Bill Morrison, and *God's Architects* (2009), a color documentary directed by Zack Godshall. For additional images (including the finest exterior shots of the front façade) see Andrew Morang's 1988 and 1990 online posts

at http://worldofdecay.blogspot.com/2011/02/margarets-grocery-vicksburg-mississippi.html. Wittgenstein's hovering "spirits" I understand as yet another description of mana; I don't know if the revered philosopher's assertion is true (it was published after his death), but it is beautiful and brave (and thus satisfying). It comes from G. H. Von Wright, ed., *Culture and Value: Ludwig Wittgenstein* (Chicago: University of Chicago Press, 1980), 3 (in German), 3e (in English).

17. There is a rich literature on cargo movements. An early, influential study is Peter Worsley, *The Trumpet Shall Sound: A Study of "Cargo" Cults in Melanesia* (New York: Shocken Books, 1986 [first published 1968]). More recent studies are Lamont Lindstrom's informative, sometimes acerbic, occasionally hilarious *Cargo Cult: Strange Stories of Desire from Melanesia and Beyond* (Honolulu: University of Hawaii Press, 1993), and the more staid *Cargo, Cult & Culture Critique* edited by Holger Jebens (Honolulu: University of Hawaii Press, 2004).

18. Terms like "unfinished," "untrained," "rude," and "rough-hewn" in these two paragraphs are misread if understood as disapproving. I'm chasing Stilley's focus here, not judging his competence, but it is well to remember that Ruskin uses very similar terms as high artistic compliment. His general remarks are no less apposite. One: "Of human work, none but what is bad can be perfect, in its own bad way." Two, italicized by Ruskin for emphasis: "*the demand for perfection is always a sign of a misunderstanding of the ends of art.*" Like the reference in note 10, above, these are from "The Nature of Gothic." Again and again, the authors of a magisterial biography note that Vincent Van Gogh remained throughout his life a clumsy draftsman, even as his mana-packed landscapes and night skies eventually thrilled and awed. See Steven Naifeh and Gregory White Smith, *Van Gogh: The Life* (New York: Random House, 2012), 443, ("deprived of natural facility"); 459, ("the precision he could never master"); 676, ("his weak draftsmanship"). Finally, for a reminder of Stilley's general competence see the anecdote in note 5 above.

19. William Morris, "The Lesser Arts," in A. L. Morton, ed., *Political Writings of William Morris* (New York: International Publishers, 1973), 34. Later in the same essay he speaks of "our work, that faithful daily companion (55)." Aware that the perception of mana is and must be a deeply idiosyncratic matter, I nevertheless offer one striking instance from a collection cited earlier. Paging through the "Plates" section of Brown's *Coming Home* in search of page references, I suddenly found myself confronted with a work in wood called "Bible Pedestal." An undated piece by an unnamed artist, it's a kind of ark, a wooden coffer. My paging stopped. For long moments I saw nothing else. It was (is) hauntingly beautiful, absolutely bursting with mana. It's on page 175. (Armstrong was an anthropologist, Bottoms is an English professor, DeLillo is a novelist, Glassie is a folklorist, Korn is a furniture maker, Naifeh and Smith are art historians and biographers, Rowland is a cultural historian, Stevens was a poet, Wittgenstein was a philosopher—a secondary agenda of this essay is the urging of more wide-ranging analytic frames for the understanding and appreciation of so-called outsider artists. Bring your A-game to these folks; they deserve it.)

20. Herman Melville, letter to Evert Duyckinck, March 3, 1849, printed in Lynn Horth, ed., *Correspondence*, volume fourteen of *The Writings of Herman Melville* (Evanston and Chicago: Northwestern University Press and The Newberry Library, 1993), 121.

21. Stilley's remark comes at the five-minute mark of *God's Own Instruments: The Ed Stilley Story*, a 2013 film by Rob White and Tim Hawley. It can be viewed online at http://www.youtube.com/watch?v=igKbP9aG5qc. Miriam as dance leader is from Exodus 15:20; David's musical consolation of Saul is from I Samuel 16:23; the subtitle for this essay's concluding section is from the opening verse of Psalm 121.

TRUE FAITH, TRUE LIGHT

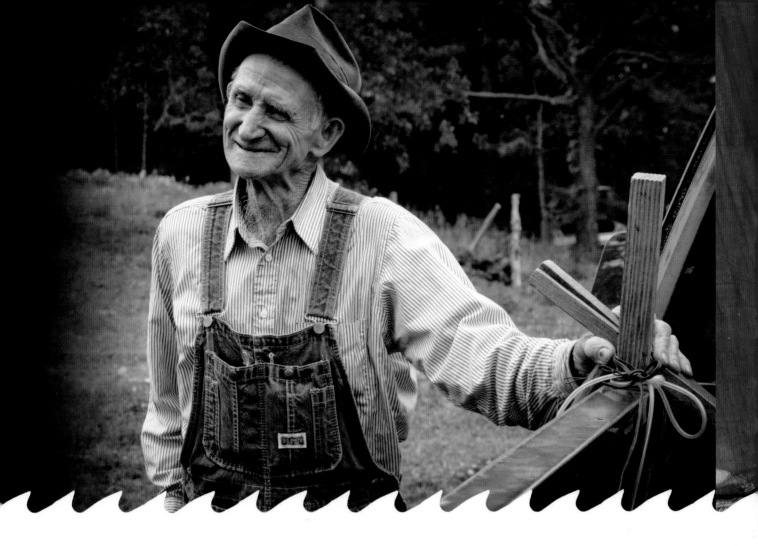

God told Ed Stilley to make musical instruments and give them to children—and he did. For a good twenty-five years. Ed worked tirelessly to create some two hundred one-of-a-kind instruments and gave them all away. He stopped only when his body could no longer do the work.

Each instrument is a crazy quilt of heavy, rough-sawn wood scraps gleaned from a local sawmill. Oak, walnut, linden, pine, and cedar were favorites. Some were left natural, but most were finished out with red barn paint.

A tailpiece might be made from an old rusty door hinge. Nut and saddle may consist of a steak bone sitting atop a stack of dimes, with frets made from brazing rods cut into short pieces. Within the sound box lie a host of hidden treasures—door springs, saw blades, pot lids, metal pipes, glass bottles, aerosol cans, and who knows what else.

On the top of each instrument Ed inscribed the words, "True Faith, True Light, Have Faith in God." Ed wants you to read these words, and he hopes you will live by them as well.

Photograph by Russell Cothren.

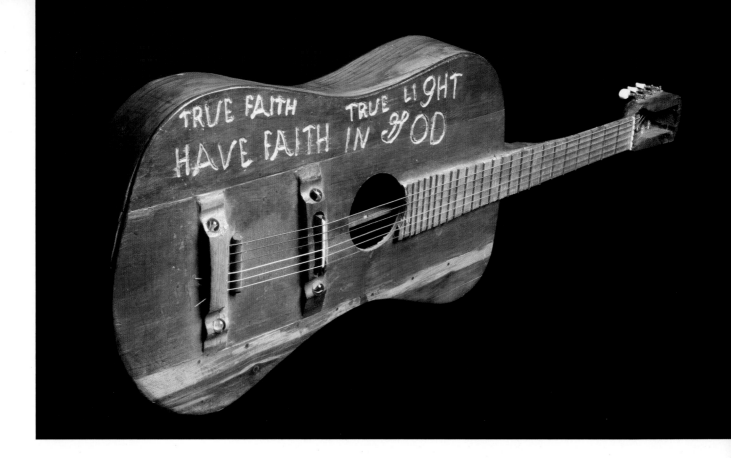

Photograph by Kirk Lanier,
(All photographs by
Kirk Lanier unless
otherwise noted.)

The "Preacher Man" of Hogscald Holler

Ed Stilley made his home in Hogscald Holler, Arkansas, and lived in much the same way as the folks who originally settled the Ozark hills. With a mule and a plow, a few cows, chickens, and a garden, Ed and his wife Eliza provided for their family. Electricity did find its way to the Stilleys' home around 1962, but it didn't change things all that much. They still made sorghum every Christmas with a mill driven by the mule. Their water still came from a pure spring that emerged from the hillside and filtered down into the "hog scalds" below.

Back when I first met Ed, I asked him if he had lived there his whole life. I remember feeling a bit surprised when he replied, "Oh no, I was born plumb on the other side of that hill over yonder." Born in 1930, Ed grew up just a few miles from what would become his Hogscald homestead and was raised partly by his parents and partly by longtime resident Fannie Prickett. He married Eliza Miller in 1959 and built a home on a sliver of Ozark hillside just above the "scalds" of Hogscald Creek. There they raised three boys and two girls, and that hardscrabble patch of land provided most everything they needed to get by.

Hogscald Holler is a little-known jewel of the Ozarks named for a section of creek bed carved out of solid limestone just down the hill from Ed's old homestead. Time has hewed the stone surface of the creek smooth and formed a graceful series of natural pools, each one not much larger than a bathtub. These pools became known as the "scalds." Early settlers and both Union and Confederate soldiers used these natural pools. Rocks were heated and then rolled into them, heating the water enough to scald hogs and assist in removing their bristly hair. No kidding.

It was his guardian, Fannie Prickett, who set Ed on his spiritual path. Ed recalls her last

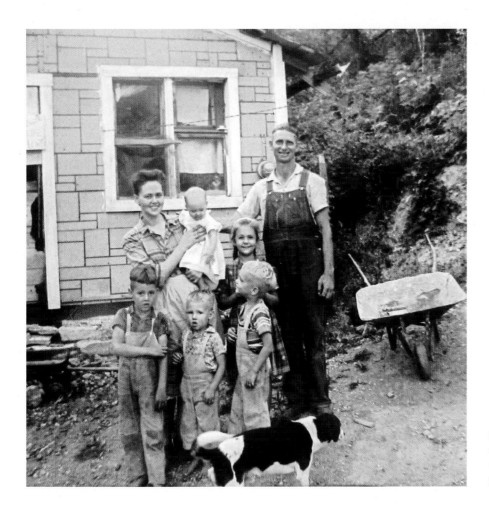

Family snapshot of the Stilleys with all five children in front of the home Ed built. Stilley family photograph.

request of him before she passed from this earth. He was a young man, sitting at her bedside when she told him, "Ed, I prayed that one of my boys would be a minister, but it didn't happen. But then God sent you my way. When I get to heaven, I want to see you up there."

Ed did try his hand at preaching at the nearby Clifty Church but was perhaps too esoteric in his interpretation of the Word to fit in. Still, his faith was always at the center of his world, and he became known as a "preacher man" by all who knew him. He knows the Bible front to back—the King James Version is always within arm's reach, with his notes written in the margins of every page. It's the only book he read after Fannie died. Even the newspaper was off limits. When asked why, Ed explains, "I got just a little bitty garden in me, and I want to fill it with beautiful flowers." This single-mindedness also helps us understand how Ed remained so unaffected by all the changes in the modern world around him.

Ed tells several different versions of the moment in 1979 when he received his directive from God to make instruments and give them to children. In recent years he recounts falling asleep during a time of great duress and receiving the vision. I asked him myself soon after meeting him back in 1996 and heard a different and much more colorful story. His son Stephen recalls hearing this version as well. I like to call the moment Ed had his vision the "great crossing," and my wife and I turned the following story into a song.

Scalds at Hogscald Creek fifty feet from Ed's mailbox. Photograph by Kelly Mulhollan.

The Great Crossing

One day when he was working in the field plowing with his mule, Ed began to feel a heart attack coming on. Ed's not the kind to go to the doctor, and there was nobody in earshot to hear him call for help anyway. He was very much on his own. Ed lay on the ground looking into the sky when a vision came to him. He saw himself as a giant tortoise swimming for his life in a raging river. His five children were tiny tortoises hanging on to his great shell. Somehow he knew at this moment that he must deliver his children to the other side of that river. If he succeeded in this task, the Lord would tell him why he was here on earth and what his ultimate purpose would be.

Ed made it to the other side with his family intact, and there he received a clear message from God that he was to make musical instruments and give them to children.

On the strength of this vision, Ed kept going for twenty-five years, making instruments and giving them to local children, his own family, and just about anyone who asked for one.

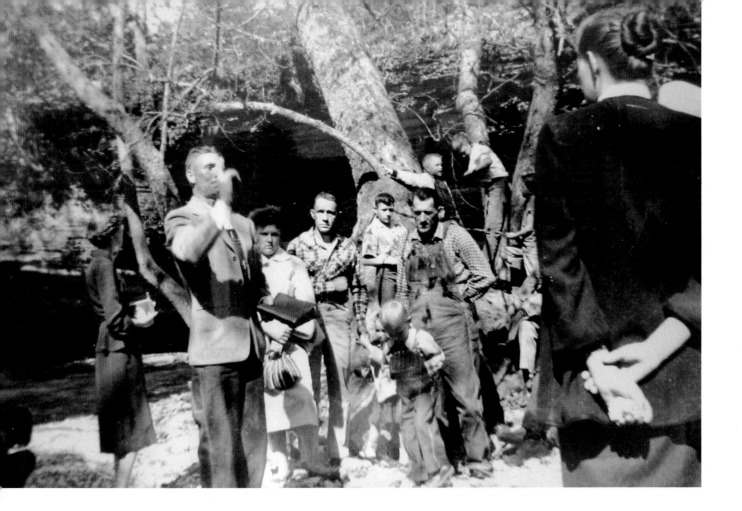

Young Ed Stilley performing a baptism at Hogscald Creek. Stilley family photograph.

Building a guitar is no simple task and Ed took it on with no instructions whatsoever. "Someone in town told me, you can't make guitars out of thick sawmill wood, but I remembered that the Lord never taught me the word 'can't,' so I went right ahead and just started makin' 'em." His early attempts fell a bit short of "playable," but he kept after it and eventually found techniques that worked. Each instrument was an invention unto itself. Gradually, word of these mysterious treasures spread, and folks from Clifty to Eureka Springs and beyond were anxious to receive one. He eventually kept a spiral notebook that held a list of children on his "waiting list." "I made 'em for twenty-five years, and for the first ten years I made one every two weeks. I never did catch up with all the ones people wanted." Over two hundred of these unique creations are scattered all over the Ozark hills surrounding Hogscald Holler.

The photographs in this book represent a good sampling of the instruments Ed built. Each one deserves a close look. Savor the details. Every instrument demonstrates Ed's profound willingness to experiment. I do hope I provide you some glimpse into Ed's fascinating process. What's on the outside of an Ed Stilley instrument tells only half the story. There are surprises that can't be seen with the eye but are revealed in the X-ray photographs. In order to fully appreciate Ed's art, one must understand the intricate arrangement of metallic objects mounted inside the instruments. The depth of his creativity is fascinating. My descriptions of Ed's process are based on observations I've made over the last eighteen years visiting him and watching him work.

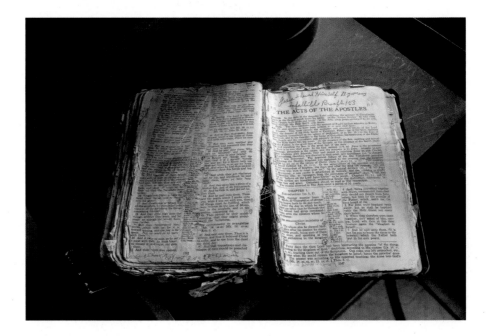

Ed's Bible. Ed writes his thoughts in the margins of almost every page and wears one out in about five years. Eliza lovingly keeps a stack of Ed's tattered Bibles preserved in plastic bags in a drawer.

Isolated from the modern world and conveniences most of us take for granted, Ed Stilley has lived his life as if the second half of the twentieth century never happened. His creative process, his craftsmanship, and the instruments themselves speak to us of a time and a way of life that's almost gone, except in memory. Maybe Ed's work resonates so deeply because we know it represents something precious that won't come again.

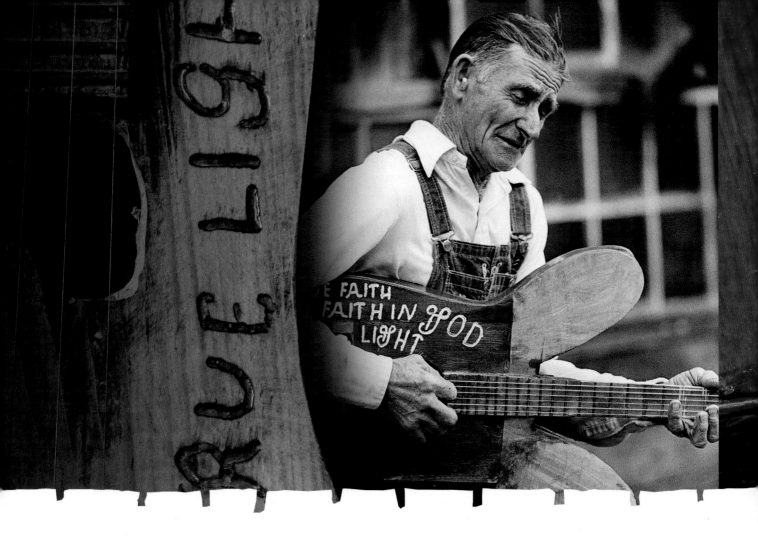

Hogscald Holler is the best place to start. The following images set the stage. They show you where Ed lived his whole life, where he and Eliza raised their five children. Ed built every structure you see with his own hands! There are very few pictures of Ed during his productive years at Hogscald Holler, before his body began to slow him down.

I'm so grateful for these beautiful photographs from 1997, when Ed was still in his prime as an instrument builder. My good friend Flip Putthoff took them when he was working as a photojournalist for the *Rogers Morning News*, just as the era of the film camera was coming to a close.

Ed was so pleased with Flip's article that he built a cedar frame for it, and it remains in the Stilleys' home to this day.

Ed Stilley at Hogscald Holler

One of the early butterfly guitars.
Photograph by Flip Putthoff.

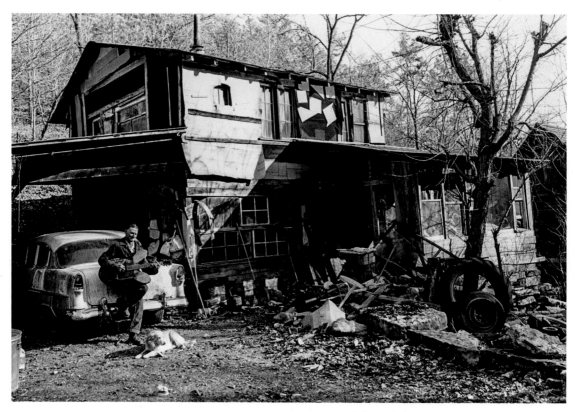

Ed's workshop. Photograph by Flip Putthoff.

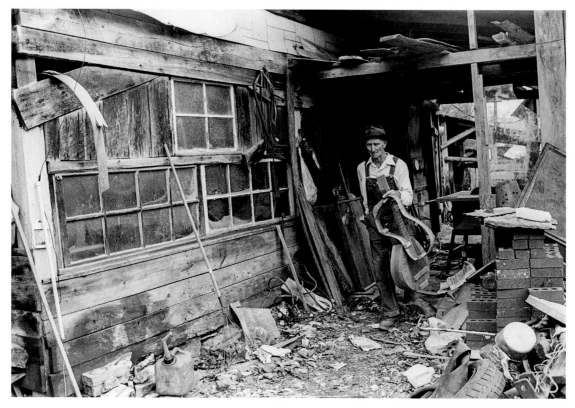

Ed emerges from his workshop. Photograph by Flip Putthoff.

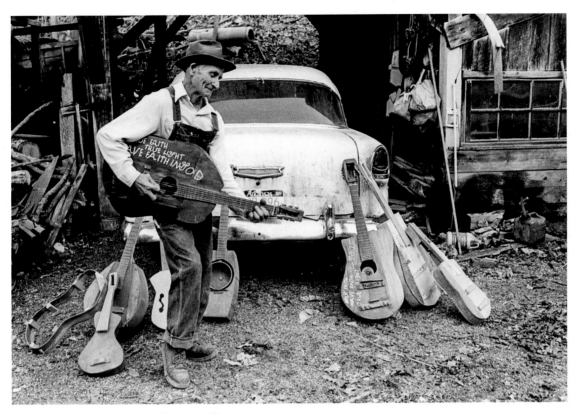

Pickin' a tune. Photograph by Flip Putthoff.

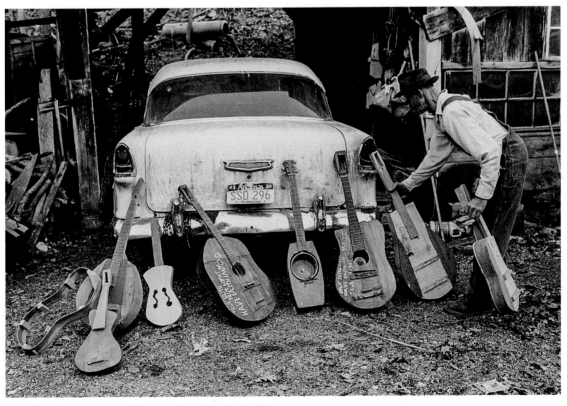

Sampling of instruments. Photograph by Flip Putthoff.

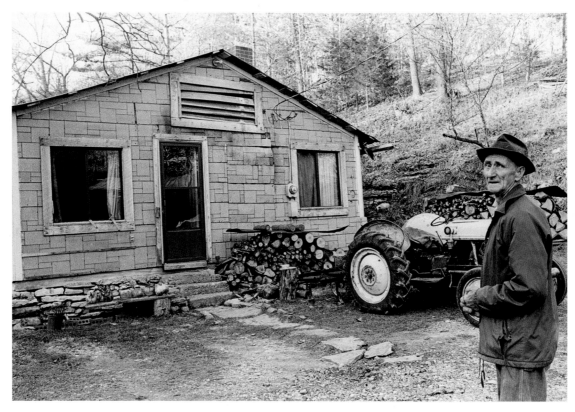

The house Ed built. Photograph by Flip Putthoff.

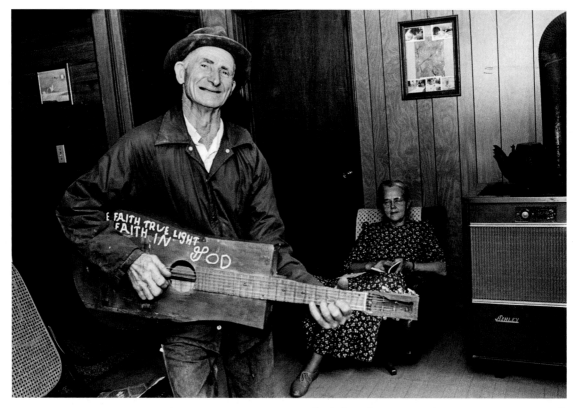

In the Stilleys' living room. Photograph by Flip Putthoff.

ED STILLEY AT HOGSCALD HOLLER

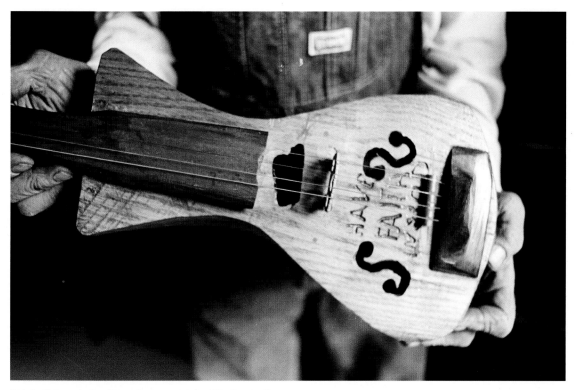

Fiddle Ed made for Eliza. Photograph by Flip Putthoff.

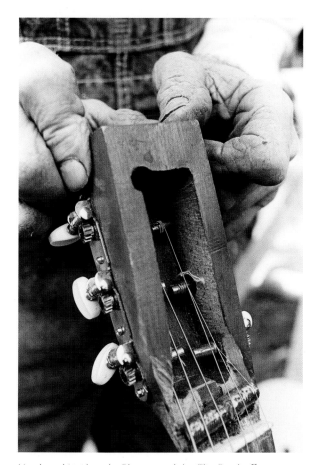

Hard working hands. Photograph by Flip Putthoff.

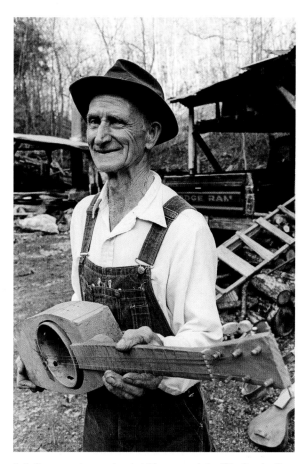

Ed's first creation—a banjo! Photograph by Flip Putthoff.

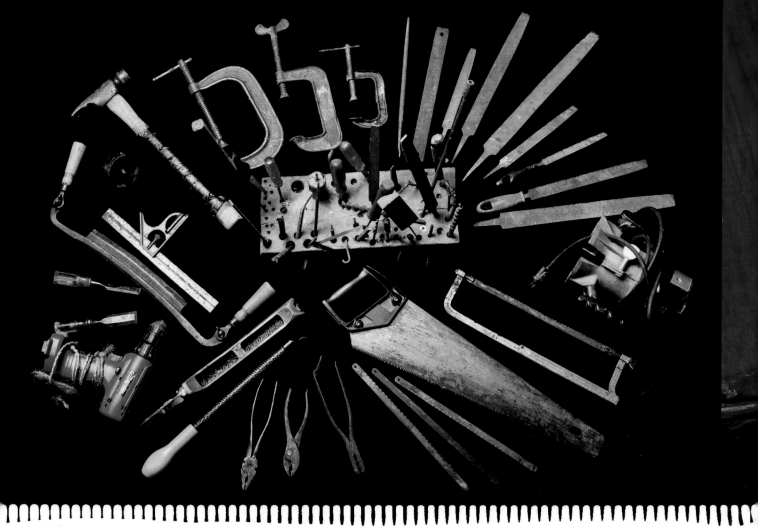

Tools of the Trade

Exploring Ed's old shop at Hogscald Holler unveils a building with a jigsaw puzzle of irregular wood scraps for siding, but the oak frame is sturdy and still sound today. One rambling room leads to another and then another. Ed lined the walls with improvised workbenches, which are all covered with a thick layer of wood scraps, metallic objects, and all manner of hand tools and unfinished projects. The floor, hardly discernible from the top of the workbenches, is also strewn with all sorts of scraps. Potential instrument ingredients dangle from nails in every nook and cranny.

Much of the space is quite dark with only a bare light bulb hanging here and there for light. Ed did most of his work at a particular bench in front of a window with good natural light, his workspace surrounded by a heap of rusty files and drill bits. This is a very special place.

There's no doubt that the tools at Ed's disposal had much to do with how he worked. When he first started out, he had nothing but simple hand tools. Just a handsaw, chisel, drawknife, hand drill, and not much else. He used files extensively and had a wide assortment of shapes and sizes. He was very fond of the Stanley Surform rasp for its ability to remove large amounts of material. Ed didn't use hand planes—instead he preferred to use a drawknife. For clamping wood during gluing procedures he utilized an assortment of heavy steel C-clamps.

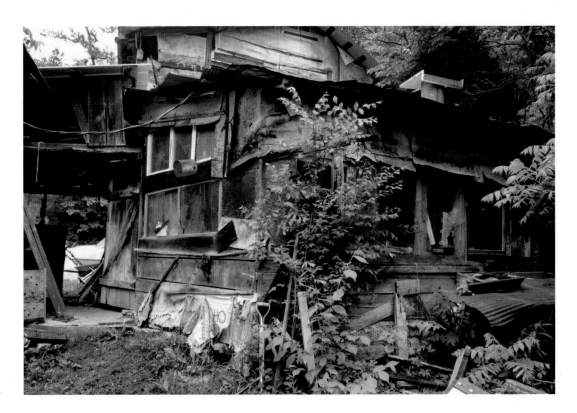

Exterior of Ed's
old workshop.
Photograph by
Russell Cothren.

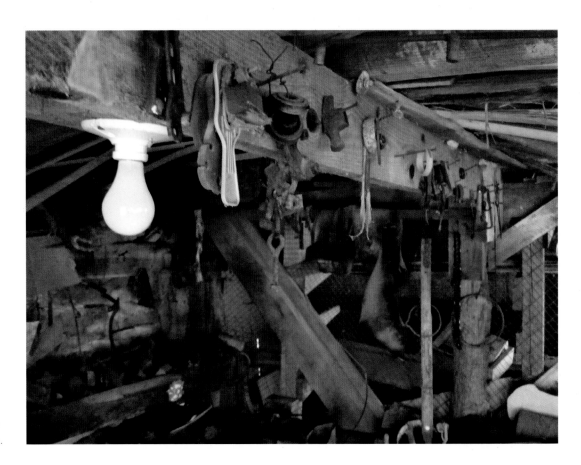

Nooks and
crannies.
Photograph by
Kelly Mulhollan.

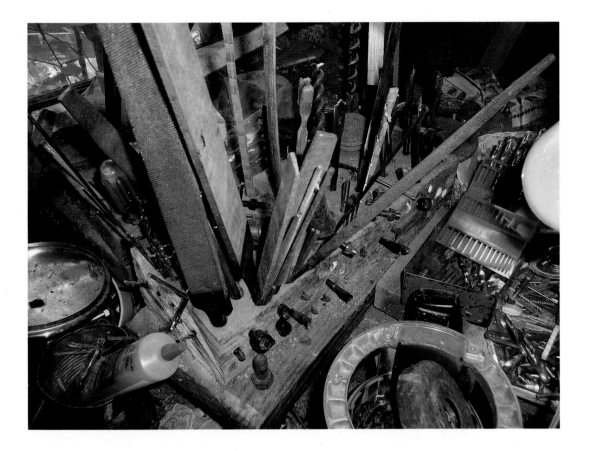

Top of Ed's work bench.
Photograph by Kelly Mulhollan.

I believe Ed's first electric tool may have been a drill, and he found all sorts of ways to use it. Fitted with a spade bit, it allowed him to hollow out peg heads and mortise his side blocks. The jigsaw may have come next, important because it can cut steel as well as wood. Very gradually, more electric tools came into play. He eventually got a small band saw and drill press, a hand-held planer, and even a small thickness planer.

It's worth noting that Ed's trademark style was relatively unaffected by the introduction of new tools. His process may have changed, but his artistic vision did not.

The Blessed Router

The router changed everything for Ed. It enabled him to begin inscribing the instruments with his message, "True Faith, True Light, Have Faith in God." These words have profound meaning for Ed. They are the cornerstone of his mission.

Ed's stepsister, Mary Jane Prickett Rohr, told us about how Ed prayed for an electric router and seemed certain that one was going to find its way to him. Apparently he was quite persistent in relating his desire for such a tool. Mary Jane's husband finally sent Ed a check, and his prayers were answered.

When I watched Ed inscribe his message with the router, I was surprised to discover that he did the whole job freehand. In fact, he didn't even pencil in the letters before he started. He just set the router down on the instrument and began to write. Ed writes a unique font that is easy to recognize. Whether it's a Bible verse inscribed on an old board in the yard or the notes he scribbles in the margins of his family Bible, you can always recognize Ed's style.

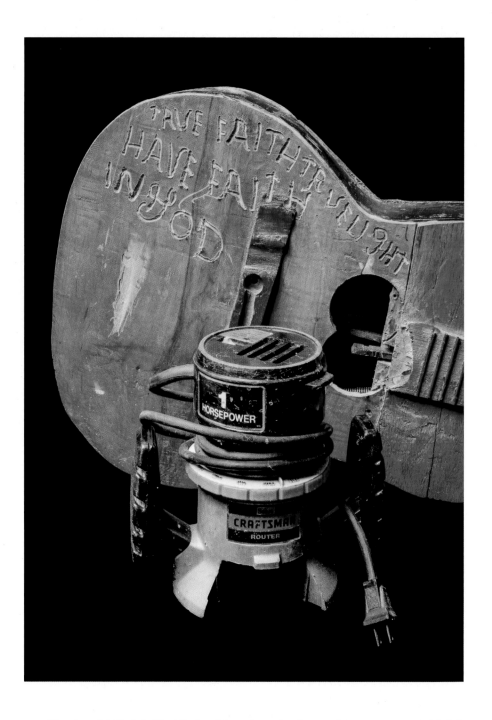

His niece, Malinda Miller Fitch, told me the guitar he gave her as a young girl didn't have writing on it when she got it. It's one of his earlier pieces. When she was a teenager, one of the marbles that surround the sound hole had fallen off, so she took it to her Uncle Ed to have it fixed. When he gave it back, it had a new marble and the words "True Faith, True Light, Have Faith in God" inscribed on the top. Ed had fixed it. You can see that guitar on page 70.

Ed loves to tell about a relative who called him up to say he "sure would like to have one of those guitars if Ed could make him one without all that writing on it." Ed told him, "They got plenty of that kind at the store."

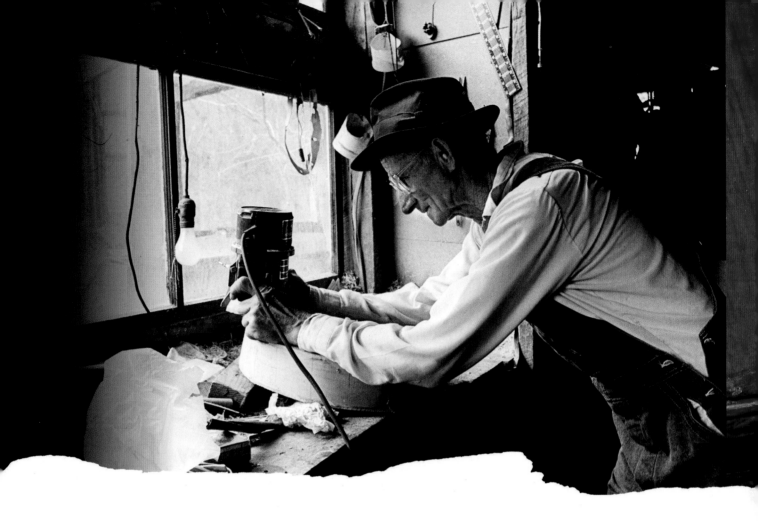

The images in this book are bound to raise a host of questions concerning Ed's process. Why did he go to such lengths to install springs, saw blades, and other odds and ends? Do the metallic objects contribute to the overall sound? Why the unconventional shapes? Why are so many of them red? And, do they sound good?

I hope I answer these questions for you in the chapters scattered throughout this book. I've attempted to describe Ed's process based on what I saw when I watched him work and conversations I've had with him over the past eighteen years. It gets technical at times, but I've tried my best to make it understandable to the layman who has no woodworking experience.

Virtually every aspect of Ed's methods is unconventional. There's little or no link to traditional instrument-building practices. Ed told me, "When I don't know which way to turn, then I ask God and he shows me the way." There are many surprises to be found in Ed's work, and an understanding of his methods and motivations will only deepen your appreciation of his work.

A great deal changed in Ed's process between when he started in 1979 and 2004 when he was finally forced to slow down due to health concerns. You might say that Ed followed a delicate path somewhere between divine instruction and trial and error. When you look at a good sampling of his creations, you can actually see Ed solving problems one instrument at

Ed Stilley's Process

Photograph by Flip Putthoff.

a time. He looked to the Creator for guidance. When he found a better way to do something, he integrated that technique into his work.

Ed is usually unable to tell you when a particular instrument was made. His hands made far too many in those twenty-five years, and today they run together in his memory. Thankfully, the evolution of his process gives us clues that can help place his work in some sort of chronological order. I've attempted to do just that for this book. The exact order may never be known, but I believe it's reasonably close. My intention is to allow Ed's ever-evolving process unfold before your eyes.

Before you see Ed's early work, I would like to show you two of his finest creations, both built in the later years of his instrument-making journey. They are exquisite examples of his mature period. From there, we will start at the beginning.

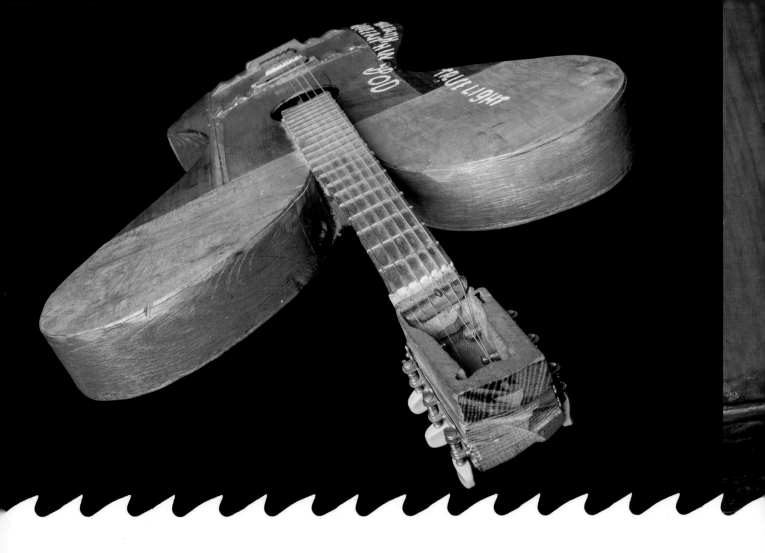

efore we get to Ed's early instruments, I want you to see one of the crown jewels among Ed's many creations—the magnificent "butterfly" guitar. Ed gave me this wonderful instrument in 2004. It was among the last instruments he built. The proportions are undeniably dramatic and it's a fine sounding instrument as well. We've been using it for years in live performance and have shared it with countless folks.

The X-ray images take you inside with an image of the front of the body, and the side of the body. You can clearly see a saw blade, door springs, coil springs, and an aluminum "echo" tube. The essays that follow will help you understand the reason behind all of the metallic innards. The length is about average for an Ed Stilley guitar at 39½ inches, but the width is enormous—a full 24 inches! The butterfly guitar is also the heaviest of Ed's instruments I have seen—11.6 pounds. Even the most exotic modern electric guitars cower in the presence of the butterfly guitar.

The Magnificent "Butterfly" Guitar

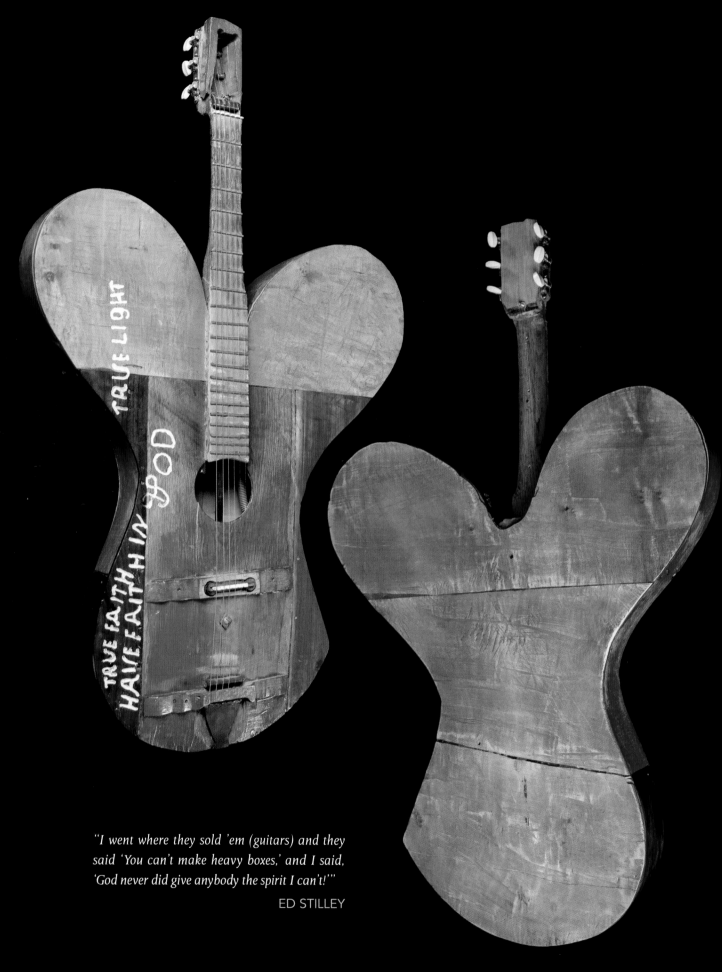

"I went where they sold 'em (guitars) and they said 'You can't make heavy boxes,' and I said, 'God never did give anybody the spirit I can't!'"

ED STILLEY

THE MAGNIFICENT "BUTTERFLY" GUITAR

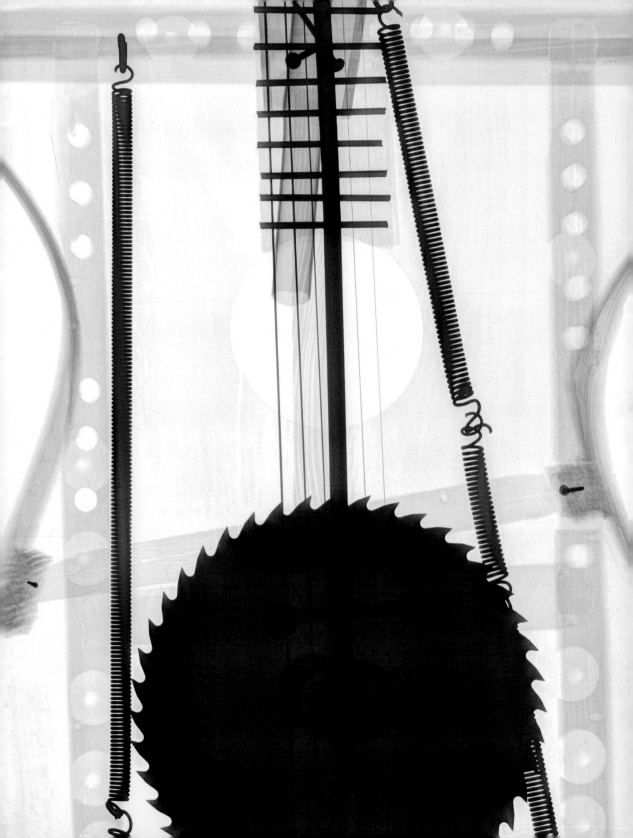

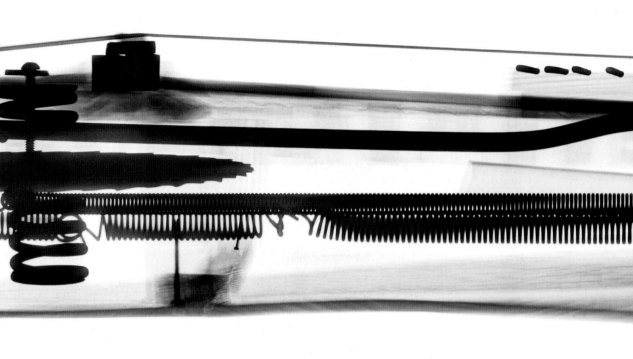

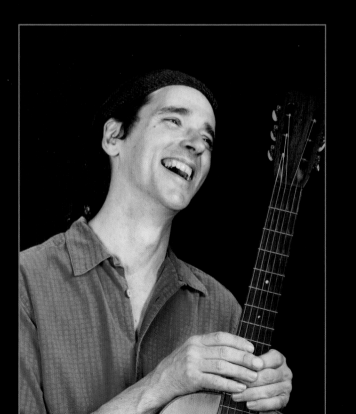

"I still have to pinch myself once in a while to convince myself that Ed really gave me the butterfly guitar. I feel grateful every time I lay my eyes on it!"

KELLY MULHOLLAN

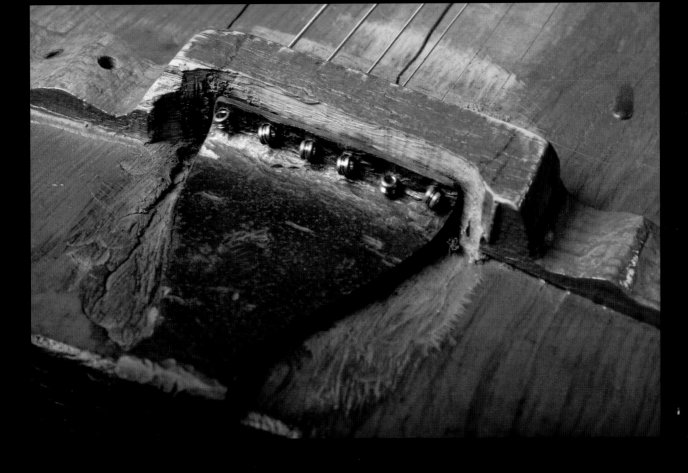

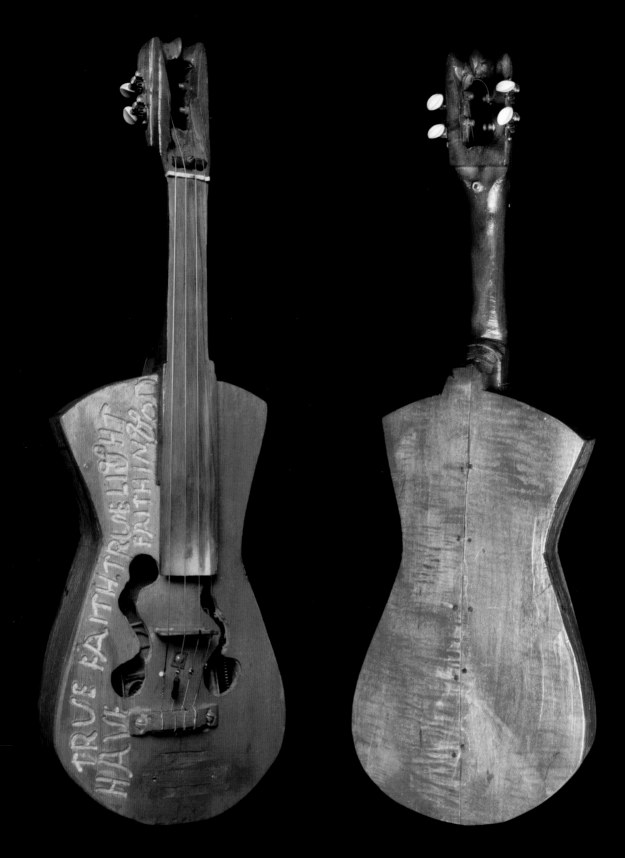

Fiddle made for my wife, Donna

It's the companion to the butterfly guitar. We use them both in most of our performances as the folk duo, Still on the Hill. The peghead is finely carved, and the sound holes reflect Ed's unique interpretation of the f-holes used in traditional violins.

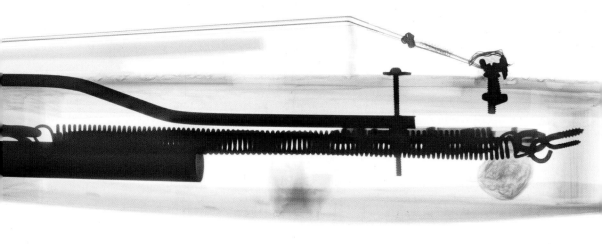

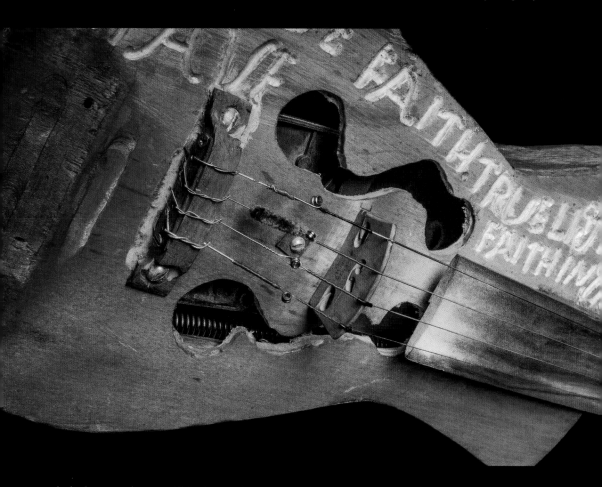

Beneath the basswood top you'll find a crankcase cover plate from a chainsaw, door prings, and an aluminum echo tube. The X-ray and close-up photos reveal the echo tube

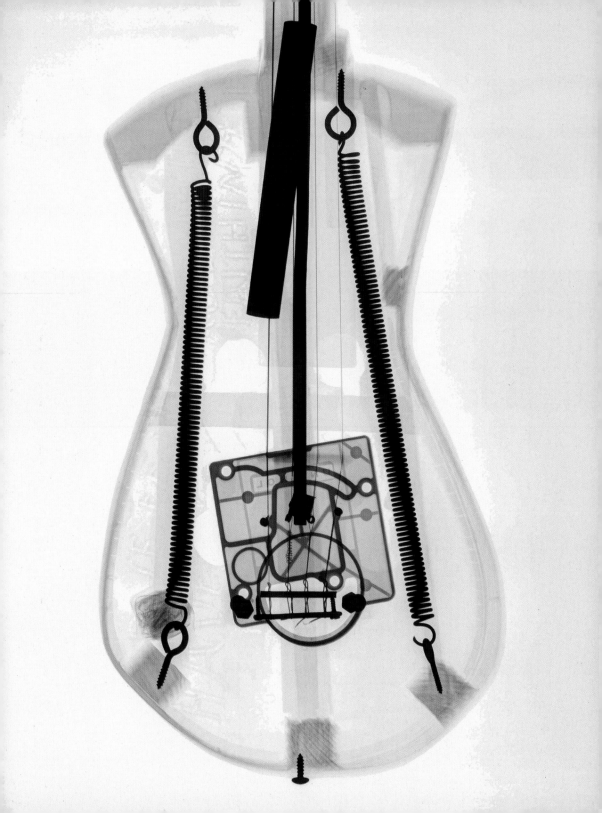

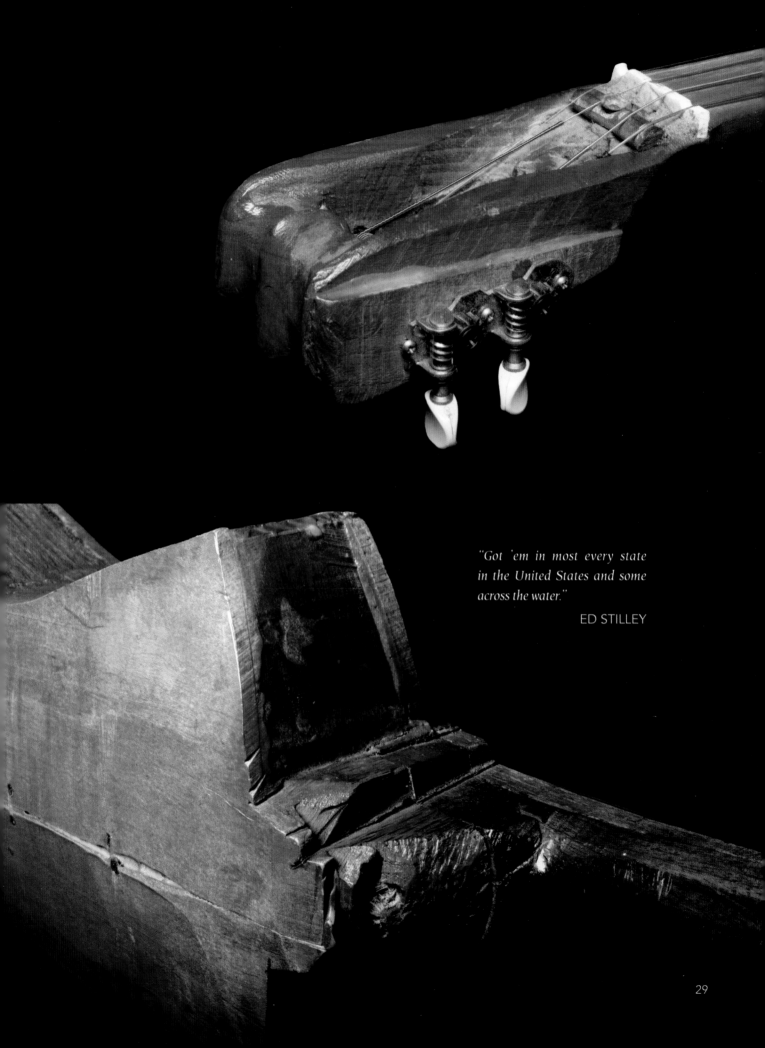

"Got 'em in most every state in the United States and some across the water."

ED STILLEY

29

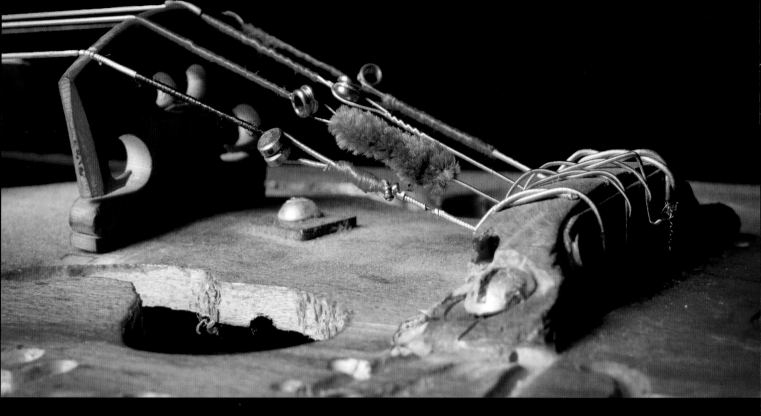

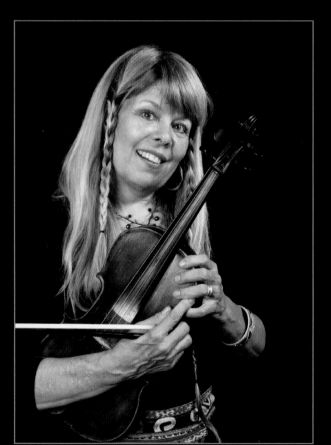

"I'm emotionally moved each and every time I play my fiddle—it sings with a voice unlike any other."

DONNA MULHOLLAN

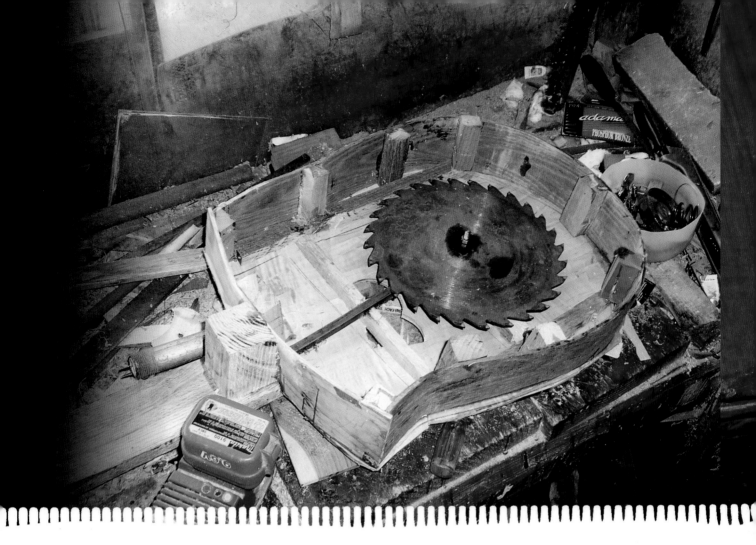

The Evolution of Ed's Process

Building a guitar that really plays with the limited tools Ed possessed would be quite a challenge. Instrument makers have passed down tricks of the trade for centuries, but Ed knew nothing of these traditions. To a large extent he was reinventing the wheel. In the early years he did mimic a few features of factory-made instruments, but most of these techniques fell by the wayside within a few years. Ed would find his own way. I like to sort Ed's work into three time periods—early, middle, and late—and each period can be identified by his ever-evolving techniques.

The earliest instruments are crude and have no writing on the top. The middle period was a time of great exploration, and these are some of my favorites. They generally have a natural finish and a great assortment of metallic and glass objects inside. Instruments made in the late period are typically painted red. Ed used red paint because "barn paint" is the least expensive paint at the hardware store. These are a few of the more obvious characteristics of each period, but there are many other clues that reveal the chronology of his work.

Photograph by Kelly Mulhollan.

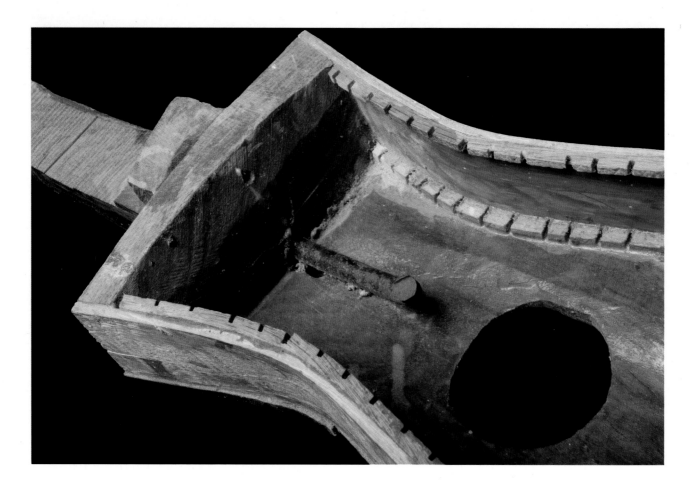

Kerfing strips.

Kerfing Strips

When Ed first got started he had a couple of cheap "cowboy guitars" that he had taken apart. He even tried incorporating some of the pieces of these guitars into his own creations. As with almost all guitars, the cowboy guitars had kerfing strips glued around the sides to aid in gluing the top and back to the sides. These are narrow strips of wood with a series of notches or kerfs that allow them to conform to the curvature of the sides. Ed made his own kerfing strips and utilized them for a while, but soon discovered another way. Making his own kerfing was slow work, and Ed soon found that stout wooden blocks glued strategically around the sides accomplished the task just fine. By the start of his middle period, blocks had become the norm.

Blocks and Braces

The side blocks also gave him a place to anchor the heavy curved cross braces that spanned the top and back of each guitar. He took the time to carefully mortise the cross braces into the side blocks. The combination of blocks and cross braces provided enough surface area to glue down the heavy top and back pieces. Such joinery, while not part of traditional guitar making, is really quite elegant and contributes much to the structural integrity of his work. Ed's instruments were built to last.

THE EVOLUTION OF ED'S PROCESS

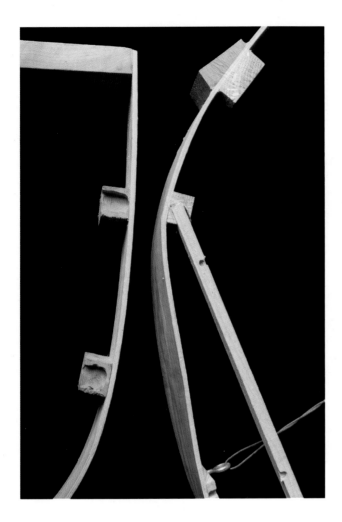 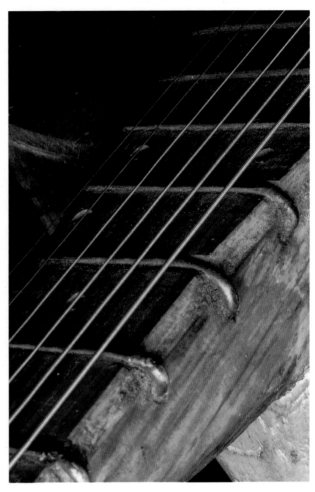

left: Mortised frames with braces.

right: J-frets.

Frets

The very early instruments are easy to spot by their fret work as well. He used what I call j-frets. They were inserted into a hole in the side of the fingerboard and bent over into a fret slot creating a "j" shape. I've heard it said that this method of fret work was used by early American mountain dulcimer makers, and I wonder if Ed has some link to this tradition. Ed would soon abandon this practice and simply glued brazing rods down for frets.

The Innards

From the very start all of Ed's instruments contained some sort of metallic objects, and it's interesting to see how this, too, evolved over time. Very early instruments often had only a minimal setup—maybe a three-inch rusty steel pipe with a small spring draped across it. Soon he was trying really elaborate variations of this simple layout, but he eventually settled into a pretty steady setup of the triad of elements that dominate his late period—the saw blade, door springs, and an echo tube. I'll discuss these components in more detail later on.

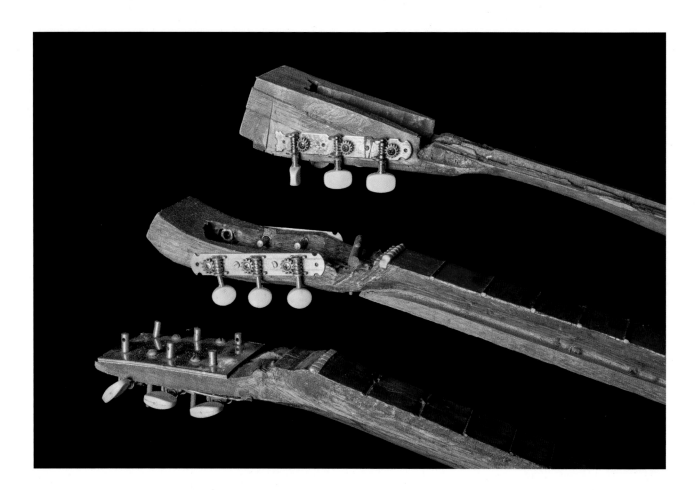

Three necks—(from bottom) early, middle, and late periods.

Headstock

Ed explored both of the popular styles of headstocks used by luthiers—the solid headstock with the tuning gears on the backside and the slotted headstock with the tuning gears mounted on the sides. His earliest instruments utilized a solid headstock with a slight back tilt and a mysterious steel faceplate. I have always questioned whether there was any benefit in having the steel plate. It doesn't seem like it would contribute to the strength of the delicate neck/headstock joint.

By the middle period, Ed began experimenting with something more akin a slotted headstock with side-mounted tuning gears. He would simply hollow out a cavity from the center of a bulky solid headstock with a drill and chisel to accommodate side-mounted tuners. I find these one-piece headstocks very attractive. Still, such a design required a very thick piece of wood for a one-piece neck and headstock and thus wasted precious wood. Ed continued to search for a better solution.

His final headstock innovation was to glue a bulky block to the back of the headstock. This enabled him to get the depth he needed without the waste. Again, he would hollow out the headstock with a drill and a chisel to accommodate the side-mounted tuners. Ed stuck with this method throughout his late period. The Dudley guitar illustrates a profound moment in the evolution of Ed's process. You can observe the one-piece headstock, which failed to provide adequate back tilt, alongside his new glued on block that ultimately solved the problem.

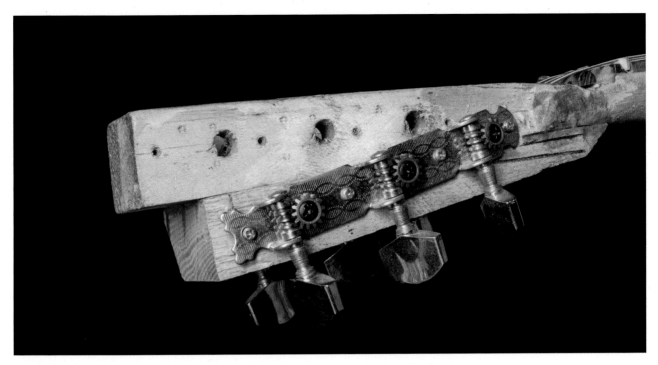

Moment of discovery!

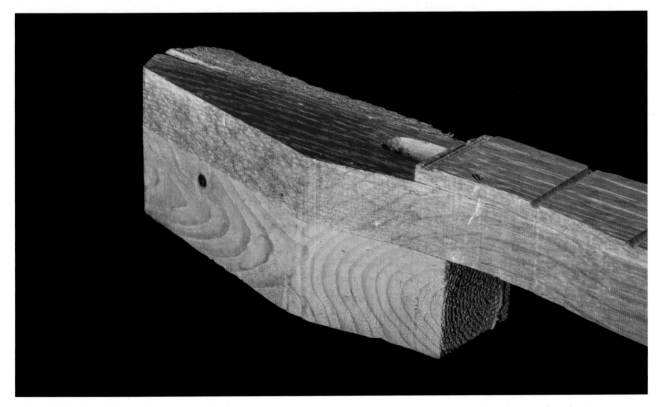

Glued-up peghead.

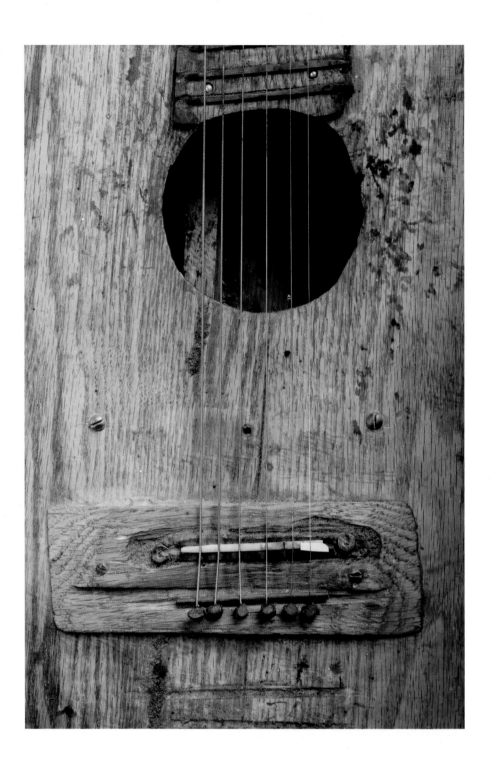

Ed's interpretation of traditional glued bridge with bridge pins.

Tailpiece

The method of string attachment is another hallmark of Ed's work that gives us clues as to an instrument's chronology. Very early instruments have a glued-on bridge with homemade bridge pins, much like a traditional guitar. The glue joint on these must have failed to hold to his satisfaction. He tried to solve the problem with a wood tailpiece block glued behind the bridge. In some ways this step didn't really accomplish any structural improvement, but Ed loved the tinkling sound of the strings between the two bridges and

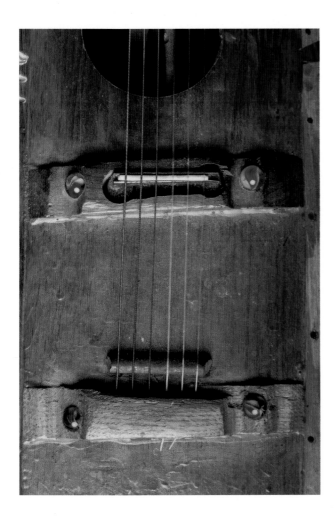 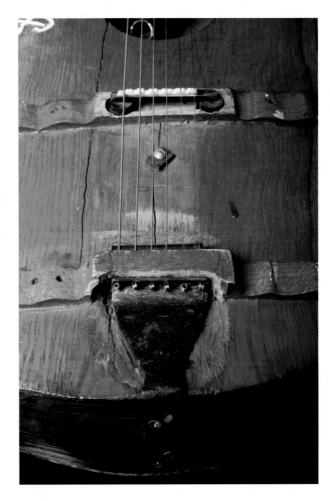

this became a standard feature. He called it the "harp" and often utilized its ethereal sound in his playing. He was able to switch over to the harp mid-song and back again to great effect. Eventually Ed began to add a sturdy metal tailpiece beyond the second bridge. Some of his tailpieces were made from old door hinges. The metal tailpiece was strong and reliable and is characteristic of the final instruments.

I've attempted to point out some of the primary features that characterized the early, middle, and late periods of Ed's work, which you can see for yourself as the photos in this book unfold. Keep an eye out for signs of trial and error as you inspect the photos. Sometimes he would glue down a bridge in one spot and then move it to another but felt no need to cover his tracks. Eventually, he discovered techniques that satisfied him and worked. Because I've played many of them myself, I can attest to the fact that most of the instruments Ed made are in working order to this day.

left: Glued bridge with secondary tailpiece—space between the two is Ed's harp.

right: Glued bridge with secondary tailpiece and steel tailpiece— Ed's final innovation.

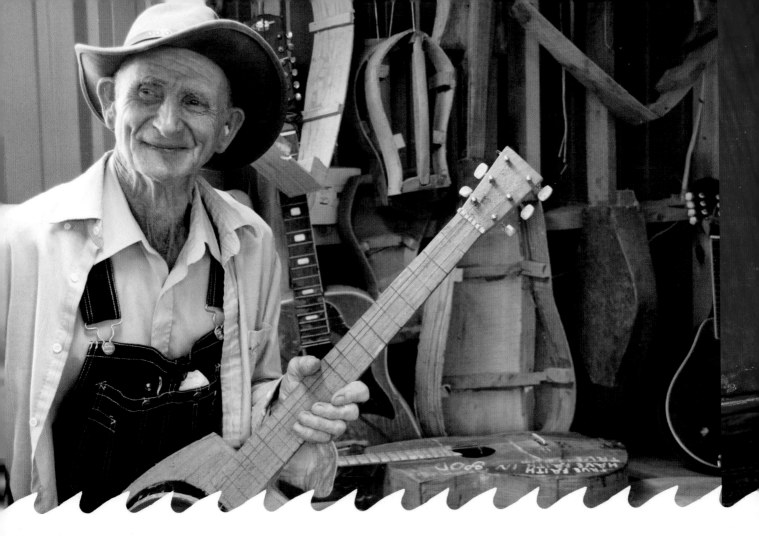

Ed Stilley's Early Creations

These instruments represent some of Ed's earliest attempts to create a working instrument after he received his directive from God. While they lack the elaborate internal skeleton that emerged in his later work, he did include a smattering of metallic odds and ends inside right from the start. This collection reflects Ed's disconnect with conventional instrument-making practices and his willingness to try almost anything to get the job done.

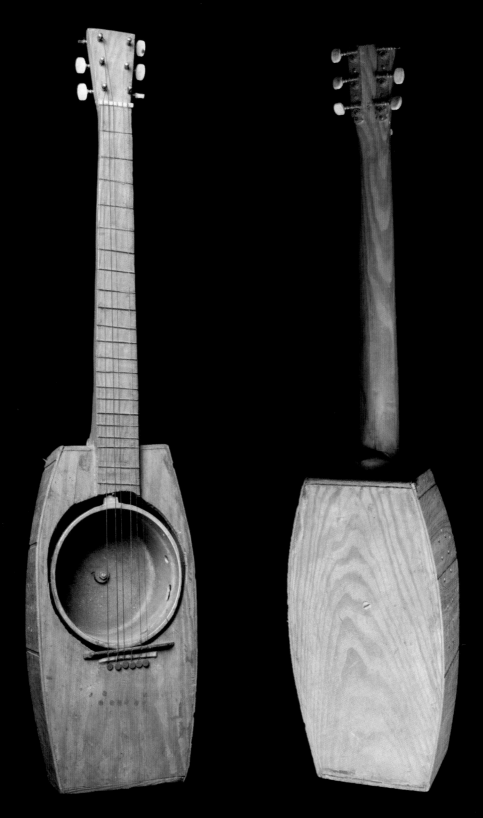

Banjo owned by the Stilleys.

Pine body with cooking-pot resonator. Ed says that this is his first attempt at building an instrument. It illustrates the exuberant creativity he brought to his task from the start. The neck would need more back tilt in order to actually play properly, but I believe it's best left as it is.

ED STILLEY'S EARLY CREATIONS

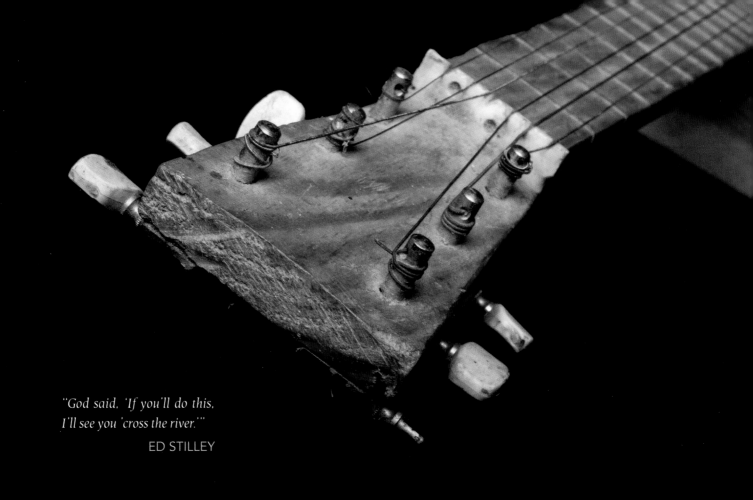

"God said, 'If you'll do this,
I'll see you 'cross the river.'"

ED STILLEY

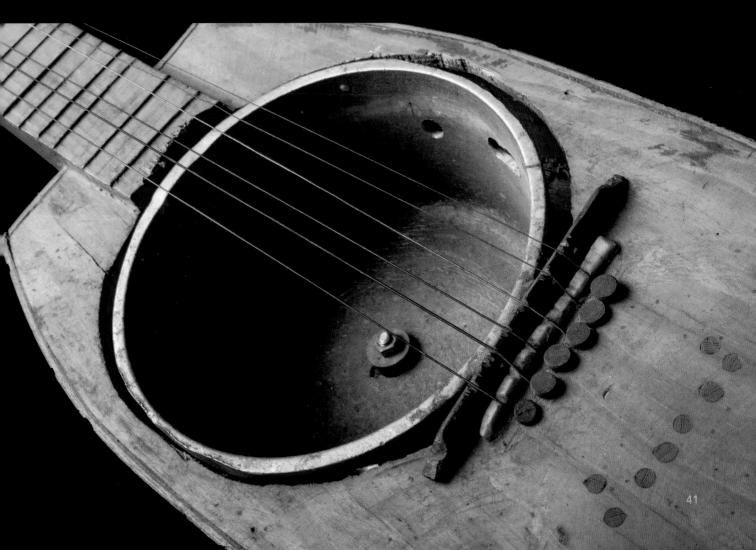

41

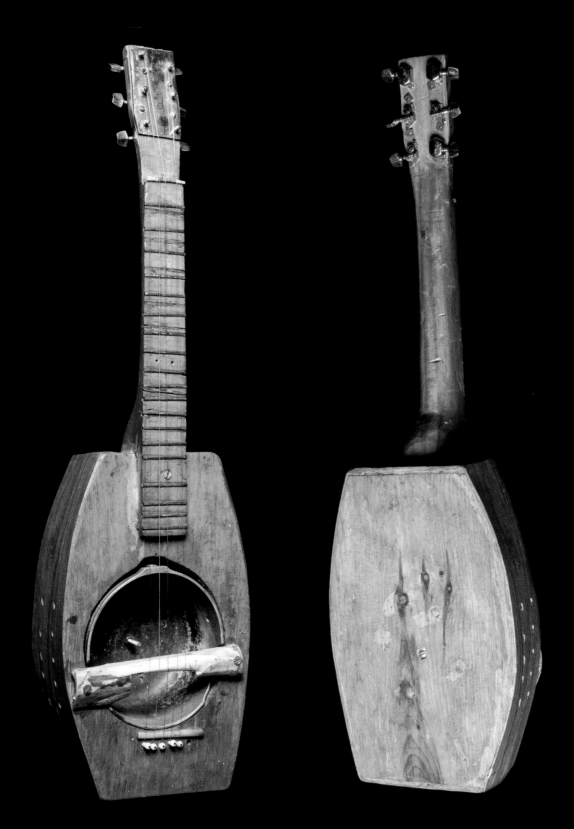

Banjo owned by Malinda Miller Fitch.

Very unusual sound holes drilled into the sides of the body. This one's a close relative to Ed's very first creation. The obvious difference is the presence of the bone bridge. Not really a good player but fascinating none the less. The metal faceplate on the peghead and the inset back are odd features characteristic of Ed's earliest creations.

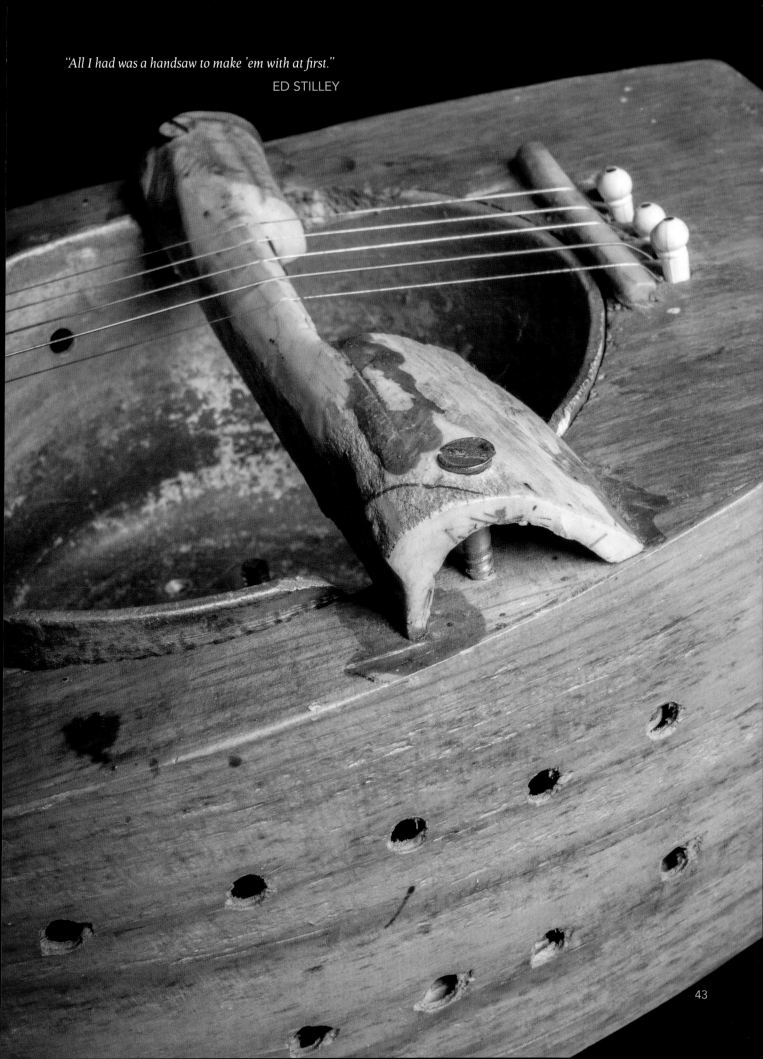

"All I had was a handsaw to make 'em with at first."
ED STILLEY

43

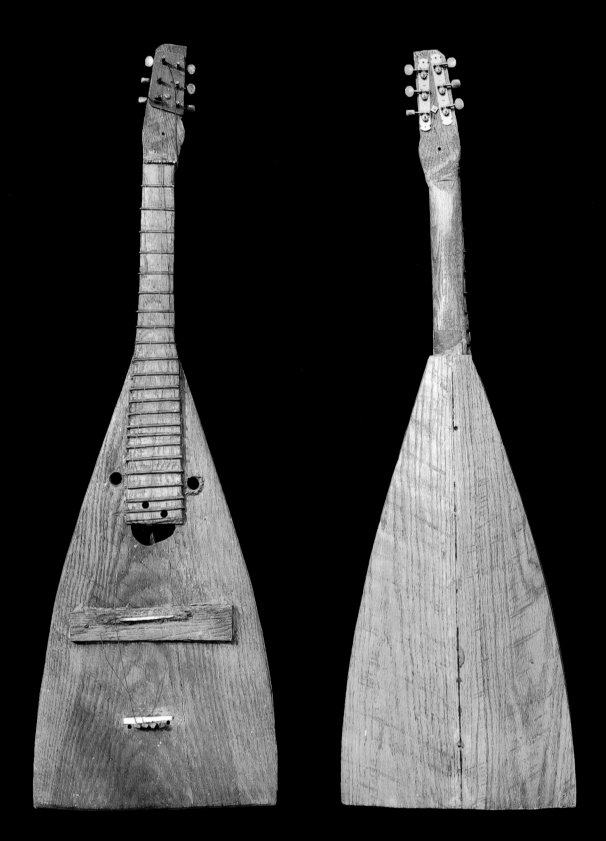

Guitar: owner unknown.

Sound holes suggest an oddly human form. We don't know much about this mysterious instrument, but it has many of Ed's classic early features—a steel faceplate on the head-stock, j-frets, and a smattering of metallic odds and ends inside.

Photographs by
Kelly Mulhollan.

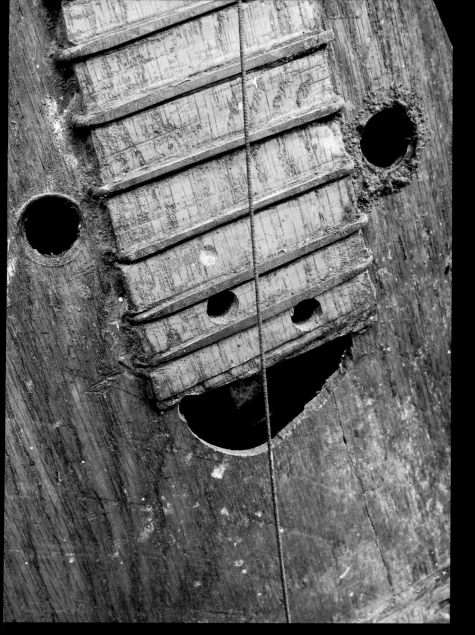

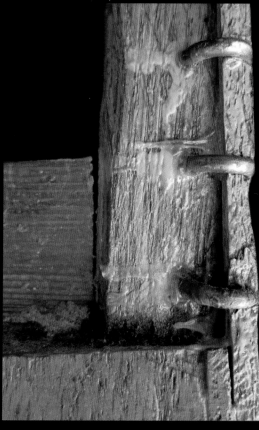

Photographs by Kelly Mulhollan.

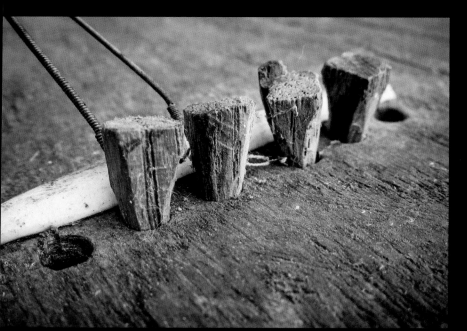

"I was going through an awful hard time when the Creator said, 'You make instruments and give em to boys and girls and I'll handle the matter.' I was glad to turn it over to him!"

ED STILLEY

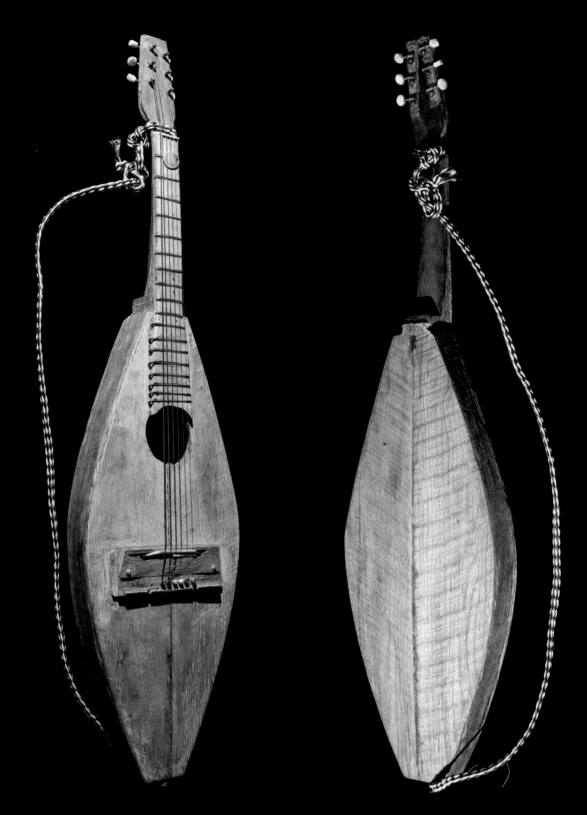

Guitar given to Kenny Sherman.

Occupies a custom-made stand in Kenny's house. At first glance, this one does not seem to be one of Ed's creations but closer inspection reveals his unmistakable touch. Classic early-period features include j-frets, an oversize bridge plate, and a smattering of metallic contents. All oak body with a walnut neck.

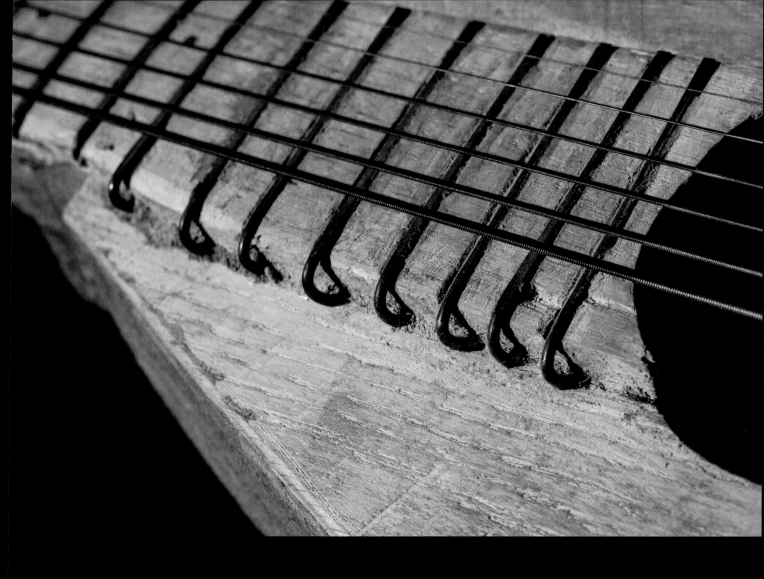

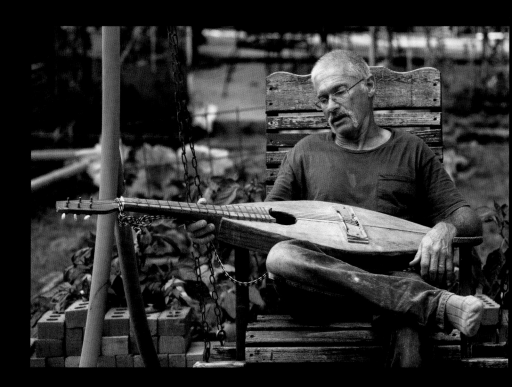

"I took mine to town a couple of times after I first got it and people were saying, 'Where did you get this—you want to sell it?' That's the first thing out of their mouth. And I'd say, 'No, it's folk art and there ain't another one like it.'"

KENNY SHERMAN

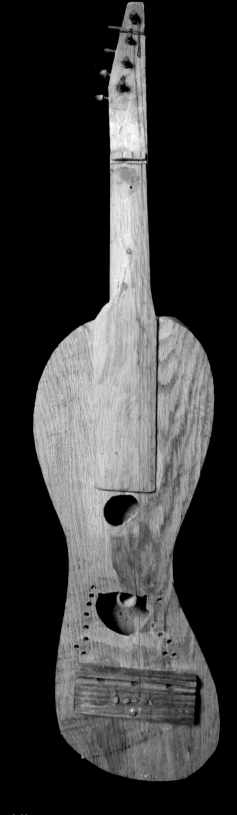

Fiddle owned by Andy Miller.

The body evokes an elegant feminine form. Could be one of Ed's very first creations. Perhaps you can explain the double sound holes and tiny holes drilled elsewhere. All oak with minimal internal components.

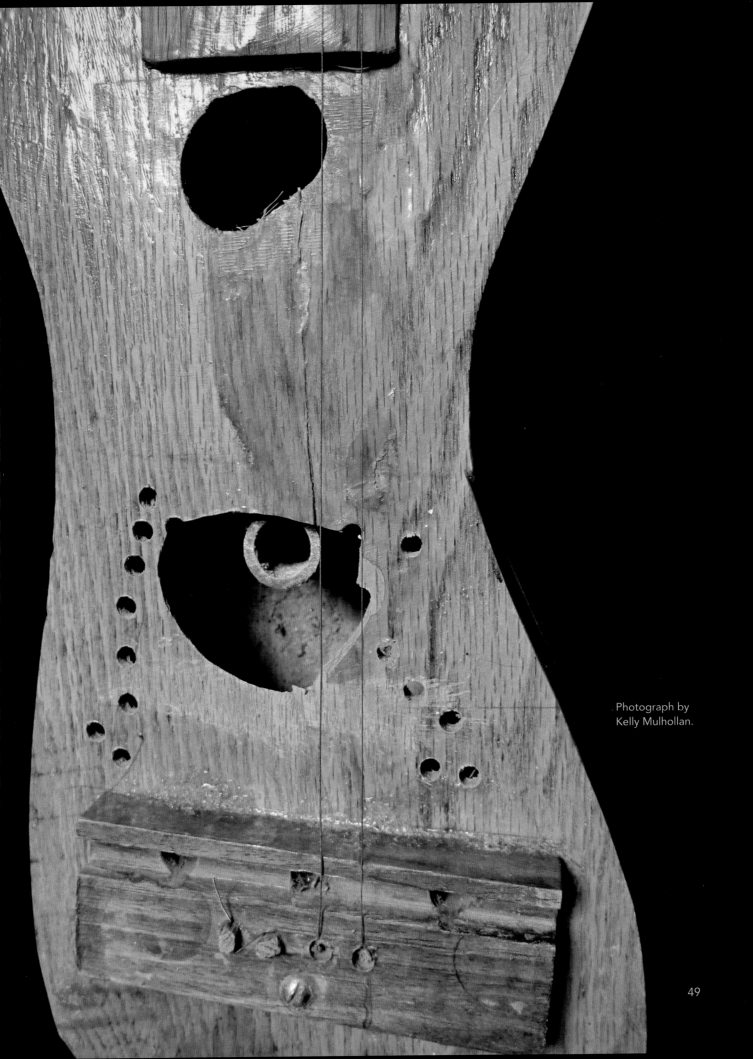

Photograph by
Kelly Mulhollan.

49

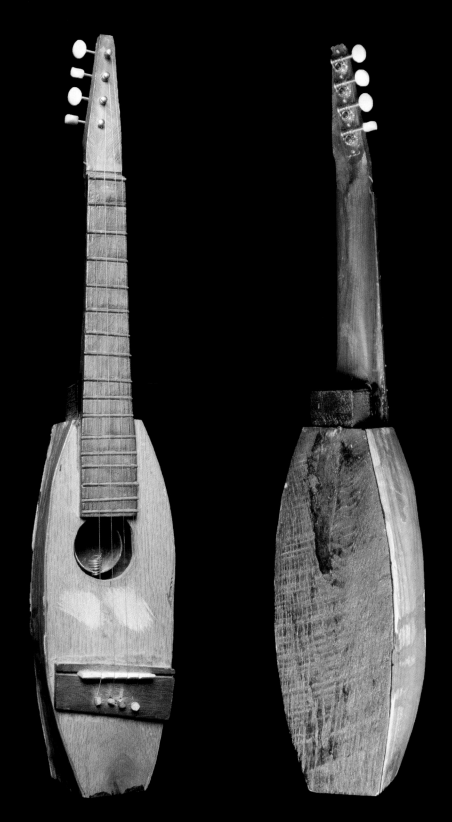

Four-string instrument given to Cindy Miller Robinson.

Has a heavy pipe straddled by a spring inside—a combination I've observed in several of Ed's earliest creations. There's a glass medicine bottle in there as well. The fret spacing does not correspond to the overall string length so the intonation is very tricky to say the least.

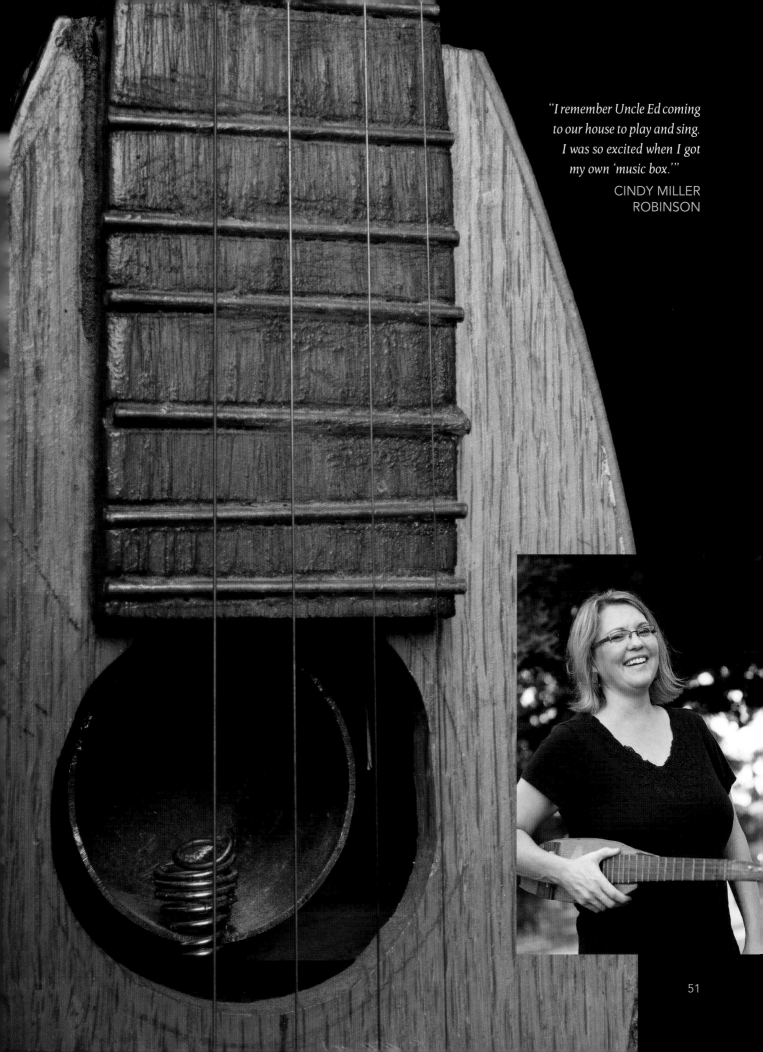

"I remember Uncle Ed coming to our house to play and sing. I was so excited when I got my own 'music box.'"

CINDY MILLER
ROBINSON

51

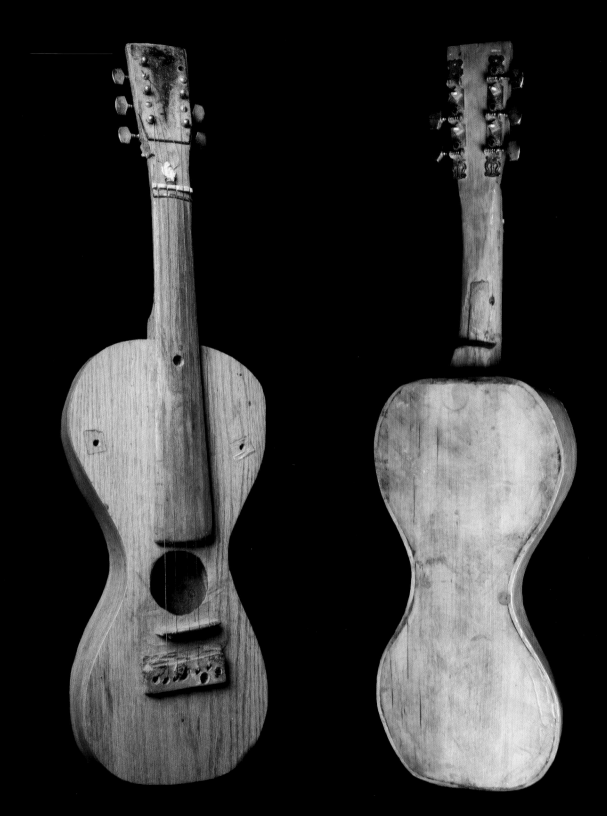

Fiddle given to Ed's daughter, Mary Jane Cover.

Built for Mary Jane Cover when she was very young. The peghead has the mysterious metal faceplate that Ed often utilized in the early days. Note the way he mounted the back within the sides instead of overlapping them (as is customary in guitar building). Oak body with walnut neck.

"I remember my dad bending the boards in hot water for his guitars and writing on the wood with his router. I'm so thankful I have one of his homemade instruments and thankful for the special memories it brings."

MARY JANE COVER

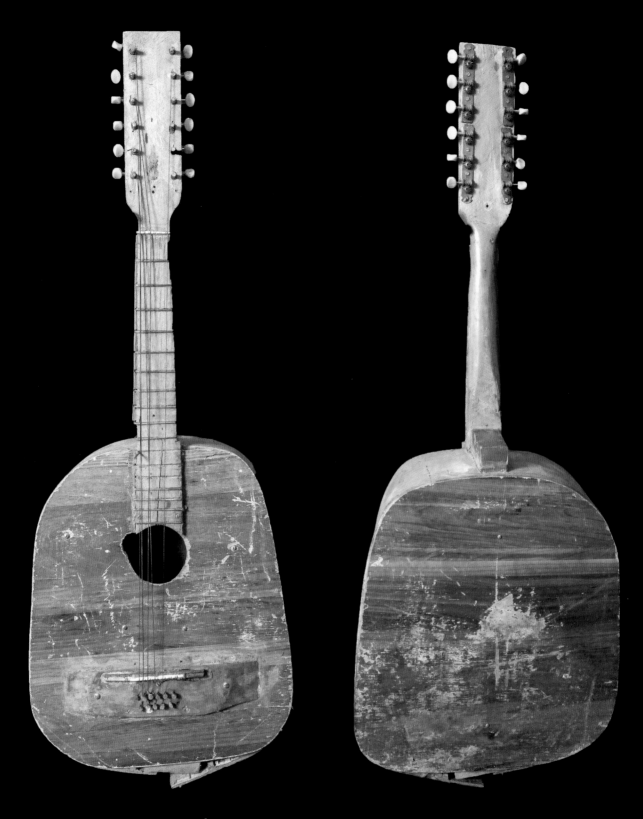

Twelve-string guitar owned by Andy Miller.

This one hasn't fared so well but it's hanging in there. It sports the classic j-frets, traditional bridge pins, and a massive walnut bridge plate. The top is made of paneling and a mouse has widened the sound-hole. Not really a player. It's surprising that Ed took on a twelve string in his early years—the extra string tension requires a very sturdy design that is challenging to build.

Photographs by
Kelly Mulhollan.

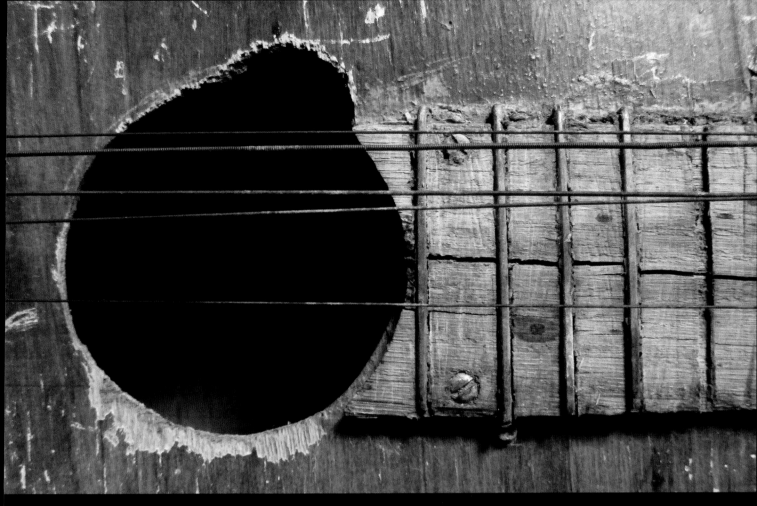

Photographs by Kelly Mulhollan.

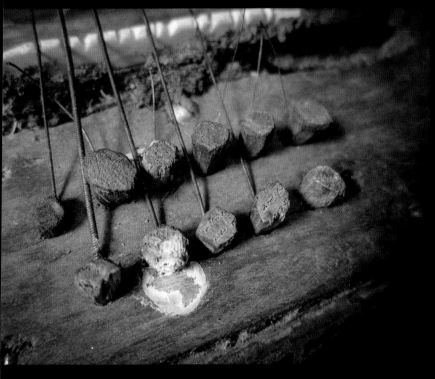

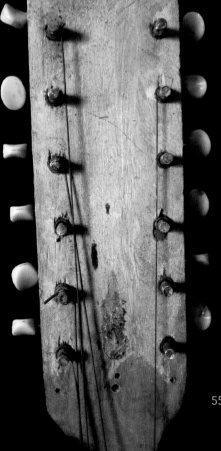

ED STILLEY'S EARLY CREATIONS

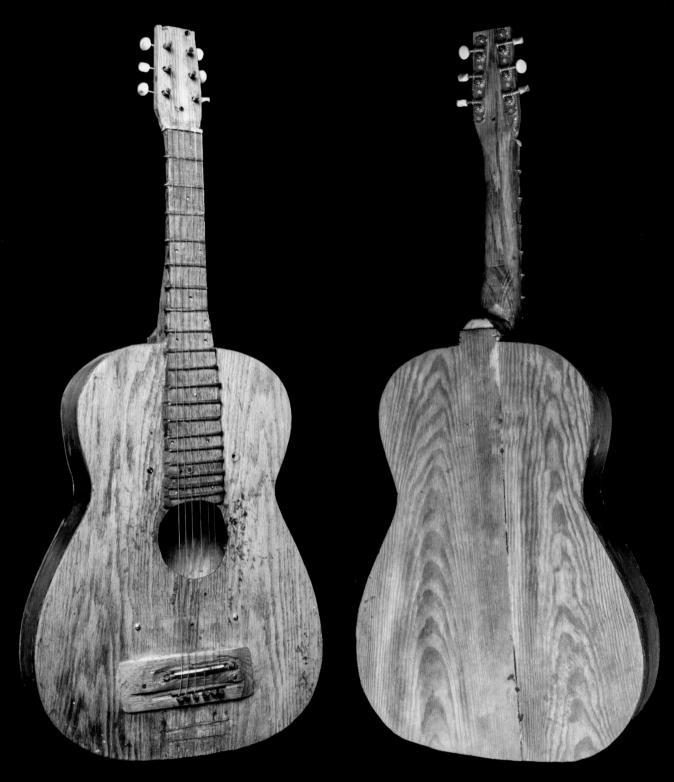

Guitar owned by Malinda Miller Fitch.

This early instrument is quite guitar-like due to the use of sides salvaged from an old factory made guitar (note the sunburst sides). The tone is dark and mysterious. Classic j-frets and crude metallic internal components inside are secured by the irregular washer on the fret board close to the sound hole. Thirty-five inches in length and 14¾ in width. Frets above body are installed like staples driven right through the top.

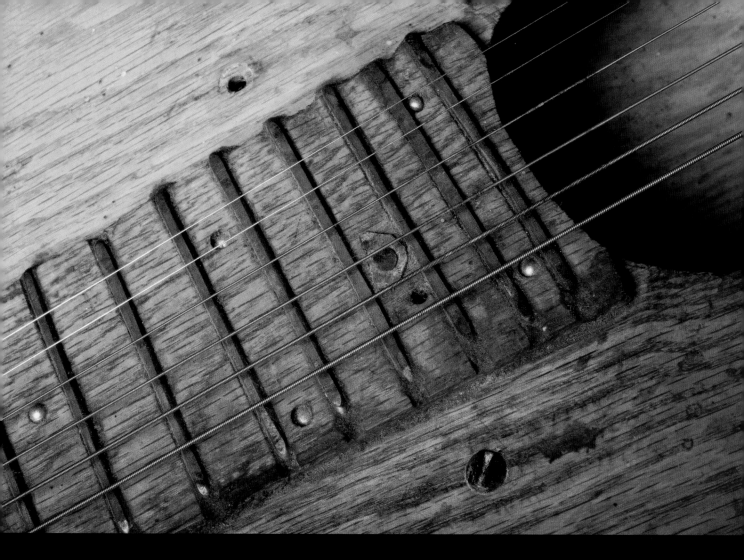

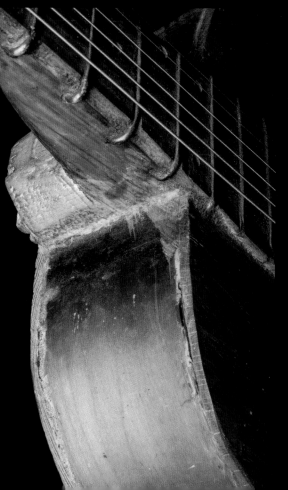

"Now, you gotta be real careful for this part."
ED STILLEY (REFERRING TO MARKING
THE PLACEMENT OF EACH FRET
FREEHAND WITH A PENCIL)

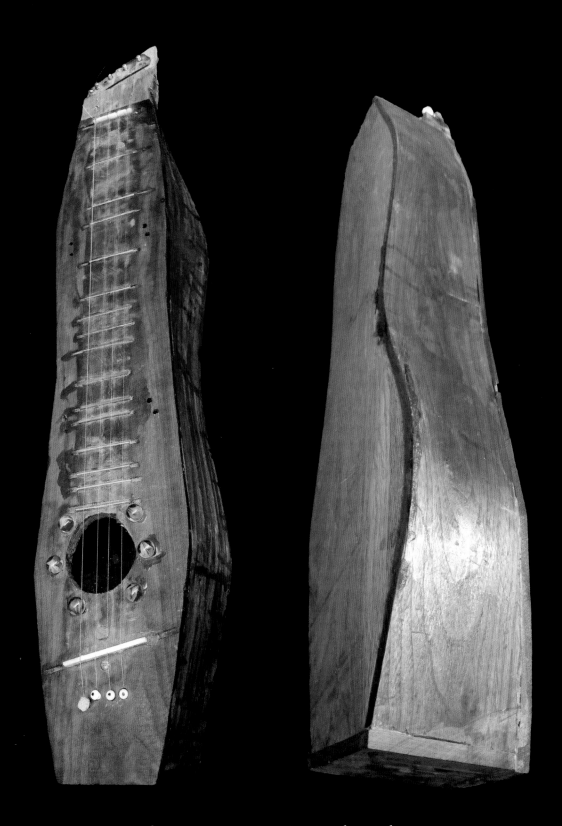

Dulcimer given to Mary Jane Prickett Rohr.

One of only two dulcimers we know Ed built. All walnut with marbles adorning the sound hole. The frets don't seem to be properly placed for its scale length. Early creation with kerfing strips, an inset back, and minimal internal metallic parts.

Photographs by
Kelly Mulhollan.

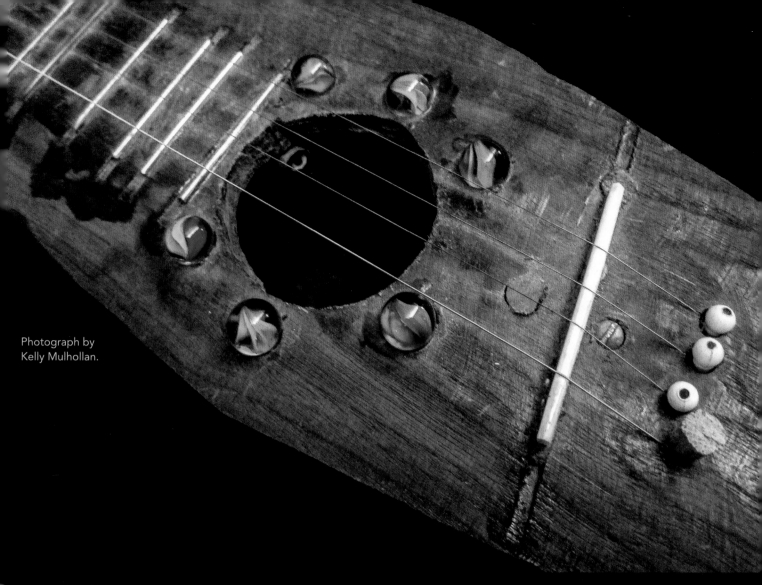

Photograph by
Kelly Mulhollan.

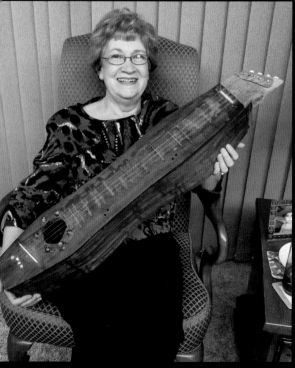

"It really surprised us [when he started making guitars] because even though he'd made this little toy dresser, we didn't know he could do anything like that. He was given a mission from God. That is why he was doin' it."

MARY JANE
PRICKET ROHR

Miniature chest of drawers (fourteen inches tall) that Ed made for Mary Jane as a young man, long before his instrument-making days. Stilley family photograph.

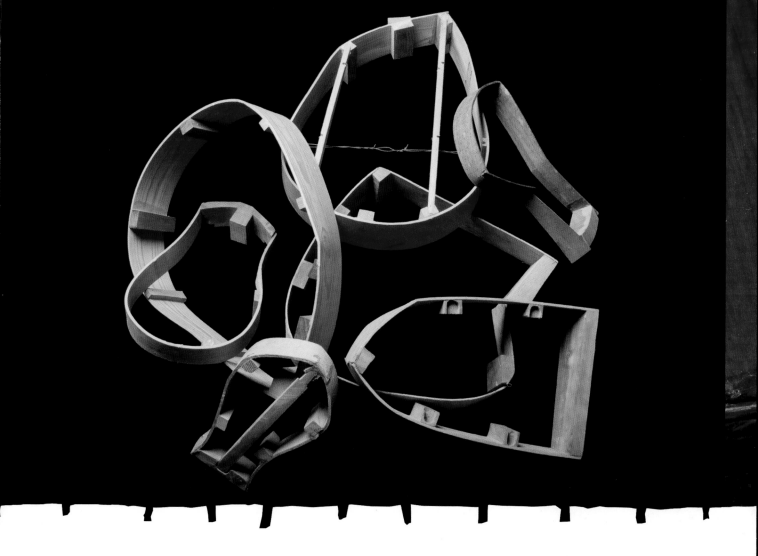

The Shape

What inspired Ed Stilley to pursue such fanciful shapes in his work? This is the first thing I wanted to know when I saw him making guitars. I asked him this very question and found his explanation profound. The fact is that Ed did not really visualize a particular shape before he started to make an instrument. For the most part, he let the wood make the decisions.

Typically Ed fashioned the curved sides from oak slab cutoffs—the waste wood from sawmills that's normally discarded or sold for firewood. Ed told me, "That sawmiller said to me one day, he said, 'Ed, my trash is your treasure.'" Lacking the tools to accurately "thickness" the top and side wood to the delicate dimensions normally utilized in guitar making, he worked with what he had. The first step in making an instrument was to bend the thick oak strips that would later become the sides. Traditional guitars are built with sides about one-eighth inch thick, but Ed's sides were typically between three-sixteenths and one-quarter inch thick.

Conventional guitar builders use steam heat and bending irons to carefully bend the delicate sides of the instrument to match the shape of the top and back. Basically, Ed's process is the reverse. Ed explained, "Well, I just got started bending 'em the best I could, and

Form

right: A side piece bent just a bit too far.

below: Slab wood, the outer portion of a tree too irregular for use as lumber and considered a waste product.

wherever they started to break, that's where I'd stop." He let the randomly bent sidepieces dictate the shape and then he fitted the top and back accordingly. Ultimately, the wood's willingness to bend dictated the curvature. This process is key to understanding the vast array of unconventional shapes that Ed came up with over the years. The wood itself had a hand in the design.

To bend the wood Ed boiled the sides pieces overnight in a steel drum he had cut in half until the oak became somewhat pliable. Then he'd take those pieces and weave them through a series of long pegs protruding from a heavy homemade pegboard, where the oak strips would dry and stabilize. This was a pivotal moment in Ed's creative process. He would simply stand back and assess the assortment of bent wood on his pegboard and

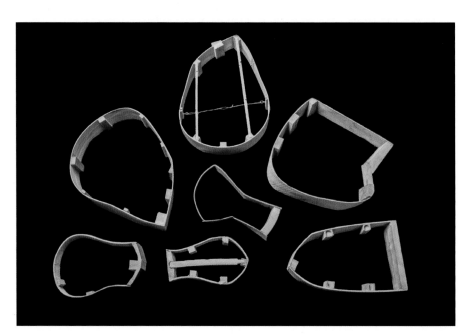

Assortment of unfinished frames.

think, "Now that piece might fit with this piece," and proceed. One piece might inspire a fiddle or a mandolin, and another piece, a guitar.

His next step was to join the assorted fragments into a closed figure. Finally a shape would emerge, and the top and back could be cut to fit. Quite a few of these structures were never fitted with a top and back. These irregular frames illustrate how the wood itself guided Ed's artistic process.

The Contour

It's a lot easier to make a flat-topped and flat-backed instrument than one with a curvature. Most modern guitars are fairly flat topped with a complex set of braces glued underneath the top to keep it flat and accentuate the tone. The same is true for the back. Archtop guitars are a different breed. The best ones are carved into a gentle curvature inside and out from solid wood, which is also how violins and mandolins are made. Inexpensive archtops utilize plywood that has been steam pressed onto a mold to create the curvature.

Ed was influenced by the only guitar he owned before he started building them himself. It was a Sears Silvertone archtop guitar that he bought as a young man in 1947. When the folk archivist Max Hunter visited Hogscald Holler in 1958, he recorded Ed singing and playing on his old Silvertone. It was an inexpensive instrument built with a molded plywood top and back, but its curvature seems to have made a strong impression on Ed as to what makes a good instrument.

Ed used a simple flat-top and flat-back design in his earliest attempts, but he soon started looking for ways to achieve a curvature more akin to his old Silvertone archtop. Creating curvature complicates guitar building dramatically, but that did not deter Ed. The methods he incorporated were not at all the ones used in traditional archtop construction. As always, he found a completely new way of doing things.

He relied on bending the top and back pieces to conform to sturdy arched braces that

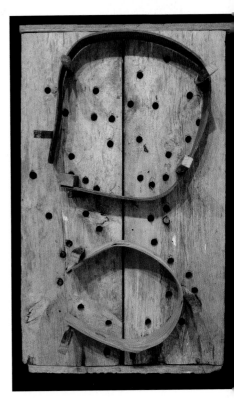

Ed's pegboard with wood for instrument sides woven around pegs after being boiled overnight. Photograph by Kelly Mulhollan.

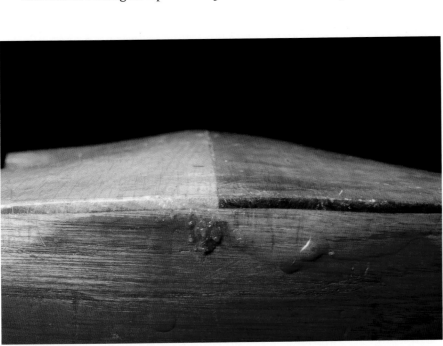

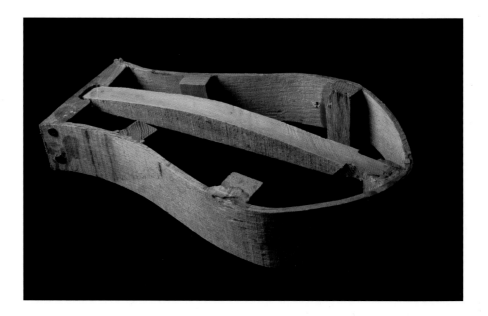

Fiddle frame with graceful
arched brace.

spanned the instrument like a ribcage. These braces normally run lengthwise but often
have cross braces mixed in as well depending on the shape and the top pieces he was
working with.

He utilized heavy steel C-clamps to force each piece to conform. Somehow he managed
to secure the thick top and back segments (typically about three-sixteenths to one-quarter
inch thick) to the arched braces using wood glue and even nails if necessary. Although
there must be a fair amount of tension in these bent pieces, they seem to hold together just
fine with only a few exceptions. Ed often planed down the outer edges of both the back and
front with a drawknife in an attempt to create even more curvature. It was a lot of extra
work, but the lovely results repaid his effort.

You might be wondering just how much these instruments weigh with wood of such
stout dimensions (not to mention the metallic innards). I weighed them, and I was more
than surprised with the results. Out of the first twenty instruments I weighed, half were
exactly 9.8 pounds. What are the chances of that? Further, the rest were only a half a

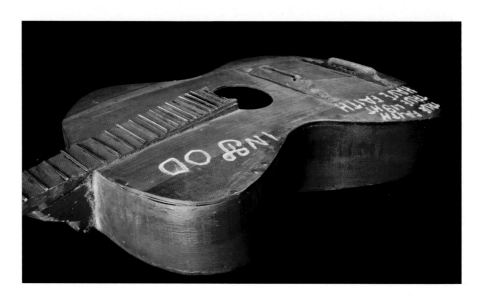

Body arched beautifully, both
lengthwise and across.

pound on either side of that. In the end, I decided it was not worth including the weight of every instrument because it was simply too repetitious. In comparison, a traditional guitar weighs between 3 and 4 pounds, and some are even less. I play an old Martin O-18 made in 1926 that weighs just 1.8 pounds!

Lost but Found: A Mystery Solved

Speaking of the old Silvertone archtop, I have often wondered what happened to that instrument. Ed was seventeen years old when he bought it for twenty dollars. I had never seen it with my own eyes, but there is a photograph of Ed playing it as a young man on page xii of Dr. Cochran's introduction. It was his only guitar until he began making his own. I had heard him talk about it with great fondness. Surely he wouldn't have given this precious thing away?

I'd asked Ed numerous times if he knew where the old Silvertone ended up, but he couldn't remember. It seemed that this would remain a mystery. Finally, in the last month before our publishing deadline, I was milling around in Ed's shop looking at the assortment

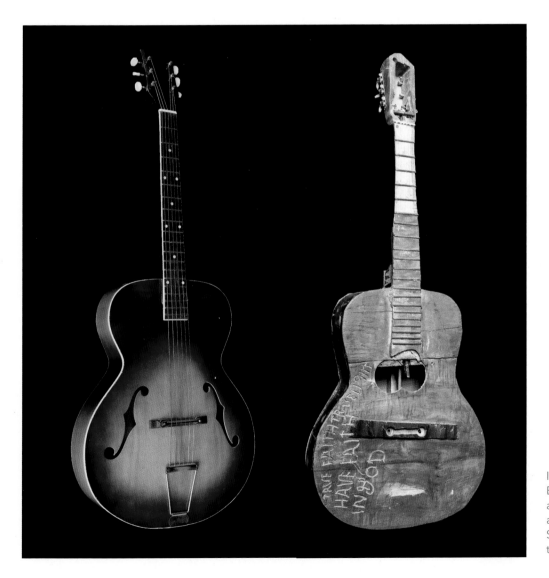

Instrument akin to Ed's 1947 Silvertone archtop guitar along with Ed's own Silvertone as it is today!

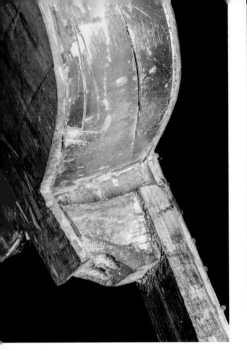

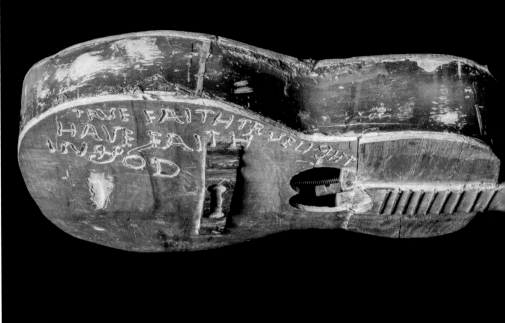

of unfinished instruments that remain there. One caught my eye. A very crude thing without strings or hardware and with factory-made sides. Factory-made sides? Could this be some remnant of the old Silvertone? I ran into the house with the instrument in hand, and Ed exclaimed, "Why that's the old Silvertone!" Mystery solved. It had been right under our noses all along.

He had replaced the back, the front, and the neck, and added the usual assortment of springs and saw blades, as well as his signature inscription, "True Faith, True Light, Have Faith in God." All that remained of the old Silvertone was the sides. Nothing was safe from his tampering. Even the Silvertone had slowly morphed into a classic Ed Stilley creation.

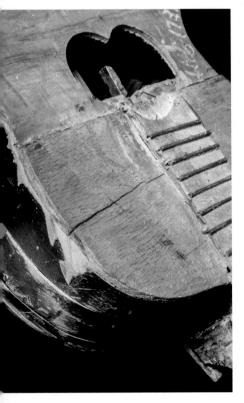

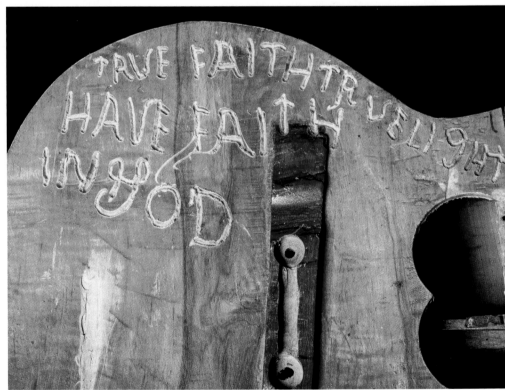

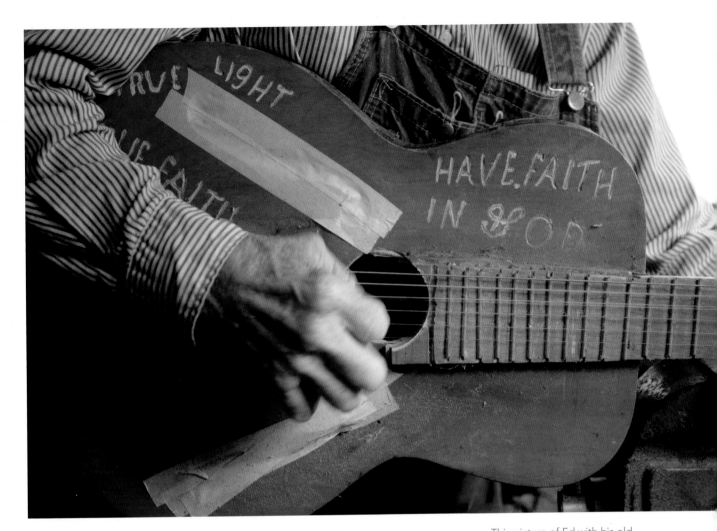

This picture of Ed with his old
Silvertone was taken in 2004 when
the instrument was in transition.
The neck had been replaced but
the top is still intact. The f-holes
were covered with masking tape
and Ed had cut a round sound
hole. He would later replace
the entire top with his own top.
Photograph by Russell Cothren.

The middle-period instruments represent a time of great exploration and include many of my personal favorites among Ed's many creations. While he had discovered how to make a truly playable instrument, he was still searching for techniques that would improve its tone and volume. During this period his internal skeleton of metallic objects began to take shape, and the X-ray images reveal Ed "the inventor" experimenting with a complex array of diverse components.

Ed Stilley's Middle-Period Instruments

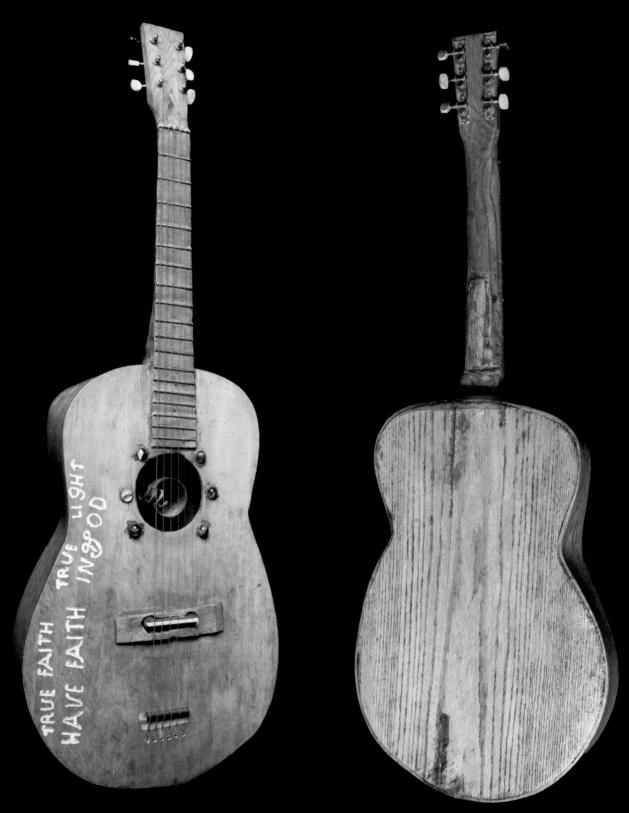

Guitar given to Malinda Miller Fitch.

Perhaps the most guitar-like instrument Ed made. Rare one-piece basswood top with decorative marbles. An inset back and pipe-and-spring arrangement seen through the sound hole are typical of Ed's earliest creations, but improved fret accuracy and overall playability suggest that Ed was emerging from his early phase. He was beginning to discover how to make an instrument that actually played well.

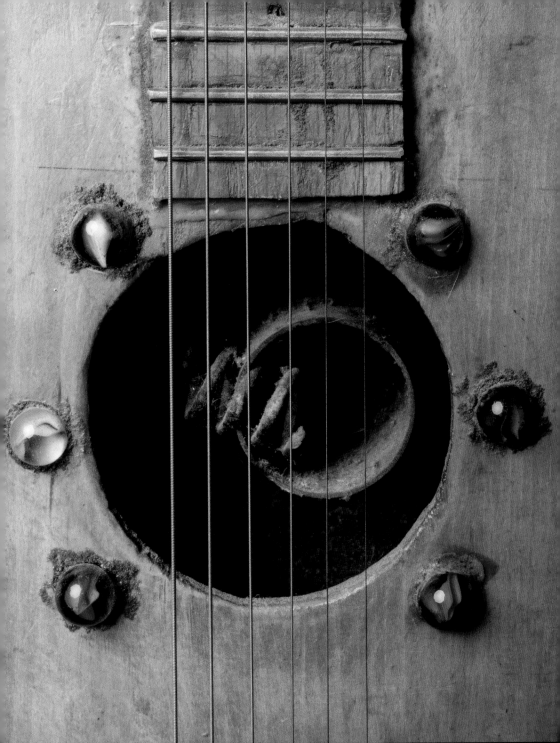

"My guitar was originally very plain with the only embe[llish]ment being three marbles on either side of the soun[d] hole. A couple of years later, Uncle Ed noticed several o[f] the marbles had fallen off, so he took it home to repai[r]. He returned my guitar with all the marbles in place agai[n] as well as the words 'True Faith, True Light, Have Fait[h] in God.'"

MALINDA MILLER FITCH

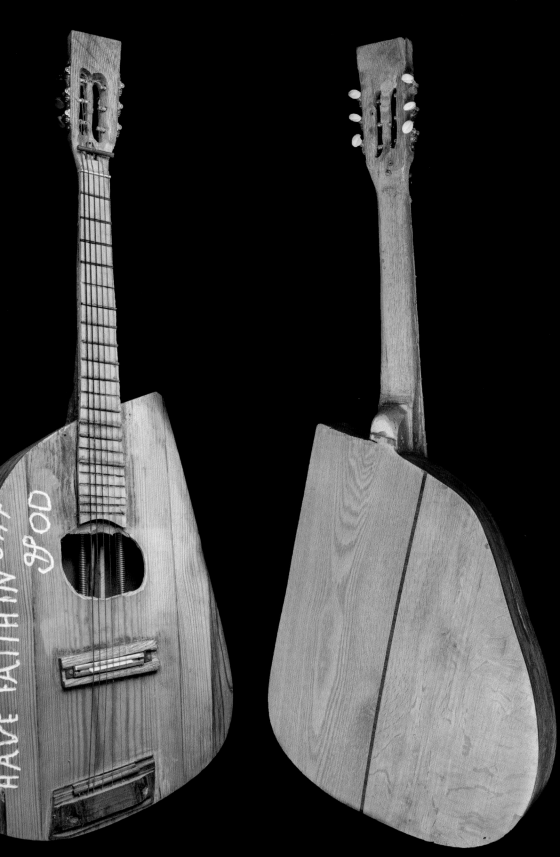

Guitar given to Paul and Joyce Hull.

Interesting diagonal styling. Has an odd headstock that's fairly flat, but hollowed out to accommodate side-mounted tuners. Contains a saw blade, door springs, and an aluminum echo tube inside. All pine with an oak neck.

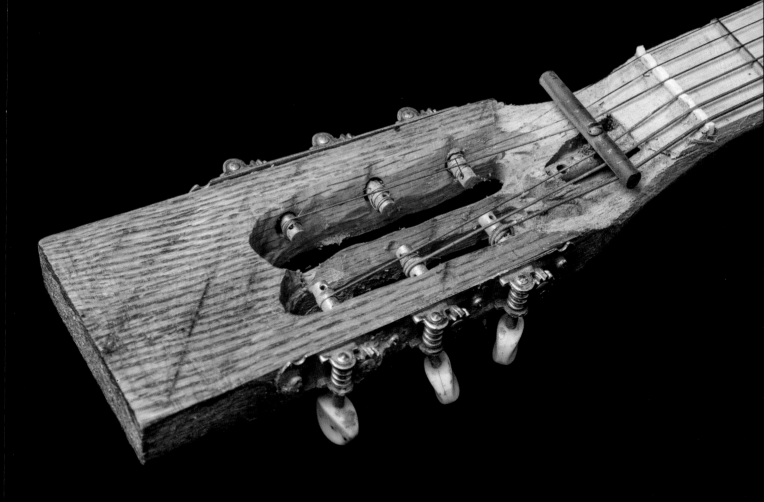

*"We called him a bare light bulb and an iron
bedstead cause he didn't believe in having any-
thing real fancy. He felt guilty about it, I guess.
He'd preach about it, too."*

JOYCE HULL

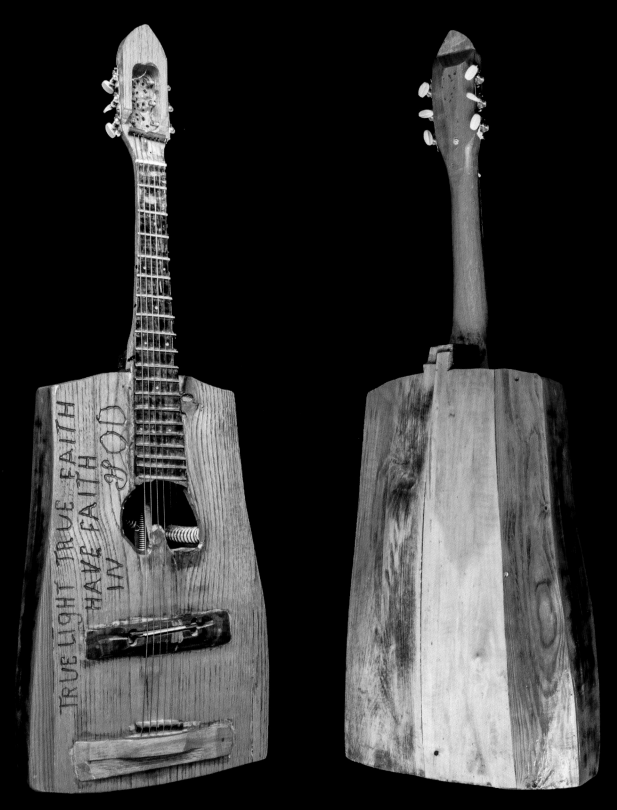

Guitar given to Tom and Nina Luther.

This is the instrument Donna and I saw at the Luthers that started us on our journey with Ed. It best illustrates Ed's middle period—a time when he was extremely experimental. X-rays clearly show a saw blade and all manner of springs along with a Right Guard aerosol can, a glass bottle, and a plastic Dixie Cup. The sound hole is a natural knothole in the oak top. Tone is dark and robust.

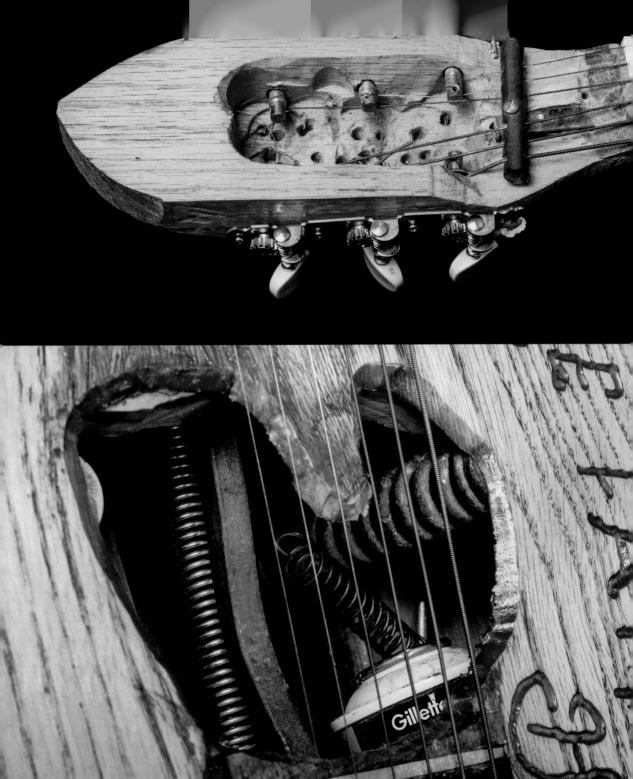

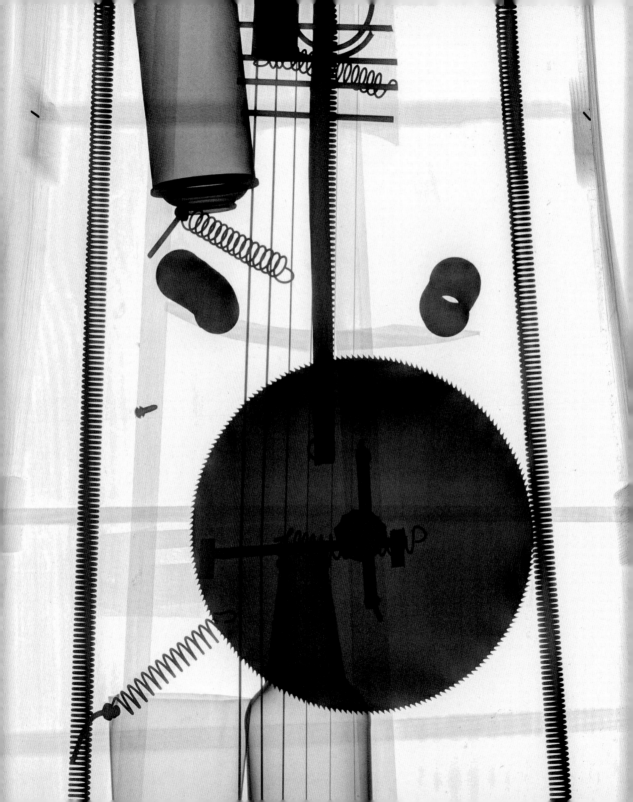

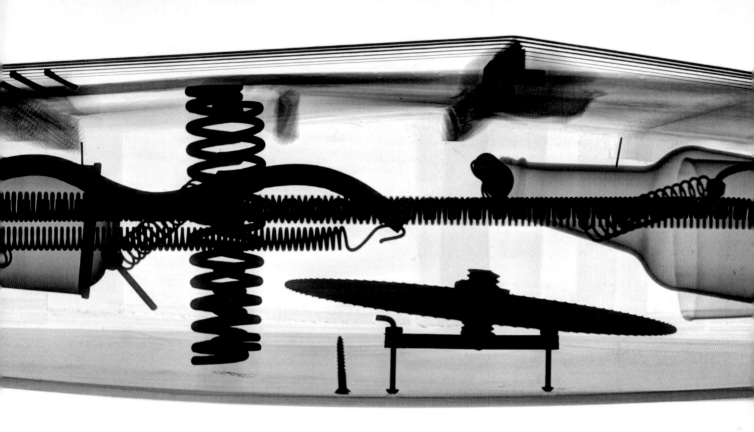

X-ray image by Dr. Dennis Warren.

"Ed was very old fashioned. Unless Tom was home,
he would not cross the threshold of our doorway."

TOM AND NINA LUTHER

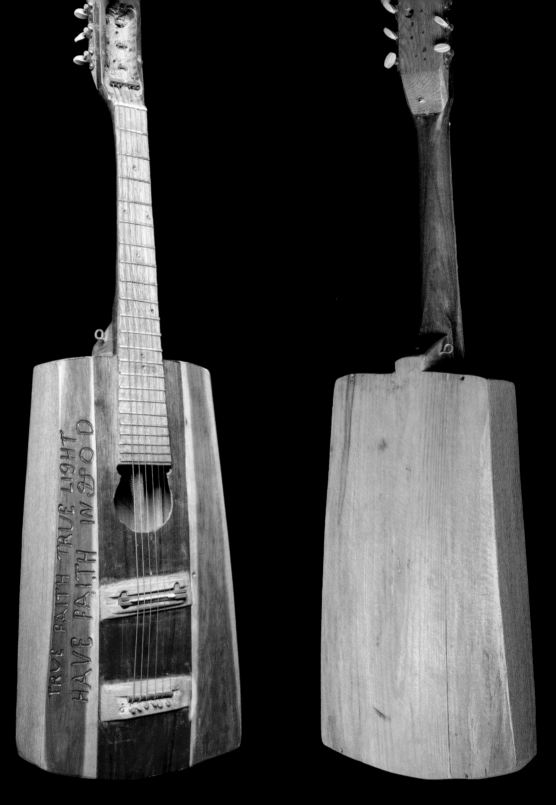

Guitar given to Rose Graham and now owned by Bobby Thurman.

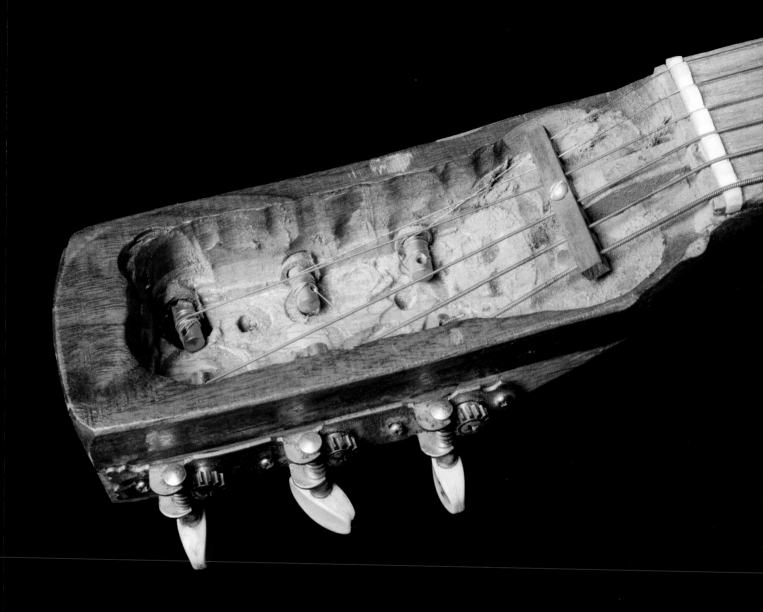

"So, Roscoe and I go down to a jam session every Monday night down in the town of Clifty, and there's a guy named Elvin that comes there from over in Springdale. Elvin was telling me, he said, 'You know, several years ago I was 'round Ed Stilley some and saw his guitars and everything. I knew he played at nursing homes for people and sang, he and his wife, and I just felt like Ed ought to have a really nice guitar.' Elvin said he had an extra guitar and it was worth around six hundred dollars in a nice case and all. A really nice little guitar, and he knew Ed couldn't afford something like that.

"Elvin said he took that guitar over and gave it to him. Ed pulled that guitar out of that fancy case and was just really pleased with that really fancy nice six-hundred-dollar guitar. And so then, about a month goes by and ol' Ed calls Elvin and he says, 'Elvin, come over—I want you to see this guitar," and when he got there, that six-hundred-dollar guitar looked just like all the others that Ed made—complete with saw blades and springs and all the rest of it!"

BOBBY THURMAN

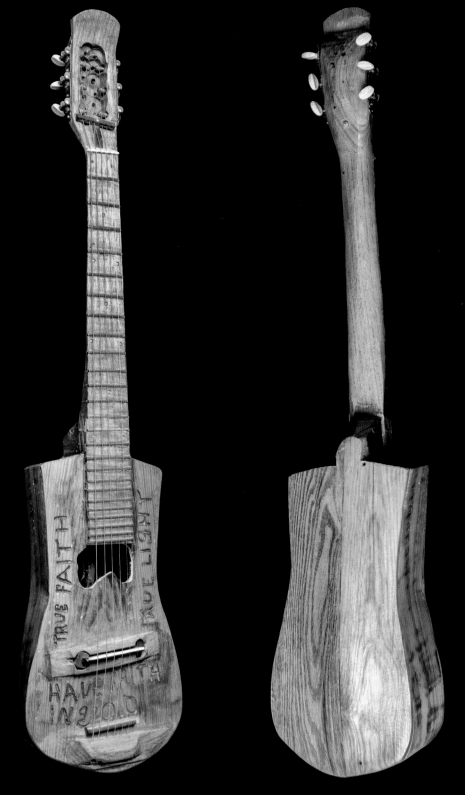

Guitar given to Jason Lawler.

I pulled several pounds of dirt dauber nest out of this one, but there are still more in there.
The X-ray shows them clearly! The slender instrument is still full length (39½ inches) and
is chock full of metallic components—a metal pulley, a tin can, and all manner of springs.
Fine example of Ed's period of exploration with internal components. Note that Ed used a
natural hole in the wood as a sound hole.

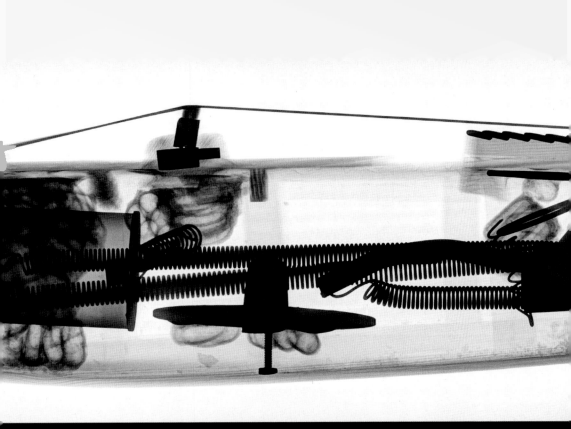

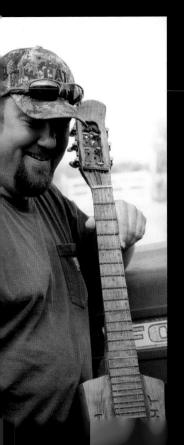

"I made 'em for twenty-five years, and for the first ten years I made one every two weeks. I never did catch up with all the ones people wanted."

ED STILLEY

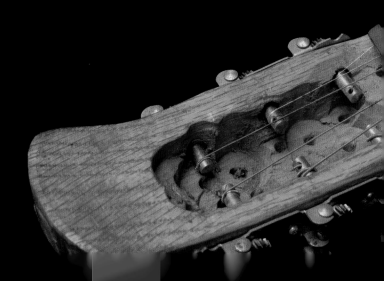

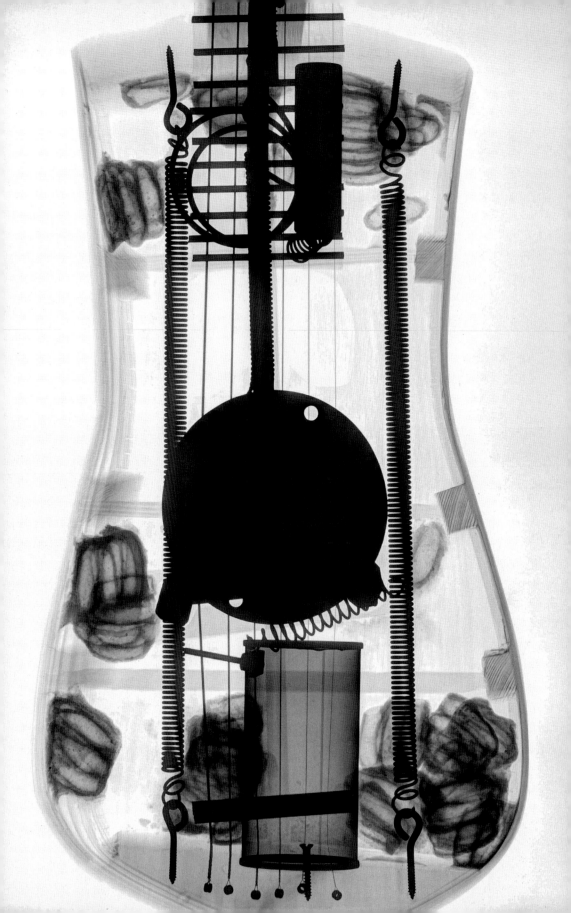

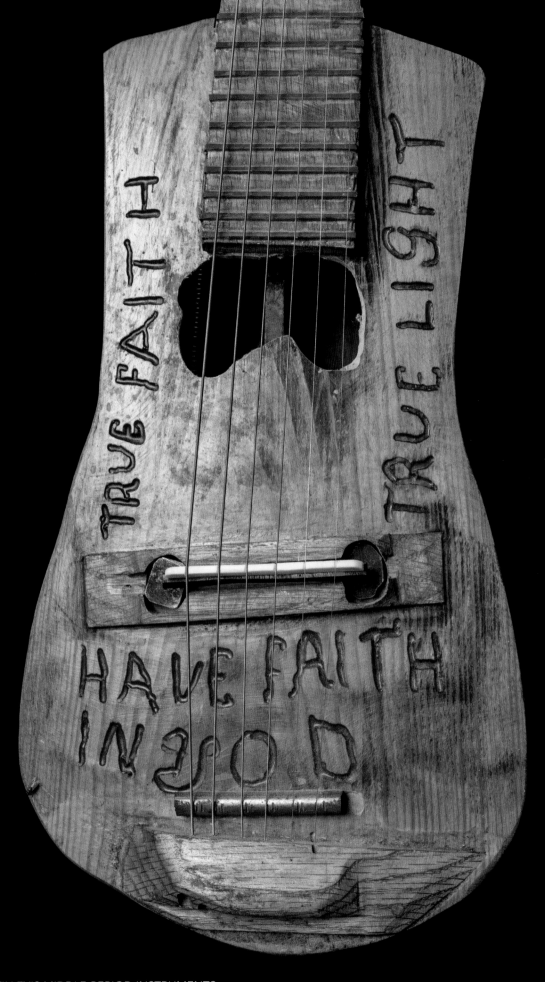

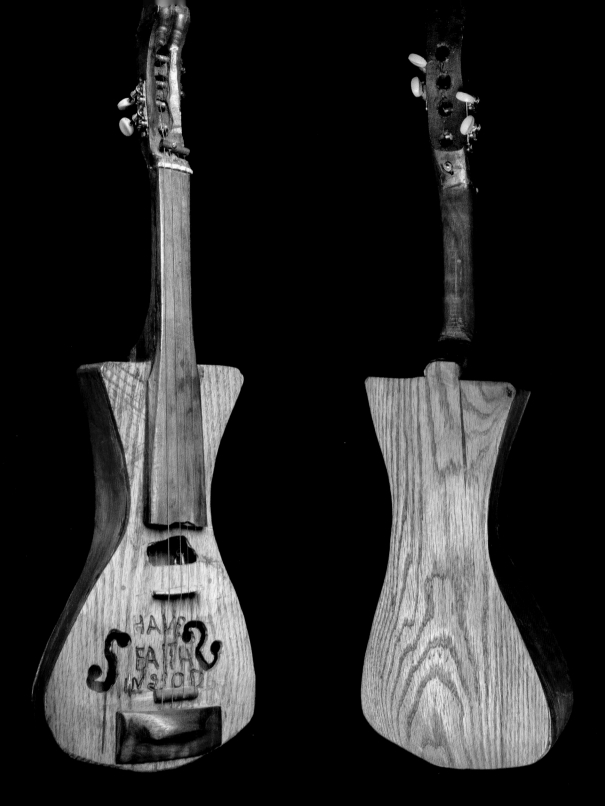

Fiddle given to Ed's wife, Eliza Stilley.

Elegant instrument built for his wife. Has a feature unique among Ed's creations—X-rays reveal "reflectors" made from the lids of steel cans cupped into the corners—apparently to focus the sound toward the center. There's a metal pinwheel sort of fan in the center. Oak with walnut appointments and a fine carved peghead.

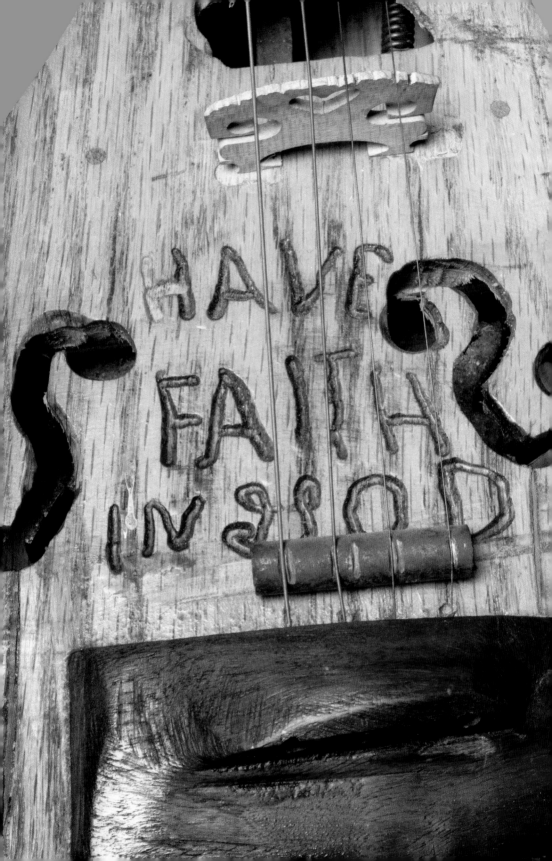

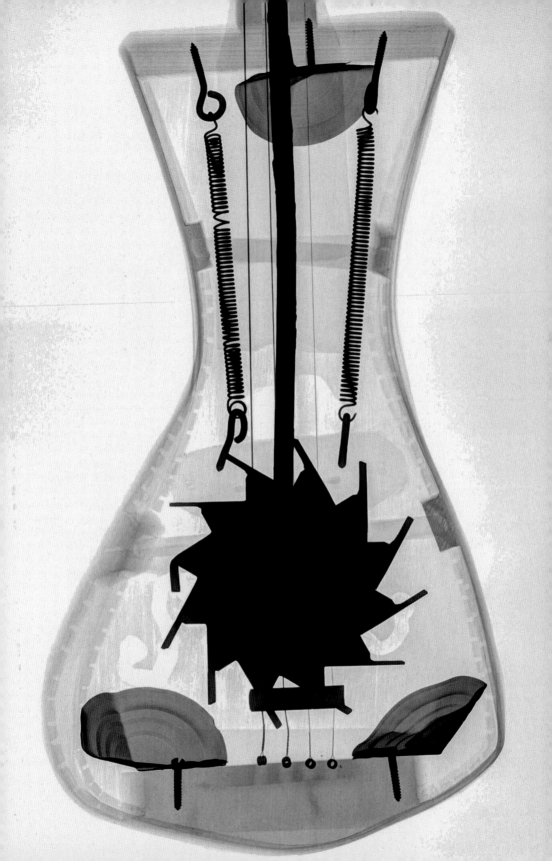

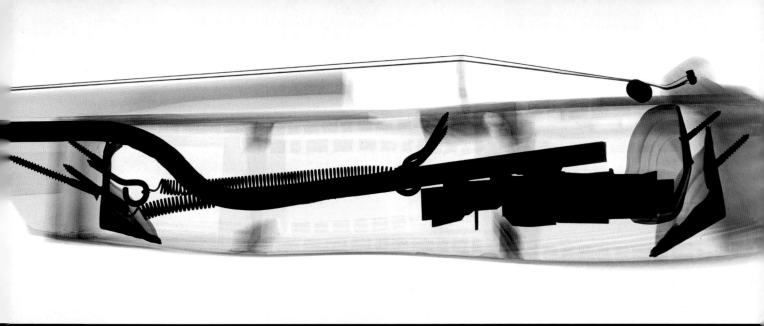

X-ray image by Dr. Dennis Warren.

"*Ed had been making these things for everybody in the family and all the neighbors and I finally said, 'When are you going to make one for me!' So he made me that little fiddle.*"

ELIZA STILLEY

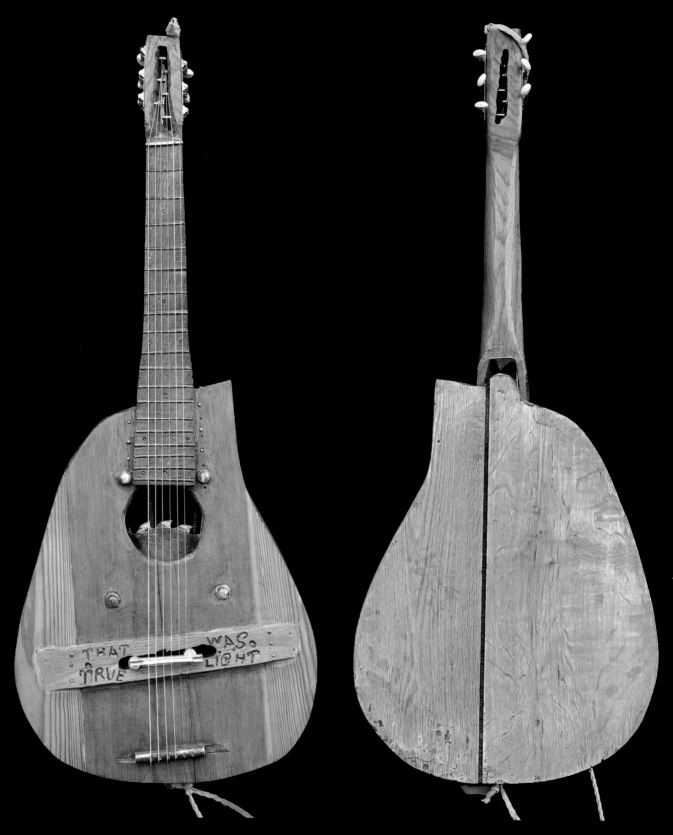

Guitar owned by Charles Stevens.

Close-up photo reveals a one-piece peghead with rear access, which may facilitate string changing. The inscription is an interesting departure from Ed's standard message. There's a saw blade, door springs, and an aluminum echo tube inside. Made of pine and adorned with marbles. The neck is oak, and the back is made from wood paneling.

Photograph by
Kelly Mulhollan.

ED STILLEY'S MIDDLE-PERIOD INSTRUMENTS

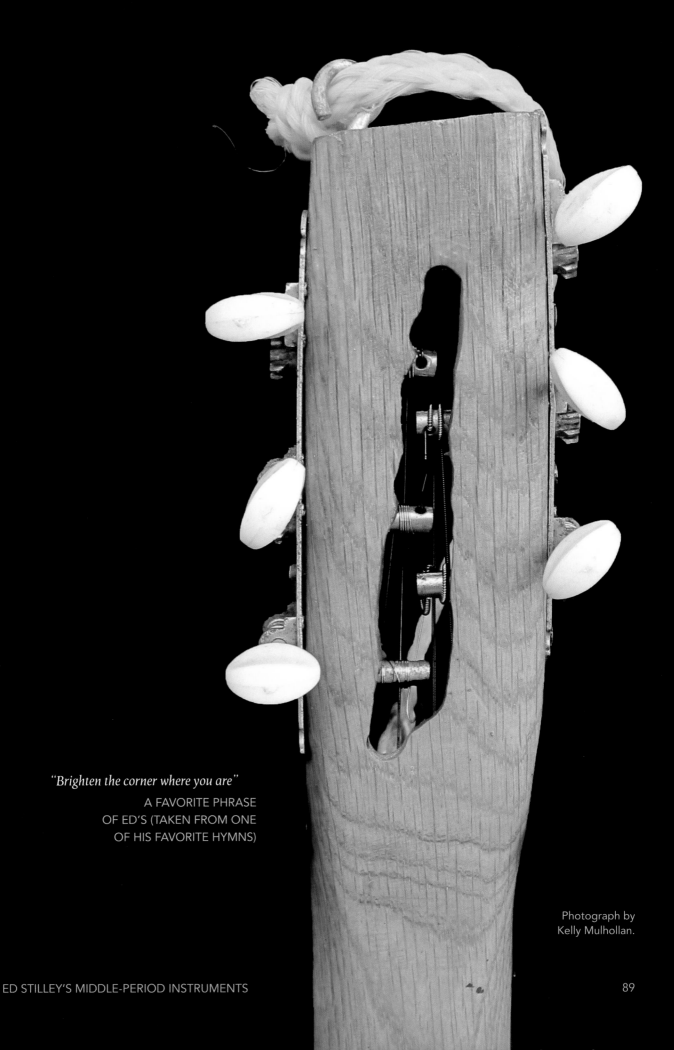

"Brighten the corner where you are"
A FAVORITE PHRASE
OF ED'S (TAKEN FROM ONE
OF HIS FAVORITE HYMNS)

Photograph by
Kelly Mulhollan.

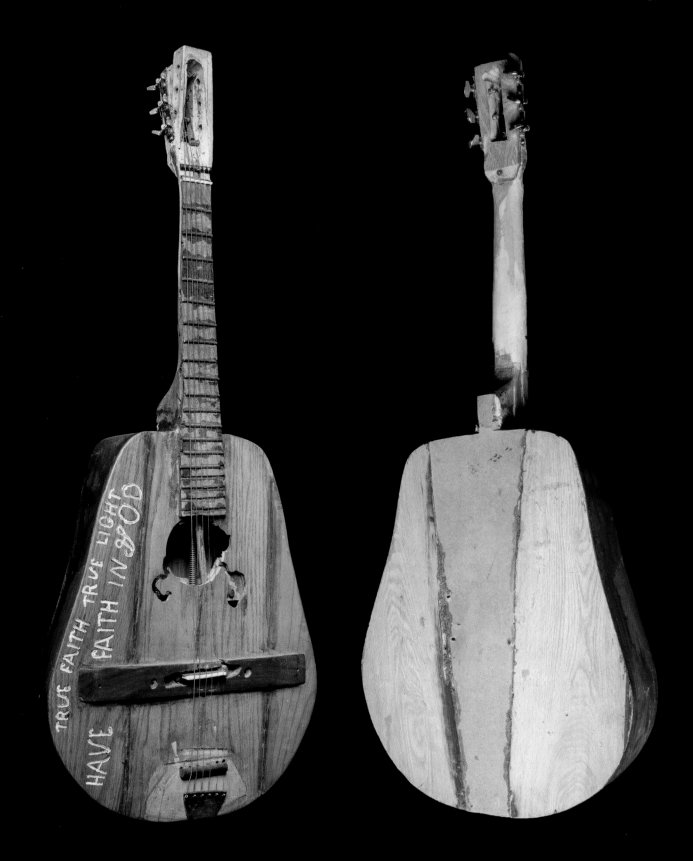

Guitar given to Jim Dudley, who performed Ed's cataract surgery.

Don't you love the squiggly lines that wander out of the sound hole? I believe they were made for a specific purpose—to access and adjust the internal components after the top was already glued down. A saw blade and springs rest inside, with a back made from Masonite paneling. The peghead is like no other.

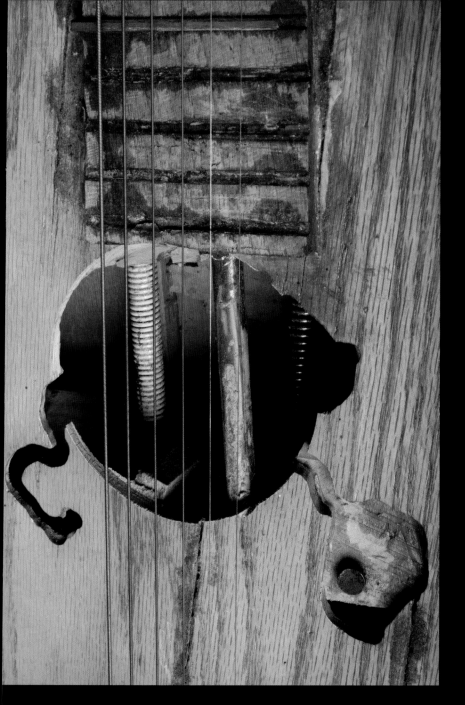

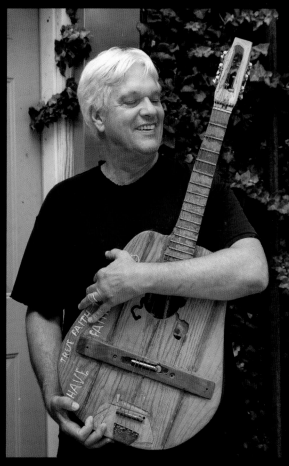

"*Money was definitely an issue with Ed, but he really had to have this cataract surgery, so we just donated our part of the surgery and got it done. It wasn't a month after he had the surgery that Ed showed up and gave me this guitar.*"

JIM DUDLEY, MD

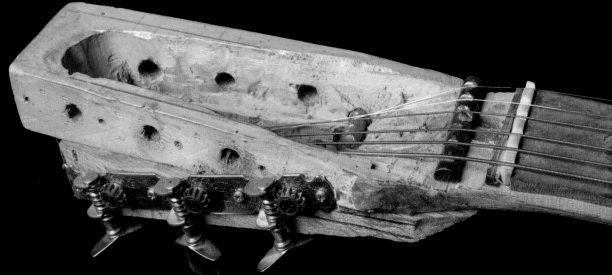

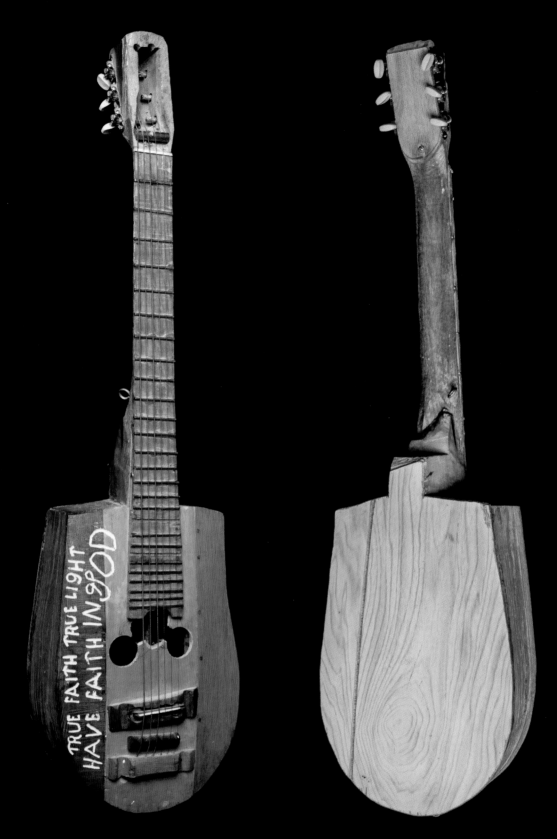

Guitar given to Johann Pott.

Fairly small body with a heavy metallic skeleton. X-rays reveal a saw blade, a chainsaw sprocket, and various springs that work in concert to produce a fine tone. Top is walnut, basswood, and oak with a back made from Masonite paneling. The fingerboard is painted red. Thirty-six inches in length and 10 inches in width.

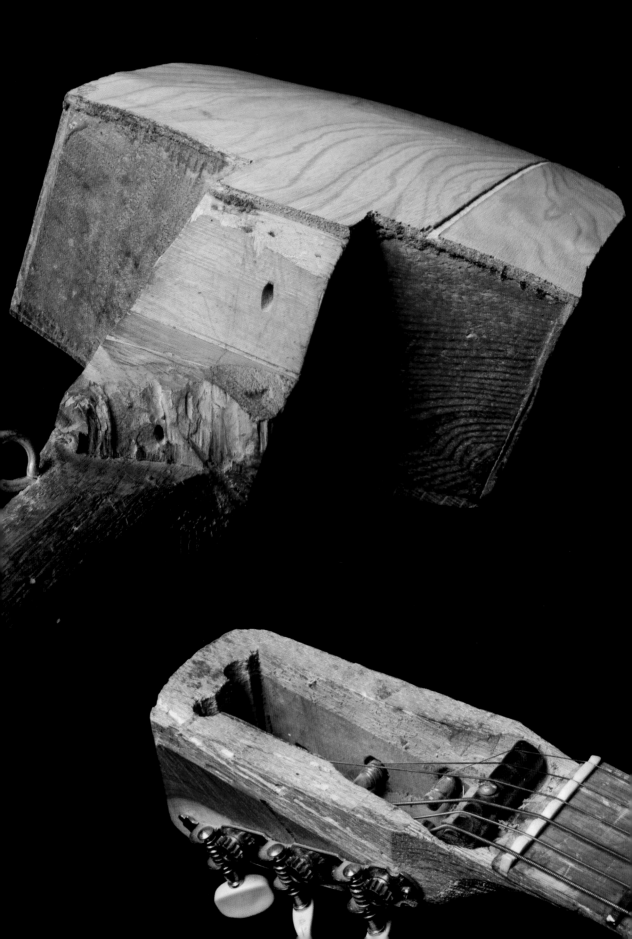

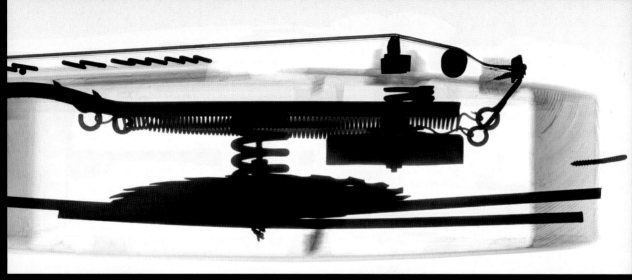

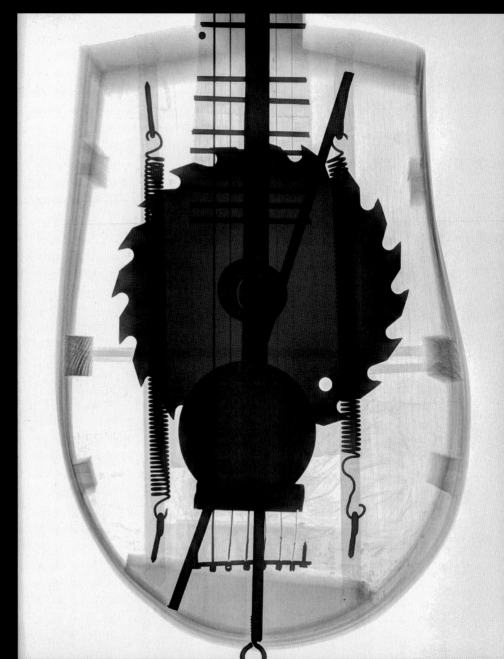

X-ray images by
Dr. Dennis Warren

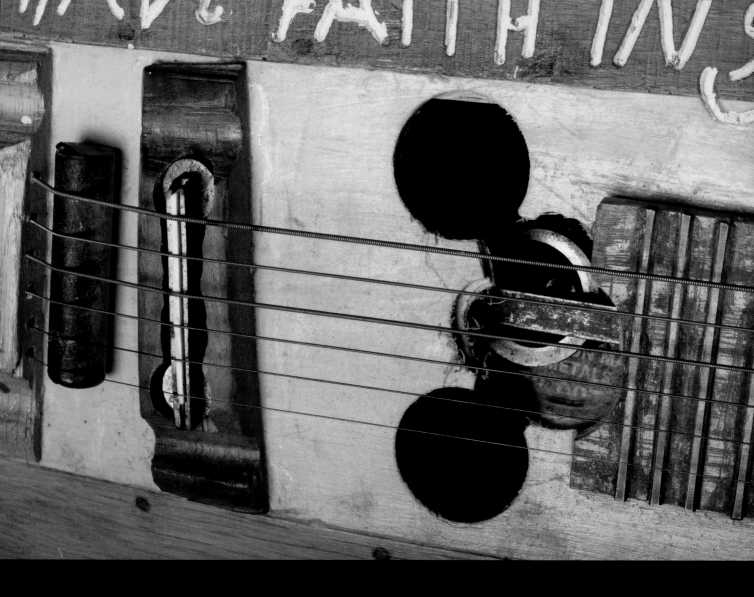

"When I jumped on it for the first time it just didn't sound right, but then you just play it for a few seconds and wow! You start to hear it from a different perspective and it brings out all these different overtones and things that seem wrong at first and then somehow more beautiful later."

JOHANN POTT

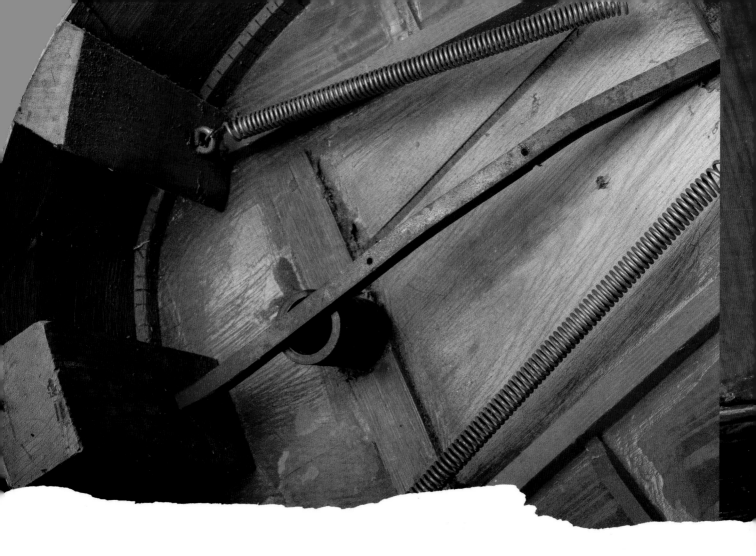

Reinventing Reverb

The Innards

If you ask Ed why he puts all that metallic stuff inside, he'll tell you, "To better speak the voice of the Lord." It's hard to argue with such an answer, but there just may be more to it. Somehow, without any knowledge of modern audio technology, Ed came up with the two basic methods of creating reverb that dominated the recording industry until the 1990s when digital technology took over.

Reverb is the sound that continues on after the sound's source has finished producing it. It's what we hear in a cathedral, a gymnasium, or the shower. Sound engineers create artificial reverb to restore the "sound" of the room itself that is often lost in the recording process. They accomplish this task by means of two very different mechanisms—spring reverb and plate reverb. In both, the sound is transmitted through metal to create reverb— in one case through a spring and in the other, a solid metal plate.

It's easy to see the connection between what Ed was doing to "better speak the voice of the Lord," and methods used by modern sound engineers to create reverb. He carefully mounted all manner of metallic odds and ends inside almost every instrument he made. Amid this assortment, he almost always included a set of door springs along with some

sort of heavy metallic "plate" object (usually a saw blade or a pot lid). So there it is—spring reverb and plate reverb. And amazingly, it actually works!

These diagrams illustrate how Ed often arranged the door springs and the heavy steel objects within the body of the instrument. Door springs stretch the full length of the body. The steel objects responsible for plate reverb are suspended in the middle of the body by a large heavy coil spring. This coil spring generates spring reverb as well but more importantly, secures the plate object (saw blade) in a way that allows it to ring freely like a bell. The whole arrangement allows the plate reverb and spring reverb to work in concert with each other.

Ed says he was mindful of the "ring" of the door springs he stretched across the inner body. They're normally in pairs and he wanted them to "harmonize." He clearly made some attempt to get all the ringing parts, including the saw blade, to work together.

You'll find an amazing array of objects in Ed's creations beyond door springs and saw blades: lawnmower parts, cooking pots, glass bottles, aerosol cans, tin cans, all sorts of springs, metal pipes, and even plastic cups. In reality, some of these objects may not actually contribute much to the sound. I believe the door spring and the pot lid may have been the most successful combination in creating natural reverb. The saw blades work too, depending on how resonant the blade is.

The word "reverb" wasn't a part of Ed's vocabulary, but I'm certain that he did recognize the sound of reverberation. I believe that when he uses the word "echo," he is describing reverb. (Echo is related to reverb, but it isn't the same thing.) Oddly enough, Ed also uses the term "echo" to refer to a specific metallic part of his own invention (see page 102). He was constantly searching for new and better ways to create that mysterious echo with each instrument he built, and he was certain that God was showing him the way forward. One way or another, without any knowledge of the practices of modern sound engineers, Ed's creative curiosity and natural love of innovation led him to rediscover reverb.

The Metallic Skeleton

Steel can be a transmitter of sound. We're surrounded by examples of this fact. Have you ever tapped your ring on a metal railing and heard the sound race through the tubing? We all know the sound of rain on a tin roof. The metal tone ring in a banjo pot or the metal-cone resonator in a resonator guitar are examples of using steel to produce tone and volume in musical instruments.

Ed tells of the skeptical warnings he received from the local music store when he first informed them of his plans to build instruments from sawmill lumber scraps. "You can't make a guitar out of those heavy boxes," they told him. Lacking the tools to obtain the delicate thinness used in conventional instruments, he was forced to search for other means to bring the sound out, and he believed that metallic components could do the job. Ed was convinced they could be configured in such a way as to increase the overall volume of the instrument itself. This is where it really gets interesting.

There's one component common to almost all guitars built after 1930—the steel truss rod. This rod runs the length of the neck and lies just under the fingerboard. It is quite effective in keeping the neck straight and true, but it's not usually thought to be a significant contributor to good tone. Ed picked up on the concept of a truss rod early on, but took it

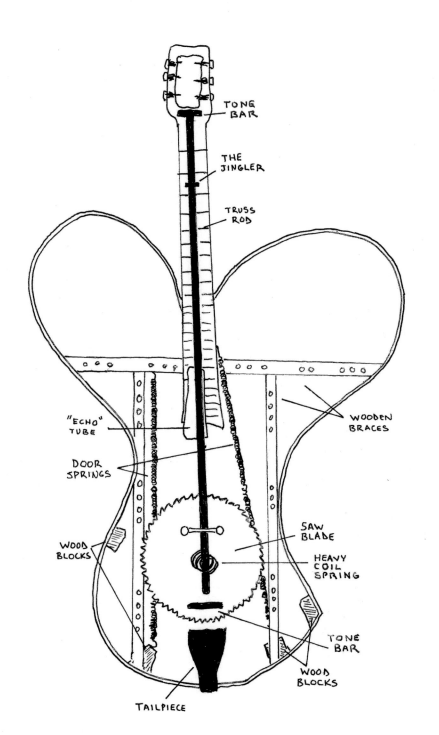

left: Anatomy of an Ed Stilley guitar. Drawing by Kelly Mulhollan.

below: Side view showing Ed's metallic skeleton. Drawing by Kelly Mulhollan.

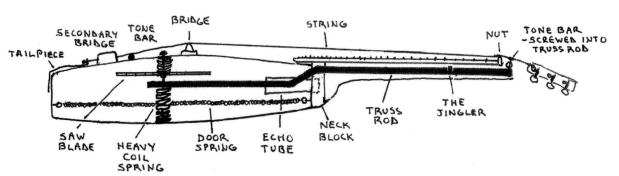

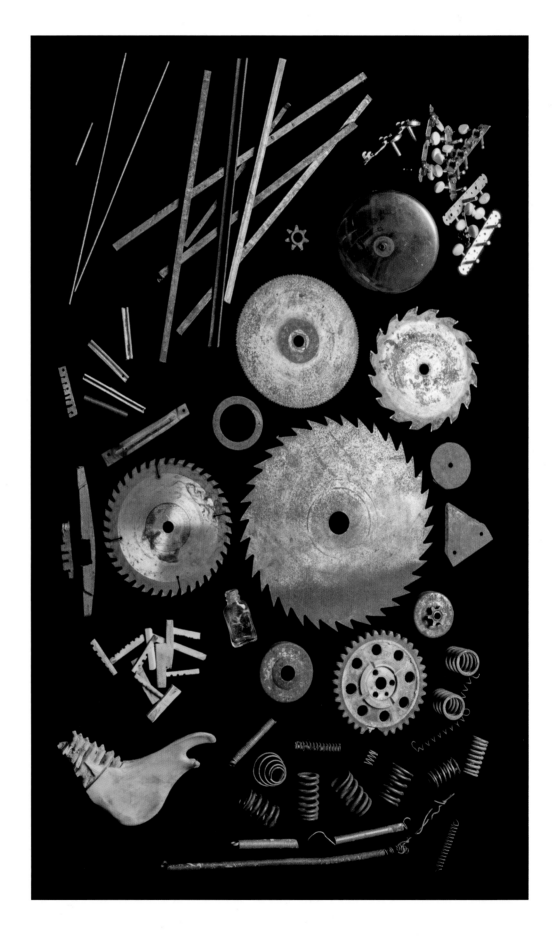

Hardware used in an
Ed Stilley instrument.

THE INNARDS

a step further. He believed in its potential to improve both volume and tone and devised a most unconventional way to make it do so. Close inspection of X-ray images reveals how he utilizes the truss rod as an active participant in shaping the sound of his instruments.

My musician friend Peter Lippincott and I were looking at one of the X-ray images when Peter discovered something I had missed. I'd often wondered why practically every one of Ed's instruments has a solid steel bar screwed down just behind the nut. The strings run over this bar before they reach the tuning pegs.

It seemed to me that the guitars would work fine without this feature. I couldn't see how the rod would contribute to the sound. Still, since every instrument possessed this mysterious feature, there must have been a reason for it. Peter noticed that the rod was actually secured in two ways: not only was it being held down by the string tension, but it had also been purposefully secured by a screw that made contact with the end of the truss rod itself. Suddenly it all made sense!

The strings are all pressing down on the rod that is screwed into the long truss rod that runs back down into the body (under the fingerboard). But it doesn't end there. Ed's truss rod runs clear past the heel block and into the body, past the sound hole and all the way to the center of the chamber where it makes contact with whatever steel object is mounted in the center, be it a saw blade or a pot lid (the plate reverb device). This rod can usually be seen through the sound hole. A heavy coil spring is compressed between the rod and the top so that energy from the truss rod is transmitted into the soundboard. Above that lies the bridge with the full tension of the strings pressing down on it. What you have is a full circle. The strings themselves are transmitting their vibration into this continuous internal skeleton by way of the truss rod and the bridge. The skeleton is a long resonant loop of steel that functions as an amplifier. The diagrams shows the basic skeleton design from the top and the side and should help you visualize how the sound moves around the metallic loop.

There's one more metallic feature worth mentioning—I call it the "tone bar." This is the steel bar that Ed pinned under the strings right at the tailpiece. It's present on all but the very early instruments. As with the steel bar at the peg head, it is not obvious to me that such a feature benefits the function of the instrument. I can only assume that he was trying again to improve the direct metallic contact between the strings and the body. It is conceivable that the extra mass provided by the heavy steel bar also might improve the overall sustain of the instrument.

The metallic skeleton that resides inside the instruments is one of Ed's greatest inventions. You could argue that the results are subtle at best, but there's no question that this design feature was important to Ed. Once he discovered it, he was amazingly consistent, and he executed it meticulously each time he built it into a guitar. There is certainly plenty of variation in his "loop" design, but it's clear he thought it was important to create an unbroken path of metal in order to achieve the sound he desired.

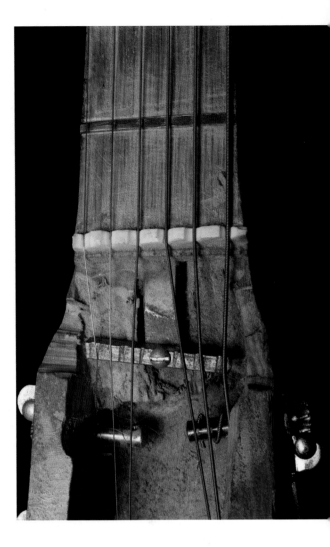

Peg head with tone bar screwed into truss rod, which is used to transfer sound to metallic skeleton.

X-ray view of tone bar and truss rod connection. X-ray image by Dr. Dennis Warren.

The Jingler

For Ed, the metallic skeleton itself was not sufficient. He was certain that there needed to be some sort of mechanism to excite the metallic loop. It was in 2013 that Ed just happened to mention something about a "jingler." A *jingler?* It seems that Ed will never run out of surprises. He would saw a little notch out of the truss rod beneath the fifth fret and loosely attach a tiny metallic object that was free to vibrate and dance around. The jingler would "chatter on down the truss rod," Ed says, "right down into the box." This chatter would then be amplified by the echo—the metal tube that juts out from the neck block inside the body of the instrument. Ed thought of this echo tube as a sort of megaphone for the jingler. In reality, the echo is inset into the wooden neck block and doesn't actually make direct contact with the truss rod. It may not function in exactly the way he intended. Still, Ed believed in function of the echo and utilized it most every instrument he built.

I could hardly wait to get back home and have a look at the X-rays images to confirm this new insight into Ed's mysterious process. Sure enough, there it was! It's actually found more often under the third fret. Clearly, Ed believed it was an important feature of his internal metallic skeleton. He was very consistent about installing both the jingler and the echo tube in his creations. Once the strings conveyed their vibration into the truss rod, the truss rod would in turn excite the jingler. This vibration would travel on down the truss rod, into the saw blade and the rest of the metallic skeleton and out of the echo tube.

Ed's use of the jingler reminds me of a trick used by mbira (finger piano) makers in West Africa. Mbiras are often fitted with metallic objects mounted in such a way as to allow them to rattle freely and chatter when they are excited by the vibration of the instruments. Ed used this same sort of technique, but for a different reason. He wasn't looking for the random buzz that mbiras make when their metallic parts get rattled. Rather, he

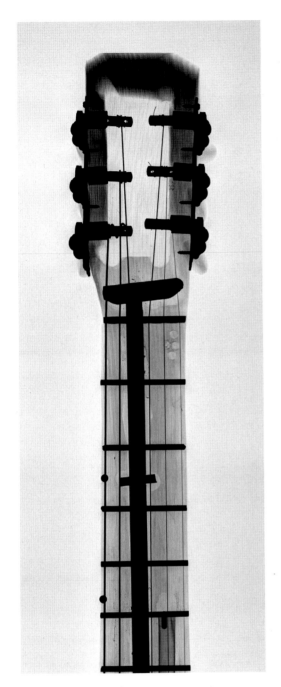

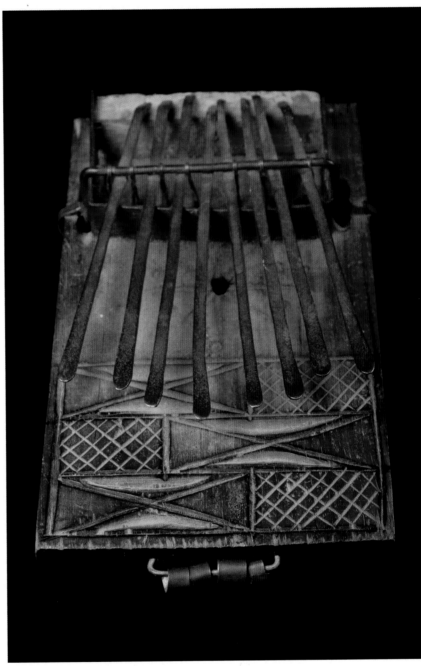

believed the jingler facilitated the transmission of sound down the truss rod. He felt the static metallic skeleton itself was not sufficient. It needed some sort of physical movement to excite the skeleton into action—and that was the job of the jingler. Whether or not this all works could be argued, but it is certainly an elegant feature to say the least. Certainly Ed's jingler is utterly unprecedented in guitar making.

above left: The jingler revealed! X-ray image by Dr. Dennis Warren.

above right: West African mbira with jinglers.

Ed's exploration continued and the playability and overall sound became more and more refined. He discovered the wonders of red barn paint! By this time, Ed had achieved a certain consistency in his work. These are all fine sounding instruments.

Ed Stilley's Middle-Period Instruments, Continued

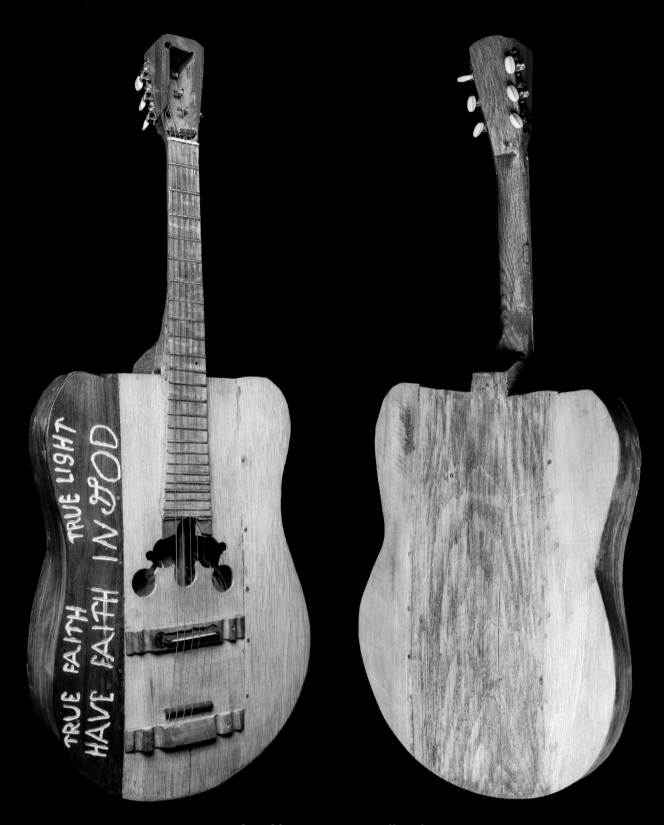

Guitar found by Darren McCullough.

It was about to be compacted! This is one of my favorites—don't you get a kick out of the one-of-a-kind sound hole! X-rays illustrate an elaborate arrangement of metallic components including a pot lid and a chainsaw sprocket—the combination produces the finest natural reverb of any I have encountered. Walnut and oak top with painted red fingerboard. Thirty-nine and three-quarter inches in length and 15 inches in width.

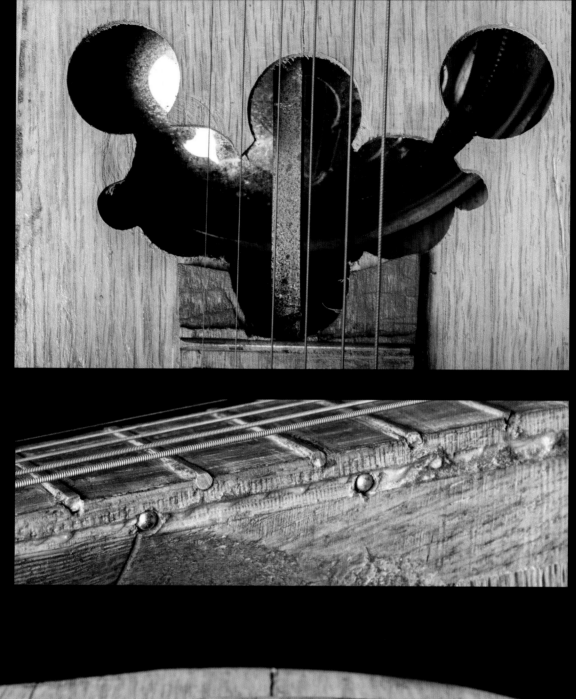

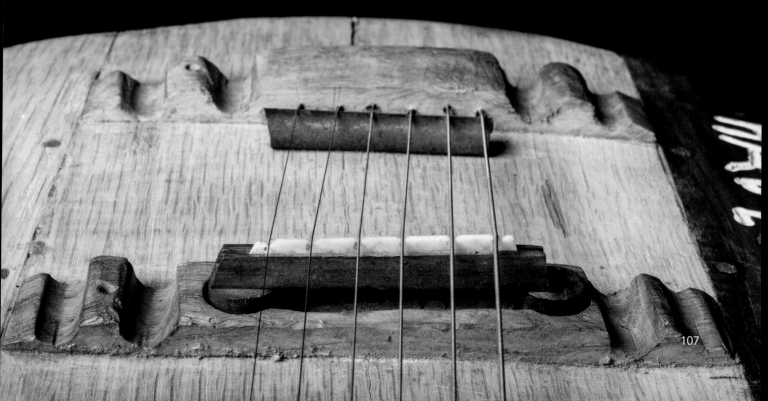

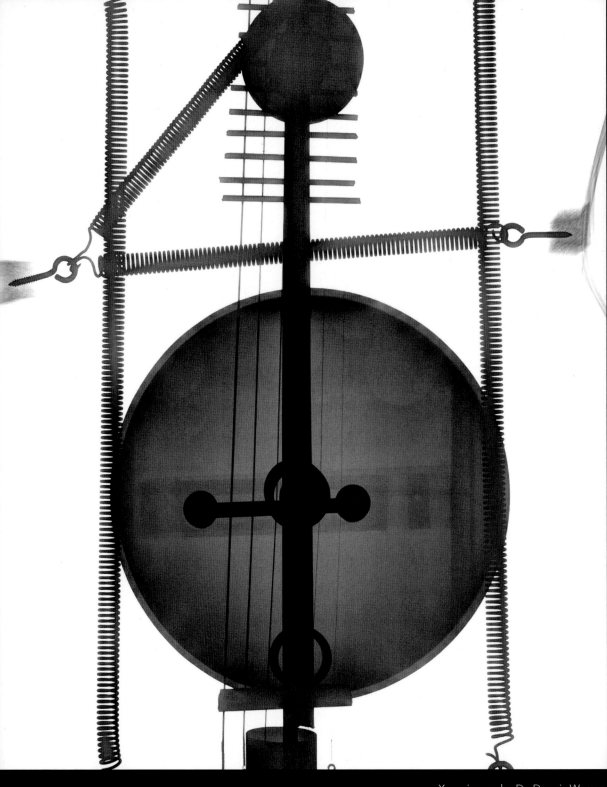

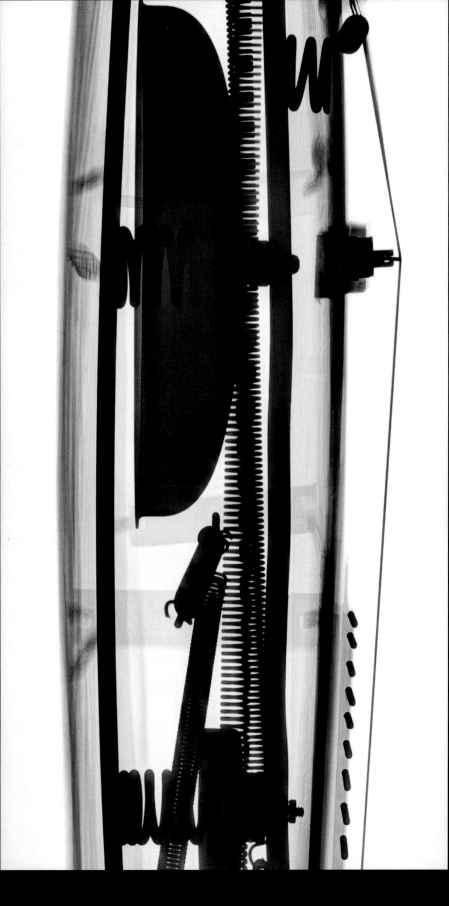

"God only gives the spirit of love—he don't give the spirit of hate."

ED STILLEY

X-ray image by
Dr. Dennis Warren.

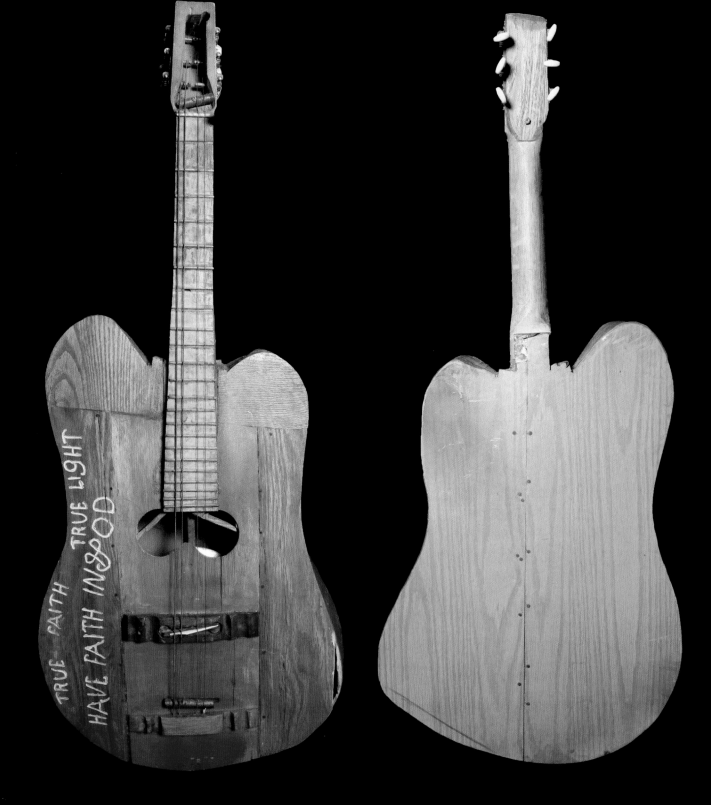

Guitar given to Andy Miller.

Handsome instrument with an unusual five-piece oak top.

There are features that characterize Ed's later period beginning to emerge, including a double cutaway at the neck. Ed goes on to push this cutaway feature to ever more dramatic proportions with his butterfly guitars. Springs and a pot lid inside.

Photographs by
Kelly Mulhollan.

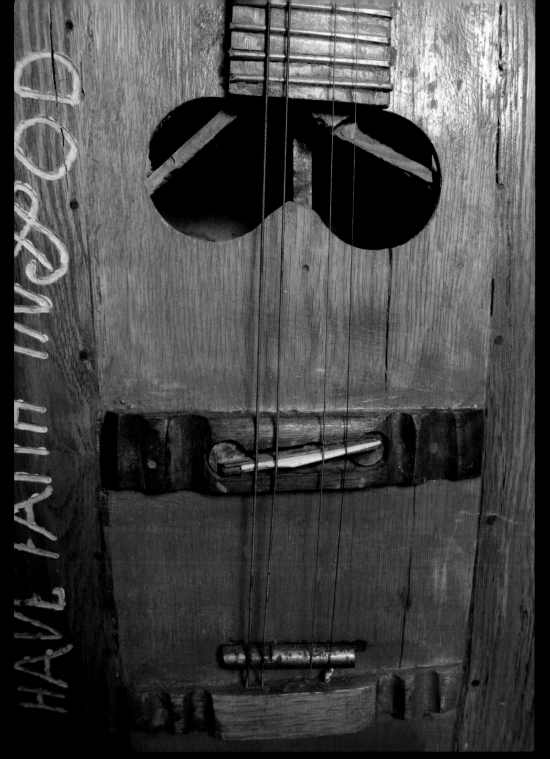

Photograph
by Kelly
Mulhollan.

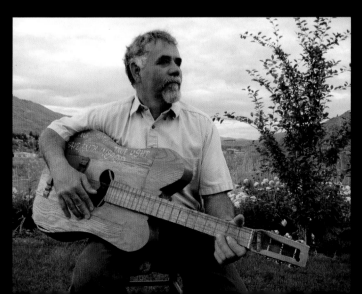

"I asked Ed how he came up
with all these shapes, and he
told me, 'I boil the wood 'til
it's soft and try to bend it, and
if it starts to break, well that's
where I stop.'"

ANDY MILLER

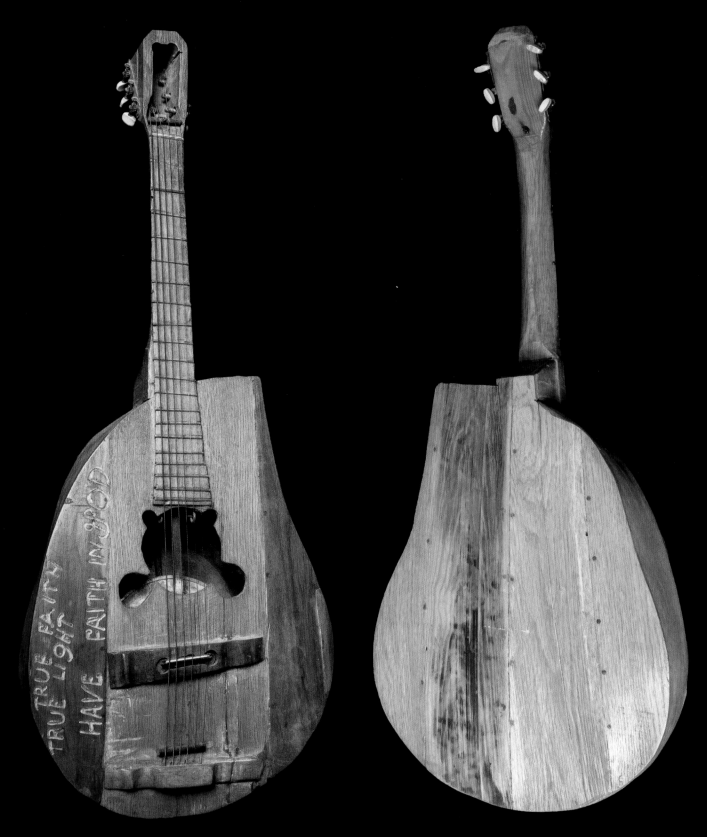

Guitar purchased from flea market by Barry Bramlett.

May be the first in a series of paisley shaped guitars. X-ray reveals double resonator setup consisting of a saw blade and a pink pot lid, along with an unusual spring arrangement. Weighs in at just under ten pounds. Handsome mix of walnut and oak.

ED STILLEY'S MIDDLE-PERIOD, CONTINUED

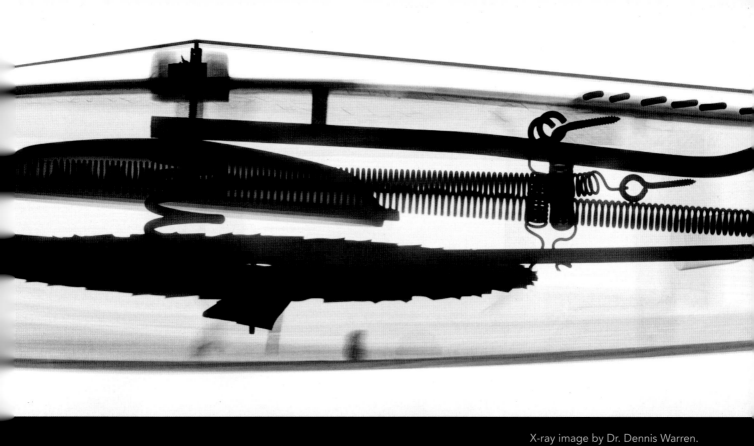

X-ray image by Dr. Dennis Warren.

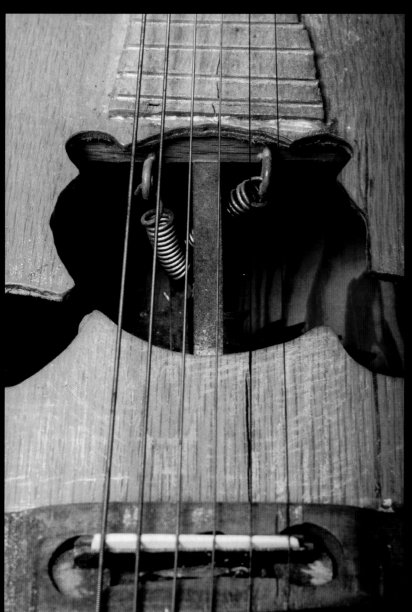

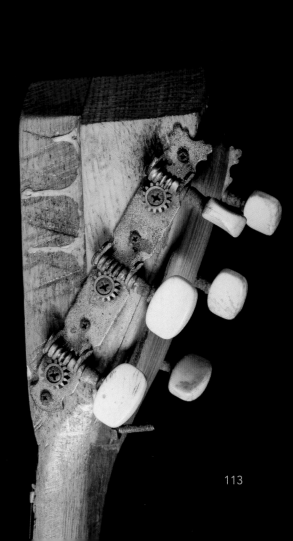

113

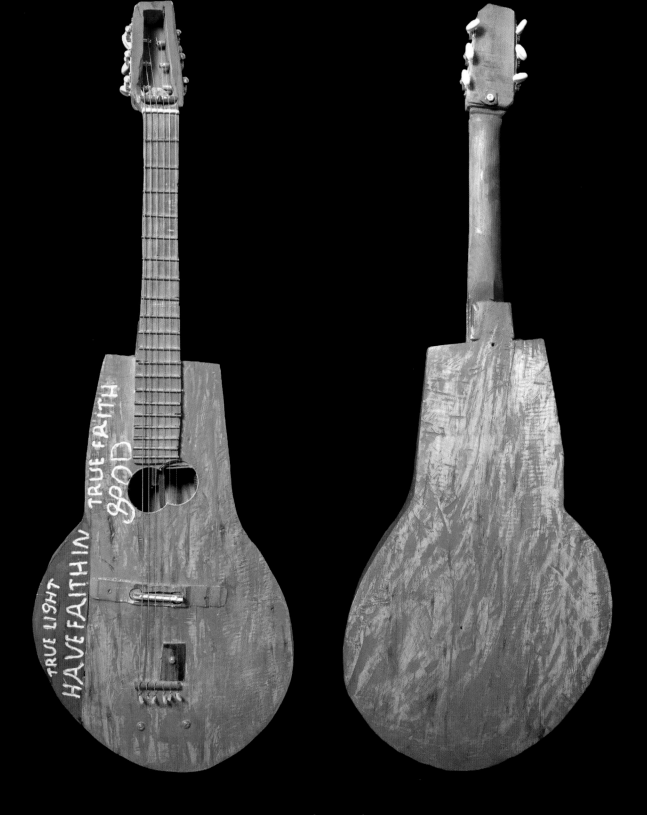

Guitar given to Matthew Rohr.

This one's loaded with personality. Quirky shape with unusual paint job. Apparently Ed used his drawknife on the top and back after the paint had been applied to achieve an attractive faux finish. The absence of a tailpiece with only bridge pins to secure the strings is also unusual.

Photographs by
Kelly Mulhollan.

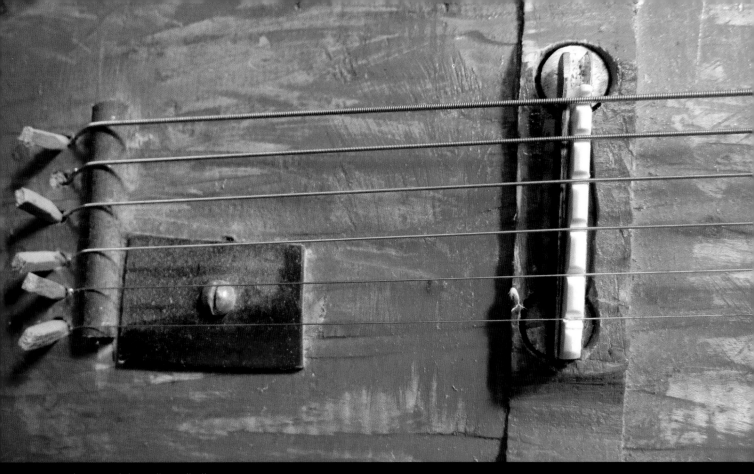

Photograph by Kelly Mulhollan.

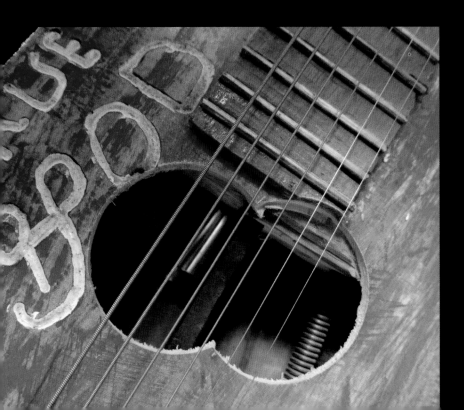

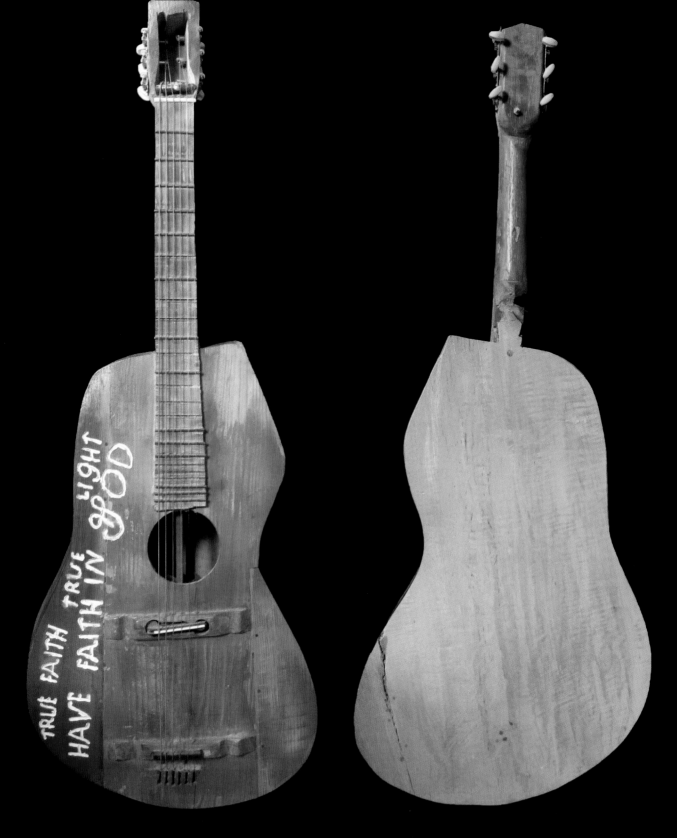

Guitar given to David Rohr.

David is a grandson of Fannie Prickett, who guided Ed's religious development. Strings drop into a slot in the top—another of Ed's unique features. I find the out-of-kilter shape attractive from both the front and the back. There's a saw blade and springs inside.

Photographs by
Kelly Mulhollan.

ED STILLEY'S MIDDLE-PERIOD, CONTINUED

"I felt honored and a little surprised when Ed Stilley presented me with one of his handmade guitars back in 1994. I knew that he usually gave his guitars to children, but I realized that he probably still thought of me as a kid since he had known me all my life. It still reminds me of the many times that Ed would play his guitar and sing hymns for my family. While I appreciate this guitar as a unique work of folk art, on a more personal level it represents the many years of friendship between our families."

DAVID ROHR

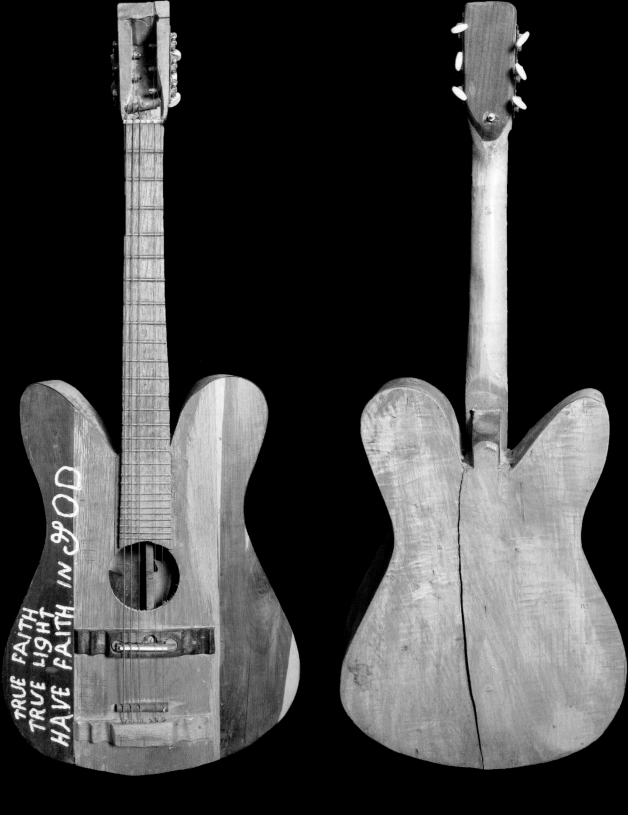

Guitar owned by Andy Miller.

Hints at the butterfly-shaped guitars that Ed would build in later years. Saw blade and door springs inside. Handsome instrument with a top of walnut, oak, and eastern red cedar.

otographs by
lly Mulhollan.

ED STILLEY'S MIDDLE-PERIOD, CONTINUED

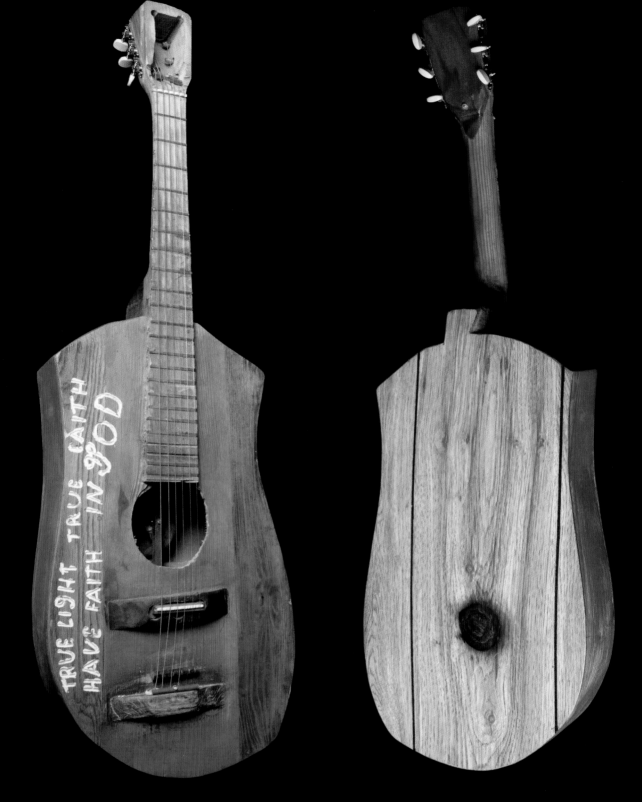

Guitar given to Ann and Bill Caldwell.

X-rays reveal a variation on Ed's internal skeleton. The only heavy object inside is a small chainsaw sprocket, but Ed still gives great attention to completing the metallic loop that was so important to his construction. Body is all oak except for the Masonite paneling back. Thirty-eight and one-half inches in length and 13 inches in width.

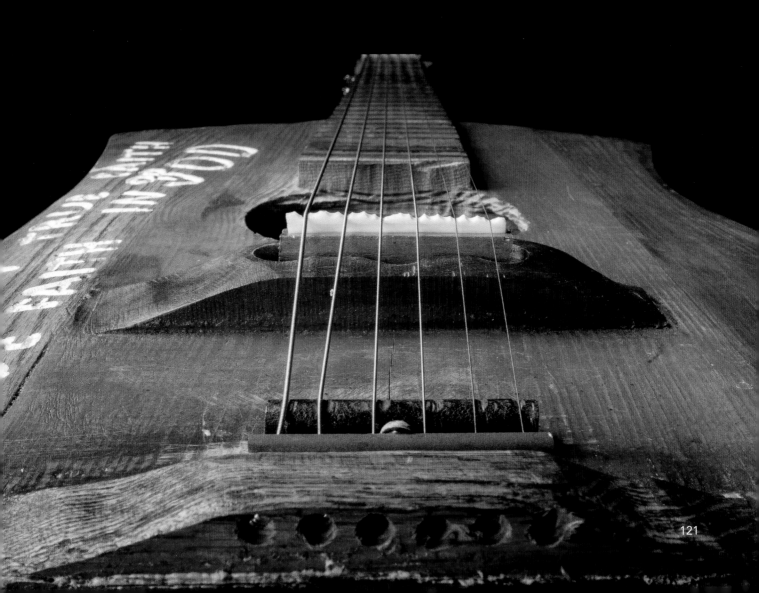

"Well, that's what they say—Ed Stilley's one of a kind."
BILL CALDWELL

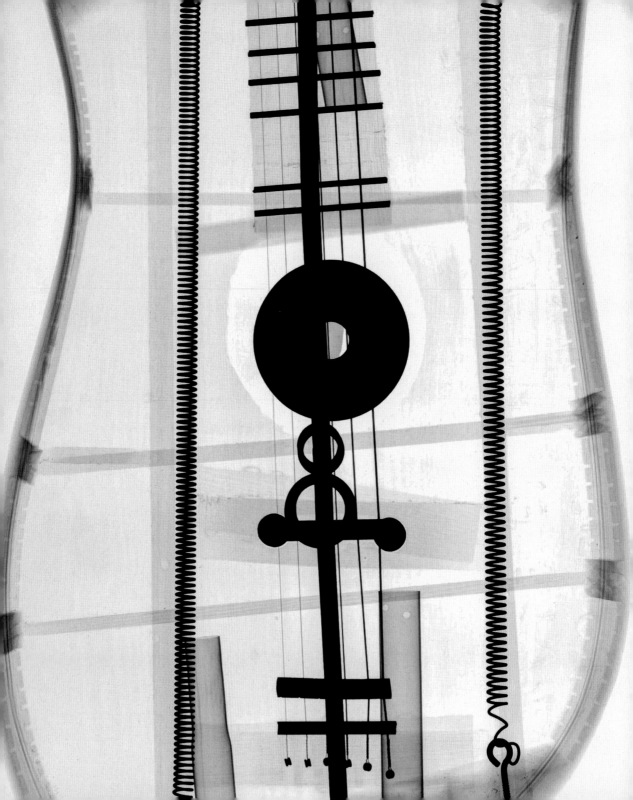

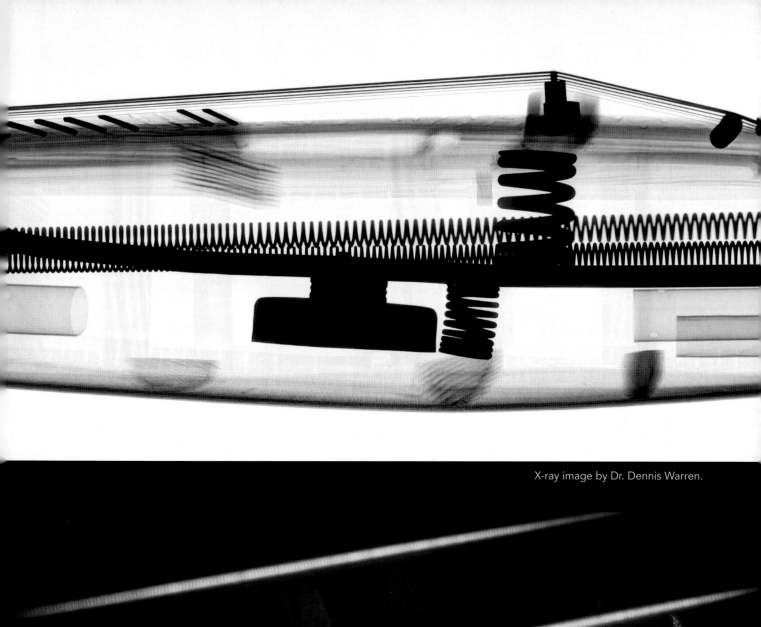

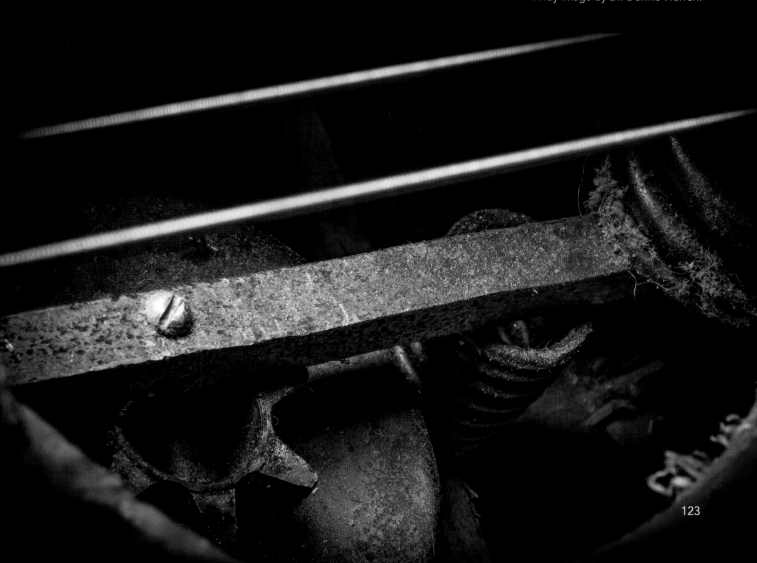

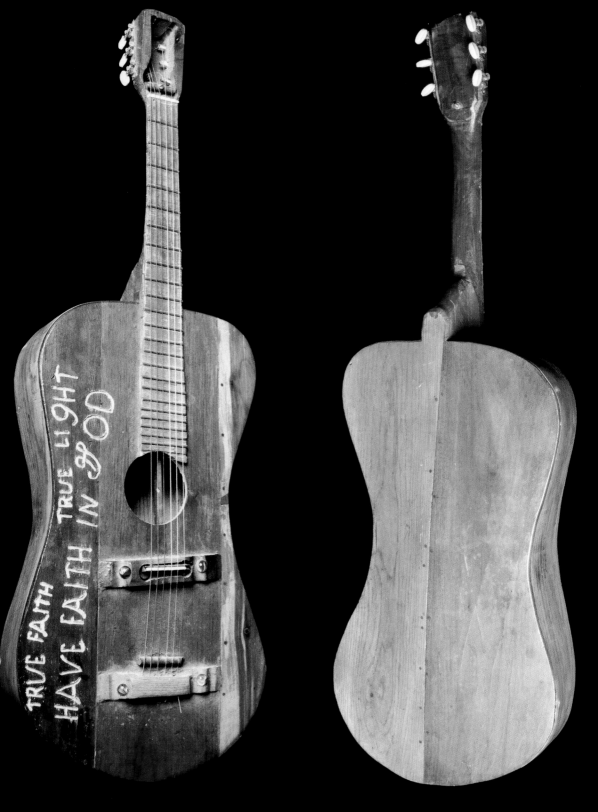

Guitar given to Jonathan Cover, Ed's grandson.

This one has a graceful contour and is a real pleasure to hold. It's the only one of Ed's I've encountered that has nylon strings. Marbles adorn the bridge and tailpiece. Walnut, oak, and eastern red cedar top with a pot lid and a saw blade inside as well as door springs and an echo tube.

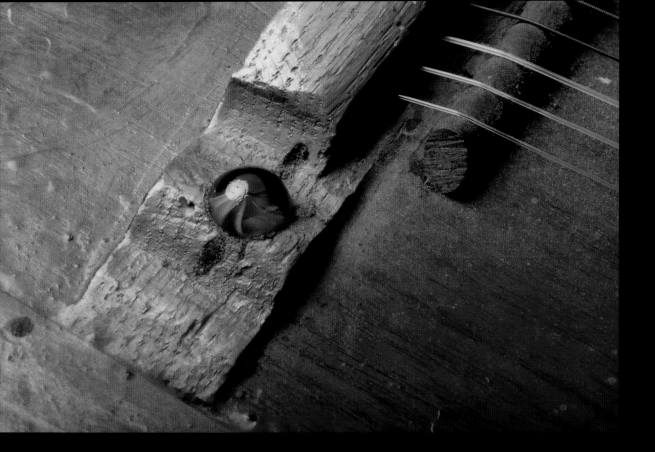

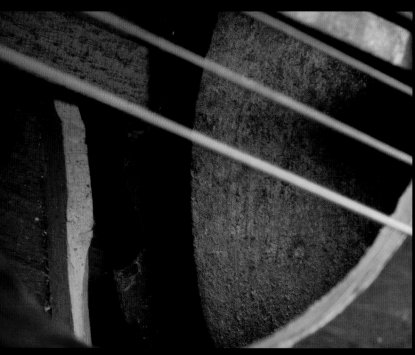

"I'm glad for the opportunities I have had to spend time with and to learn from Grandpa. I'm also very glad to own a guitar that he made."

JONATHAN COVER

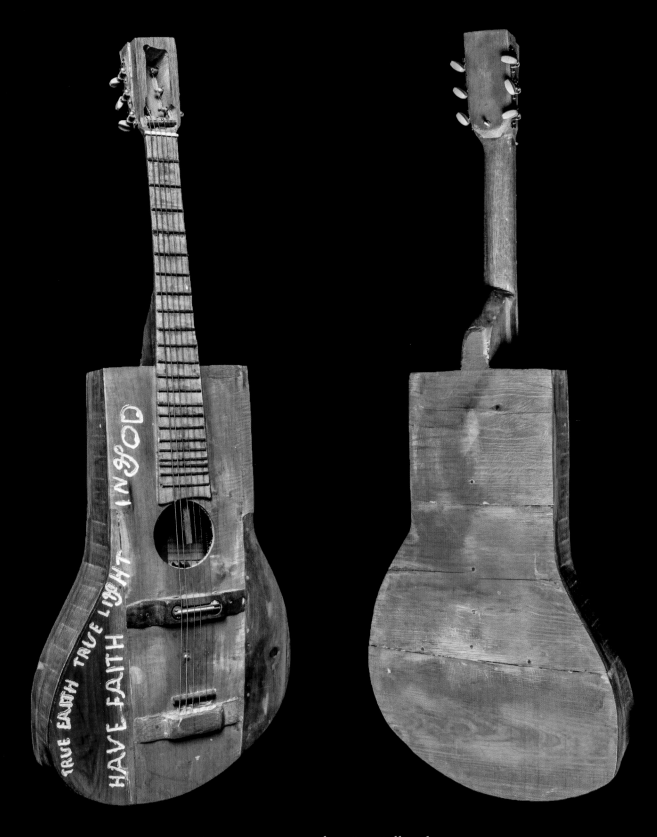

Guitar given to Matthew McCullough.

Truss rod falls short of the internal saw blade so Ed added a chainsaw sprocket suspended under the fingerboard in order to complete the metallic loop. The mix of wood used on the top may not be so random as one might think—this particular mix of walnut, basswood, and eastern red cedar is often found in Ed's creations.

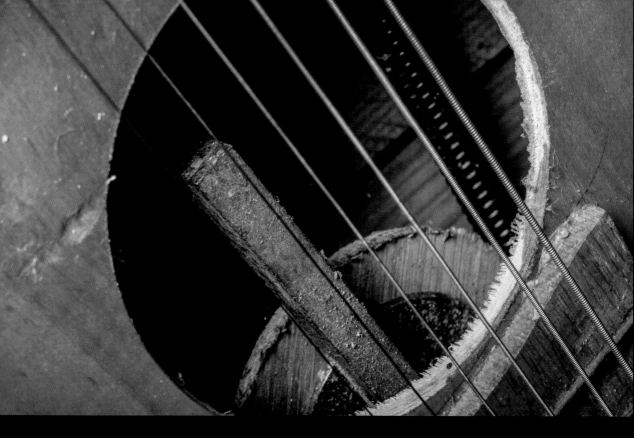

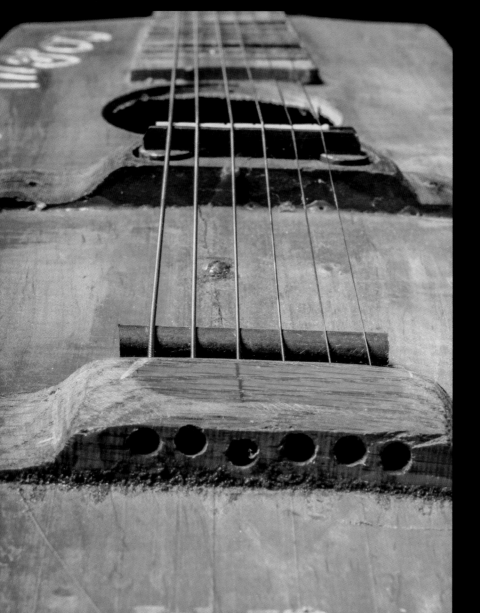

"*They're all made from scratch. We did the best we could.*"

ED STILLEY
(REFERRING TO HIS
COLLABORATION
WITH GOD)

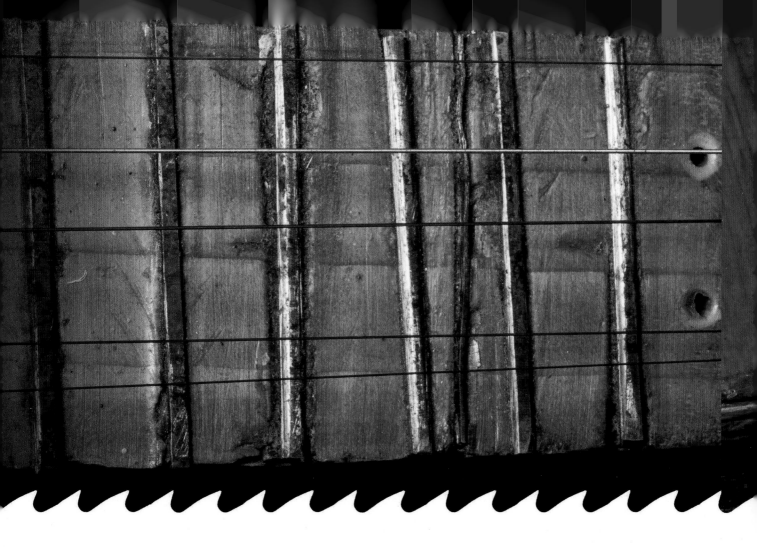

Intonation

Even a quick glance at the fingerboards of Ed's earliest creations reveals something unconventional about his fret placement. The term "higgledy-piggledy" comes to mind. He still had much to learn. Fret work is a complicated task. Every fret must be placed with great accuracy in order for the instrument to intonate properly (play in tune). There is serious math involved in this process, and luthiers have adopted many tricks of the trade over the years to ensure accurate intonation. But Ed wasn't privy to this knowledge. Even though it's pretty technical, I've included the following discussion of intonation because it's so important to understanding how these guitars actually function.

His early attempts to place frets were inaccurate and did not produce a tonality that our ears can recognize. Undeterred, Ed kept searching for solutions and eventually came up with procedures that yielded fairly consistent results. The two fingerboards shown here are good examples of his earliest work. It is not hard to detect irregularities in the fret placement here. His fret work on later instruments is far more accurate and most are, in fact, quite playable.

I watched Ed mark the frets a few times in the late 1990s. By this time he had standardized his procedure. He used a fingerboard from an old "boughten guitar" as a guide. Holding it up against the fingerboard he was working on, he carefully marked each fret position with a pencil. This step requires extreme precision, but Ed managed to get it done

freehand, without the use of a square. It's true that every fret is not exactly perpendicular, but they are certainly in the ballpark. This irregularity is one of the characteristics that give each of Ed's instruments their unique voice.

Traditional guitars use a refined fret wire (a T-shaped wire) with a tang that's driven into a tight slot cut in the neck with a fret saw. Ed never even tried this method. He looked for materials and methods that were within his reach. He would cut slots in the neck for each fret by hand with two hacksaw blades clamped together. Then he used a round file to refine the channel, glued lengths of brazing rods into each slot with super glue, and carefully leveled the brazing rods with a file. Despite his unorthodox procedure, it all worked in the end. The overall scale length is yet another story.

The midpoint of the overall scale length is the key to establishing the tonality our western ears recognize as music. Pythagoras discovered this truth 2500 years ago: that the octave is found at the exact middle of a string's overall length. This midpoint not only produces the octave, but yet another octave above that is known as the harmonic. The harmonic is the chime that's produced by touching the string lightly at the midpoint as you pluck the string—a phenomenon that laid the groundwork for western tonality.

For fretted instruments this all-important midpoint of the scale falls precisely on the twelfth fret, and the twelfth fret is also the exact midpoint between the nut and bridge. When asked about this idea, Ed had no knowledge of it. He did mention that he had noticed a "special quality" that the twelfth fret possessed when he ran a steel slide up and down the neck. Still, it seems that he had no understanding of harmonics or the midpoint concept.

The overall scale length (the distance from the nut to the bridge) must be determined first when designing a fretted instrument. This distance then determines the corresponding placement of the frets. Somehow Ed came to believe that the length between the nut and the bridge should be twenty-five inches and just about every guitar he made had that scale length. By holding a modern fret ruler up to a number of Ed's fingerboards, I found that the exact scale length of that "boughten guitar "fingerboard Ed used as a guide should actually have been $25^{11}/_{32}$ inches long.

As I mentioned, there's serious math involved in fret placement! By whatever means Ed arrived at the twenty-five-inch scale length, it was incorrect and this inaccuracy caused every guitar he constructed to have a scale length eleven thirty-seconds of an inch short of what it should have been. This error results in every fret playing just a bit sharp, and the sharpness becomes progressively more pronounced as you move up the fret board. Still,

Midpoint of a string's length defines placement of twelfth fret. Ed never learned this fact but still managed to create instruments that played within tolerable limits. Drawing by Kelly Mulhollan.

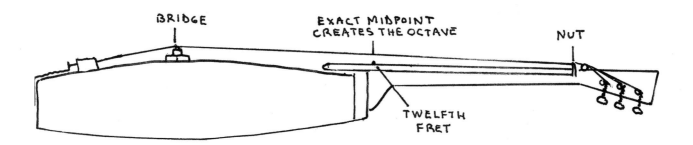

INTONATION

it's pretty close and many of Ed's instruments play quite nicely up through the seventh or eighth fret. Beyond that, it becomes a bit iffy.

You might wonder how Ed even tuned his instruments to pitch. The Stilleys did have a piano, but he says he didn't use it to establish pitch. Rather, he would just tune the strings up and down using his ear to find that magic place where all the notes blended properly.

Contemporary musicians have come to expect near perfect intonation from the instruments they play, but this degree of perfection hasn't always been available. Around the year 1700 the concept of equal temperament (where the octave scale is divided into equal parts) began to emerge in Europe and standardized our concept of what is in tune and out of tune forever. What we left behind was a lot more colorful. Before equal temperament, every key signature possessed a distinct personality all its own, and musicians of the day relished the resulting tonal irregularities that would seem out of tune to our modern ears. I believe Ed was more of that world.

This period might better be called Ed's Red Period. He had settled on a finish coat of red barn paint for almost every creation. He also seems to have finalized a design concept for the basic internal skeleton. Later instruments utilize a fairly consistent configuration that includes a circular saw blade, a pair of door springs, and an aluminum echo tube. The shapes of the instruments themselves are as varied as ever with ever more dramatic proportions.

Ed Stilley's Late-Period Instruments

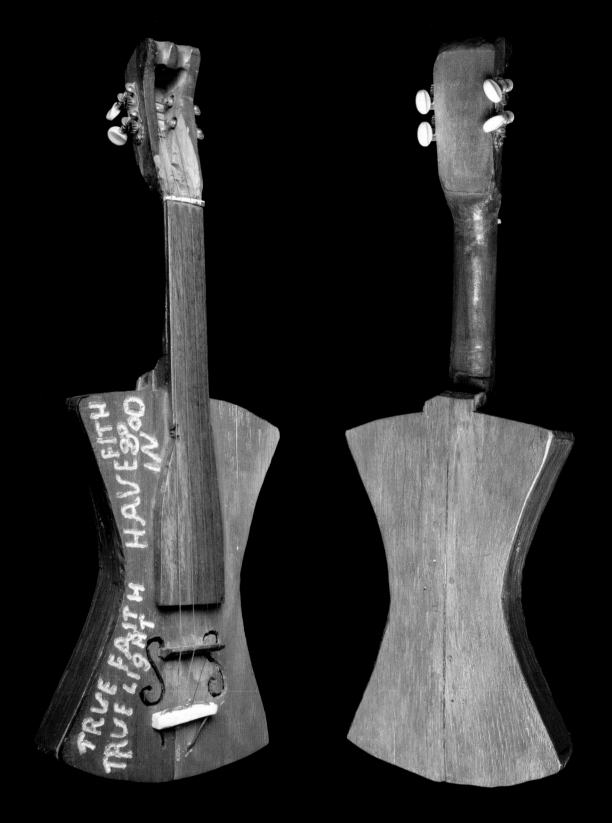

Fiddle given to Gabriel Hope Bass, Ed's granddaughter.

Gabriel enjoyed helping Ed in his shop and remembers cutting the f-holes on this very instrument. She accidently sawed too far so Ed removed that half of the top and replaced it with another piece. The only metallic component is a lone door spring. Note the fine carving on the peghead. Light and delicate instrument with two-piece top of walnut and oak.

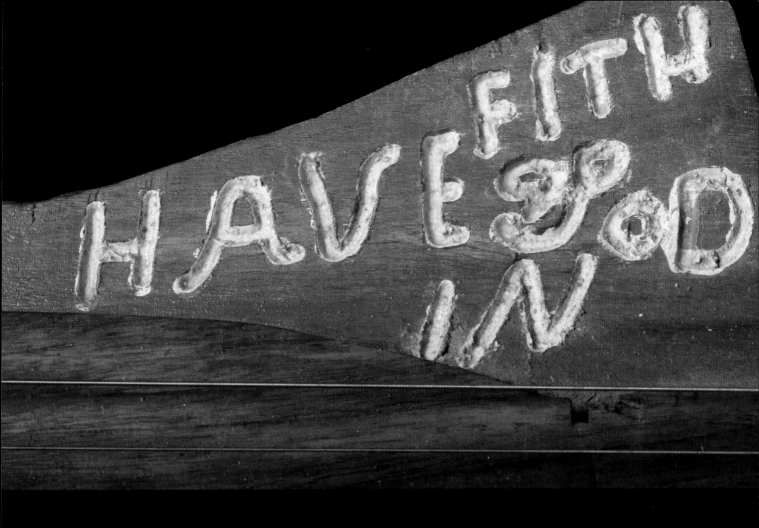

"*The best part was when he brought me my bow.
It was made out of a cow's tail, a curved stick and
electrical tape. I don't have it anymore.*"

GABRIEL HOPE BASS

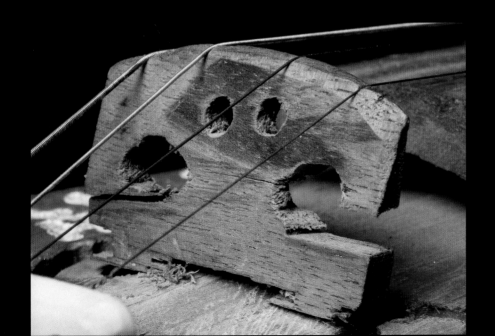

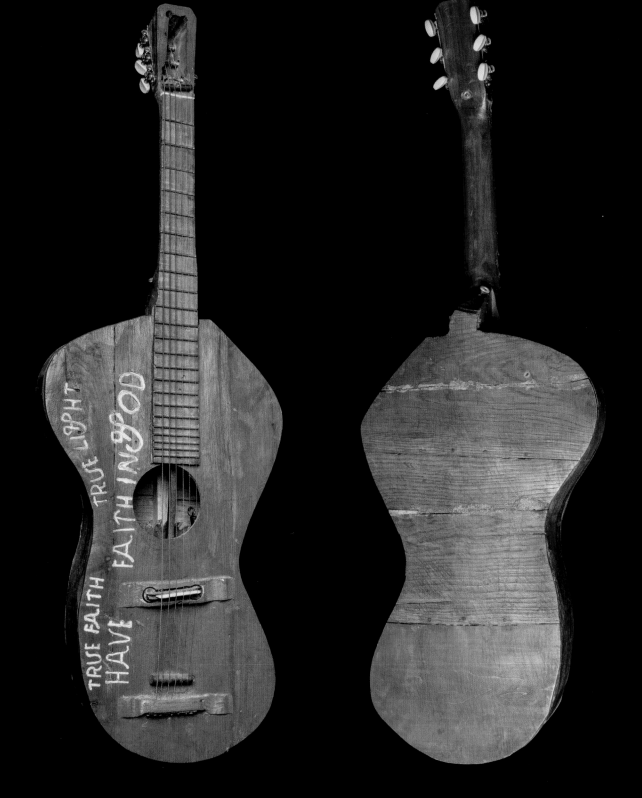

Guitar given to Sarah Cover, Ed's granddaughter.

Among the most asymmetrical of Ed's shapes I've come across and one of my favorites. Demonstrates how Ed used the wood's willingness to bend as his guide to creating shape. Saw blade and door springs inside. Three-piece top made of walnut, oak, and cedar. Back is basswood and the neck is walnut.

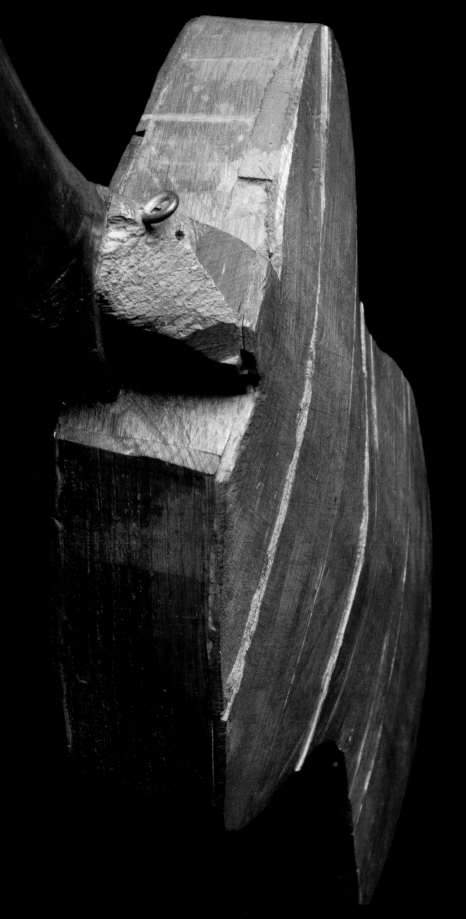

"Grandpa knows how to keep a secret! He can do things that are an absolute mystery as to how he accomplished it! One of the things that still puzzles us today is how he built a high tire swing without any assistance when he could not even walk without walking sticks to aid him. I love my grandpa, like he always says in his own words, 'You can't hide true love.'"

SARAH COVER

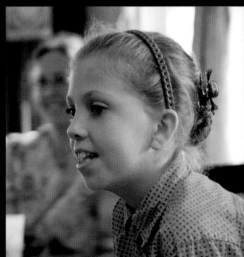

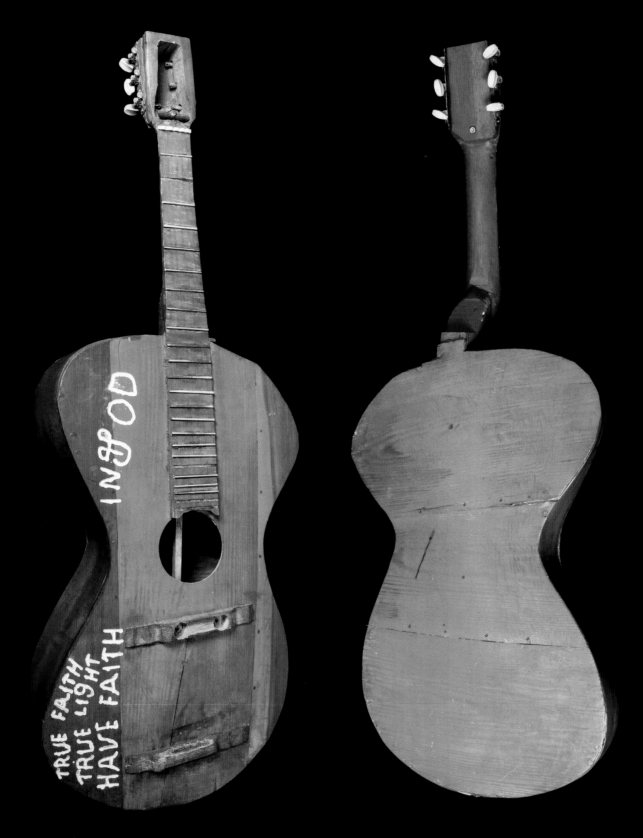

Guitar given to Valerie Cover, Ed's granddaughter.

Possibly the most shapely of Ed's instruments. I love the exaggerated curvatures that abound on every surface—an almost "cartoonish" profile. I have plans to bring this one back to playability, and I bet it will be a fine-sounding instrument. Pot lid and springs inside. Top of walnut, oak, and eastern red cedar.

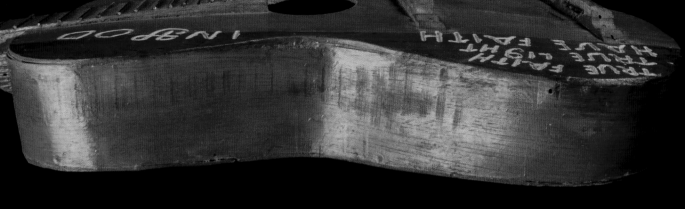

"I have a favorite memory of playing piano with Grandpa. I was eleven and we made a tape . . . I think it was 'Jesus Loves Me.'"
VALERIE COVER

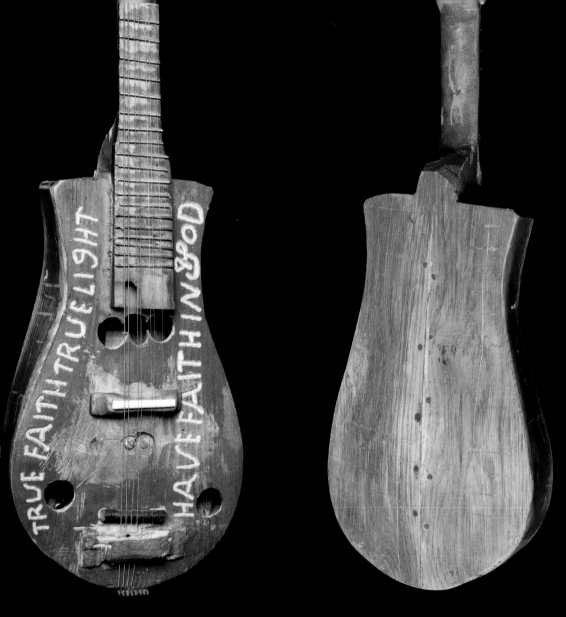

Mandolin given to Stephanie Stilley, Ed's granddaughter.

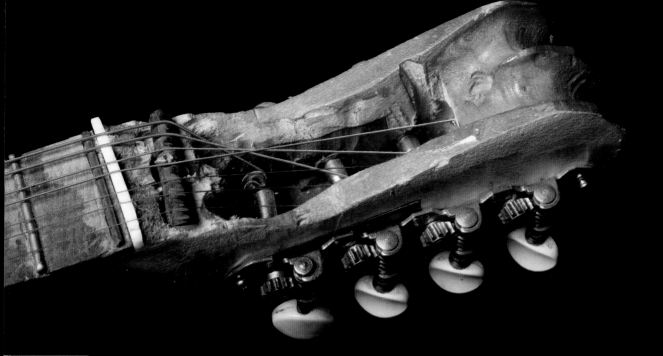

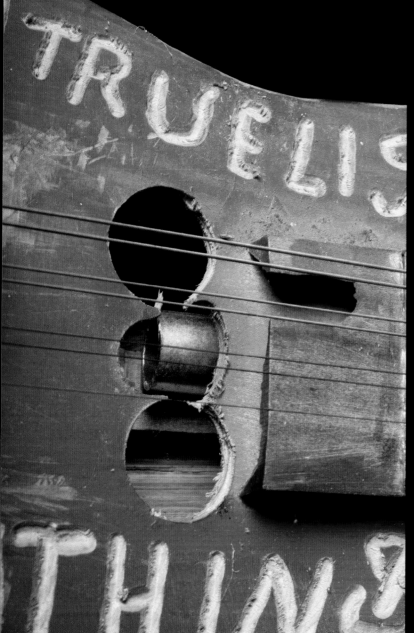

"*The thing is that there's a lot of people that do a lot of nice things like what my Grandpa did and never get acknowledged. I'm not saying it's right or wrong—that's just the way it is.*"

STEPHANIE STILLEY

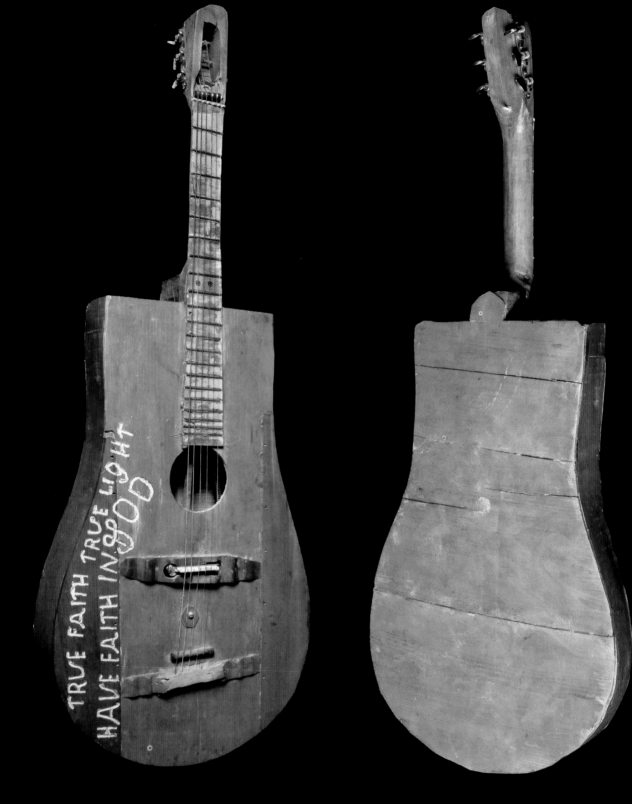

Guitar given to Valerie Thompson.

Ed built several big-bodied instruments with this basic shape. Metallic innards include a saw blade, door springs, and an echo tube. The edges of the top and back were starting to separate but I was able to re-glue them. Top is mostly pine surrounded by walnut and eastern red cedar.

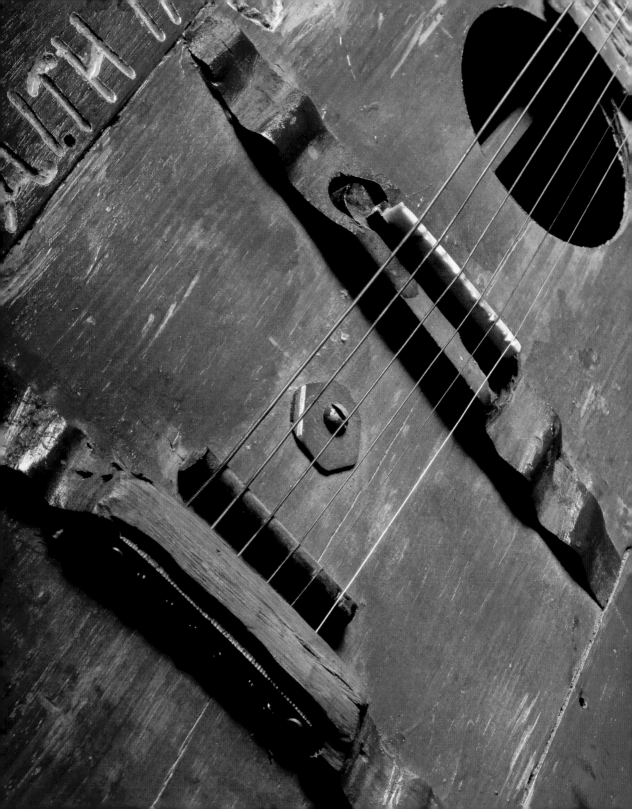

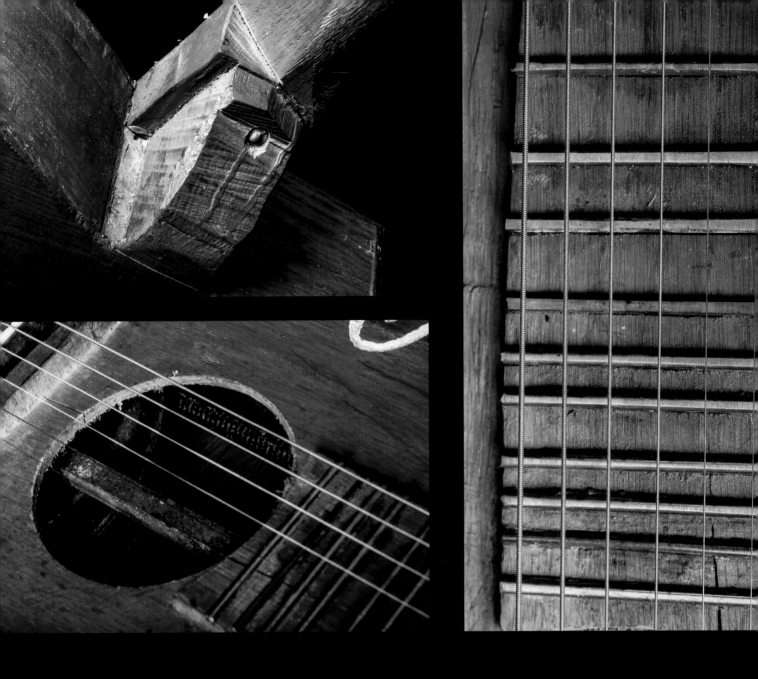

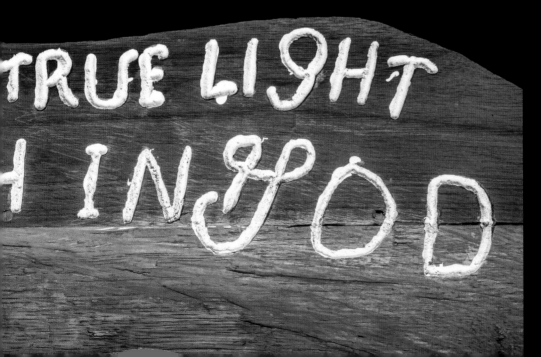

"I wanted to hear Ed play. That's all I can remember as a little kid. And I remember him going inside and asking Grandma for a glass, and he used it as a slide. And that's what I remembered being the coolest thing, the sound he made with that kitchen glass on his guitar."

MATTHEW REUTER

145

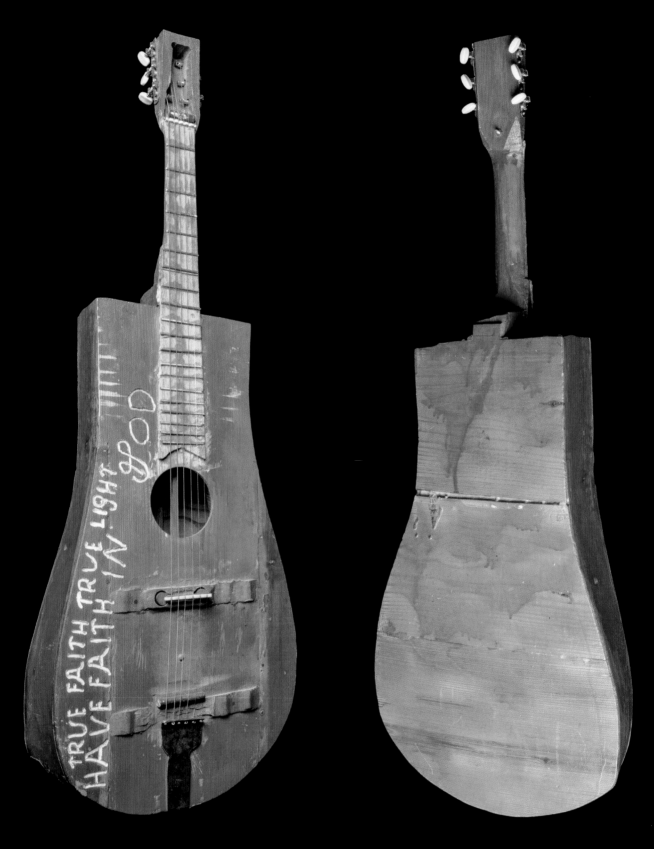

Guitar given to Eliza Stilley, Ed's wife.

Has some of Ed's most refined features such as the steel tailpiece. Lighter weight than most despite its formidable size. Pot lid and door springs inside. Top is walnut, oak, and eastern red cedar. Sides are walnut and the back is pine.

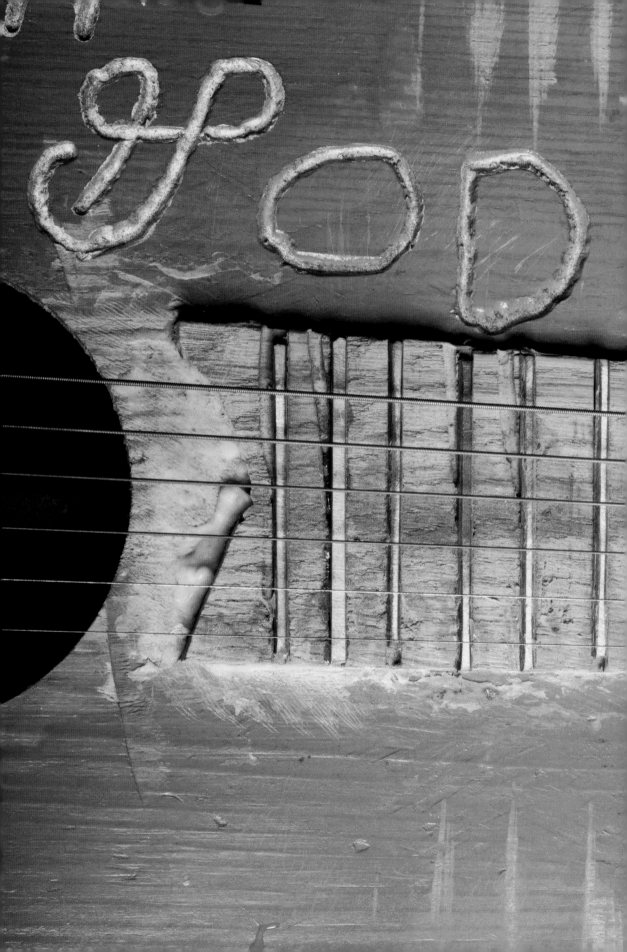

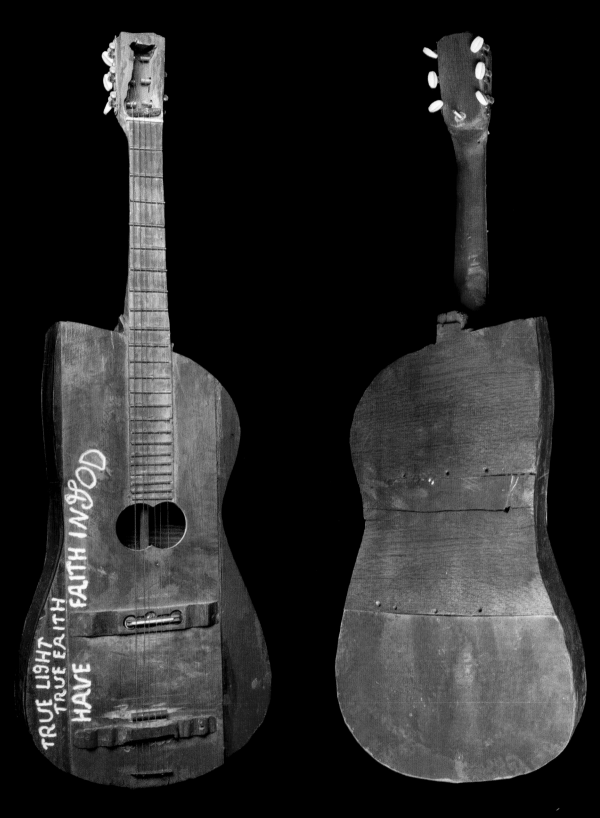

Guitar given to Roscoe Van Jones.

This one has jet age styling. Roscoe had a music store in Eureka Springs and sold Ed strings and tuners for years. The glued tailpiece had failed and split into pieces. I had no choice but to add a steel tailpiece to hold the tension—a modification I have observed Ed utilize on several instruments when the wood tailpiece failed. I tried my best to mimic Ed's

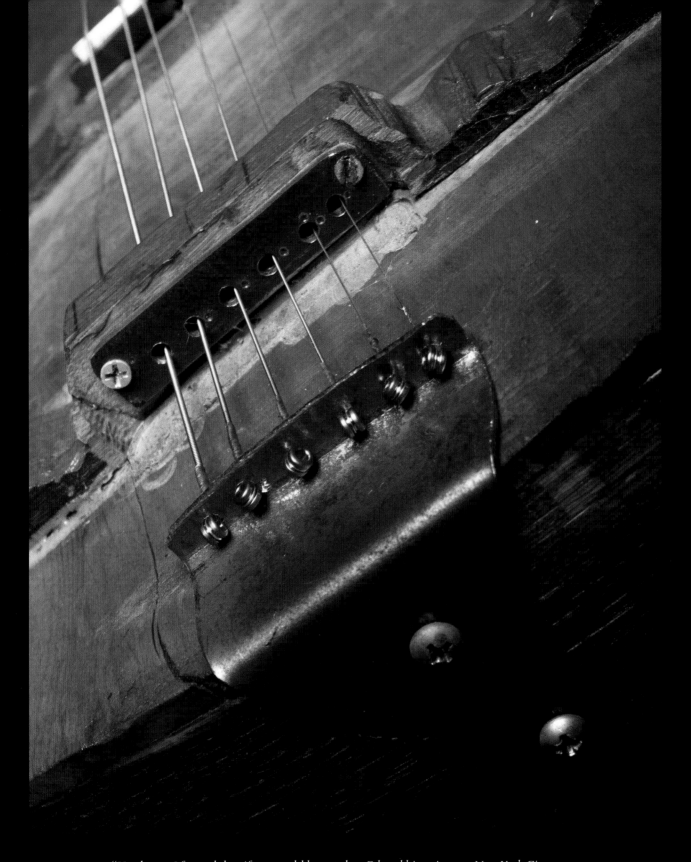

"You know, I figured that if you could have taken Ed and his guitars to New York City, you'd probably come back with a big fat pile of dough: cause if this isn't the essence of folk art then I don't know what is."

ROSCOE VAN JONES

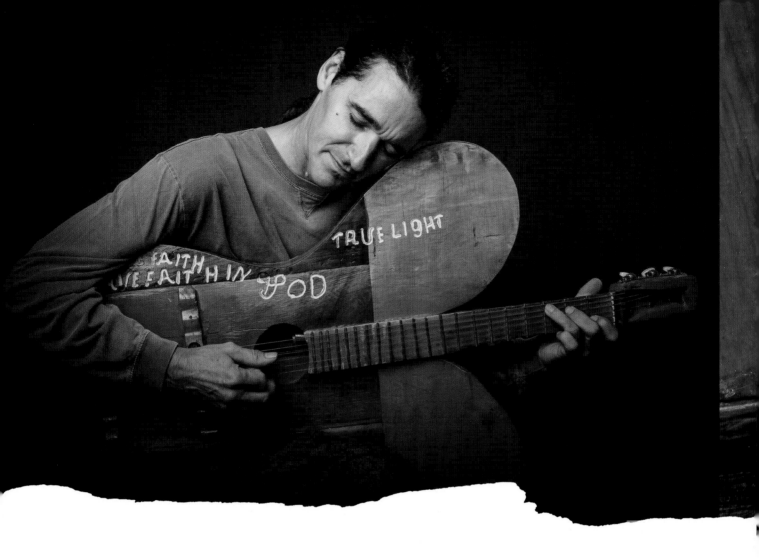

Folks often ask me, "But do Ed's guitars sound good?"

That's a simple question with a complex answer. Each instrument is different in so many ways that no two sound alike. The fret work is fairly rough so they don't intonate accurately, but the intonation is in the ballpark, and a clever player can make the best of it. The metallic objects inside create an ethereal reverb that is beyond that of any conventional instrument. The action is rough but most players can deal with that as well. Virtually everyone who grabs hold of one of Ed's creations can hardly let it go. Each instrument has a mysterious charm that wins folks over in the end.

When I hold one of Ed's instruments in my arms and feel it resonate against my body, it's better than good. I can easily get lost in the odd blend of texture and tone that drifts from the nooks and crannies of each metal-laden chamber. The unsteady intonation steers me away from some chords, but invites others. If I just allow the instrument to take me where it wants to go, it whisks me away on a unique musical journey.

So do they sound good? Yes, they sound good! And as Ed's son, Stephen Stilley, once remarked, "It's not about perfection. That's not what it's about."

Ed's own words complete that thought—"I've had different folks ask me, 'Do you think these things will be played in Heaven?' But I said, I'll tell you this—I read the Book of Revelations where it said that the kings would bring all their glory and honor into that city. If this is the glory of God, in honor of him there'd be some of 'em brought in there."

CHAPTER 14

But Do They Sound Good?

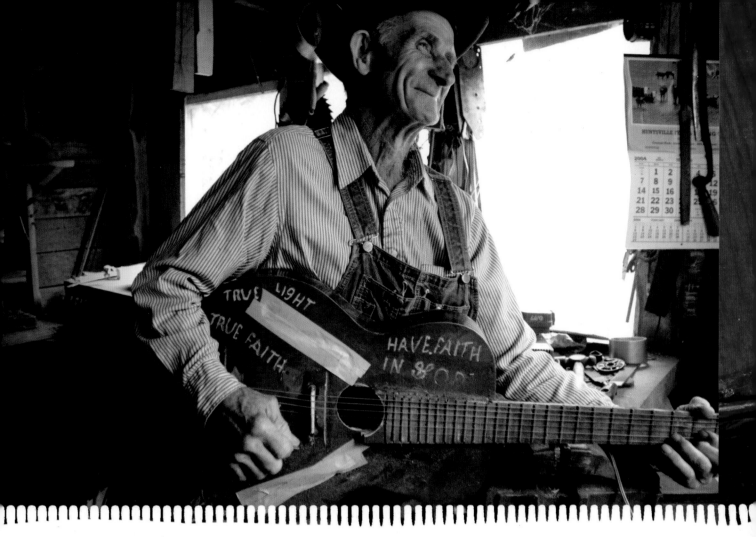

More red! Ed made good use of that barn paint. These are all good players and structurally sound. These later years saw the birth of the dramatic butterfly shaped instruments—among his finest creations.

Ed Stilley's Late-Period Instruments, Continued

Photograph by Russell Cothren.

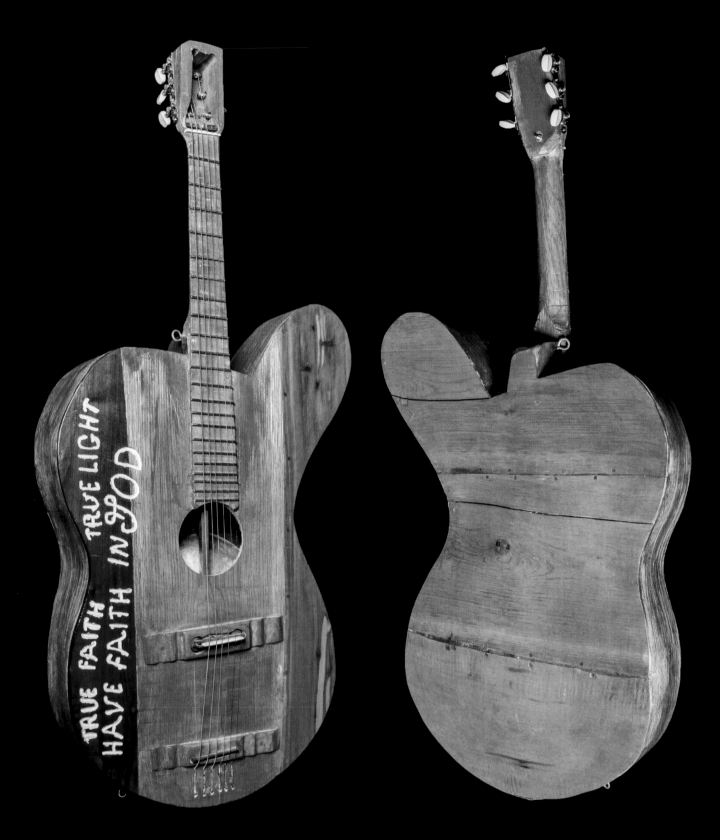

Guitar given to Darren McCullough.

Magnificent "half butterfly" shaped instrument—one of Ed's finest creations. Darren hangs it on the wall in his office, and it's much admired by his clients. Pot lid and spring arrangement inside is revealed in the X-ray images. Very well constructed of walnut, oak, and eastern red cedar.

ED STILLEY'S LATE-PERIOD, CONTINUED

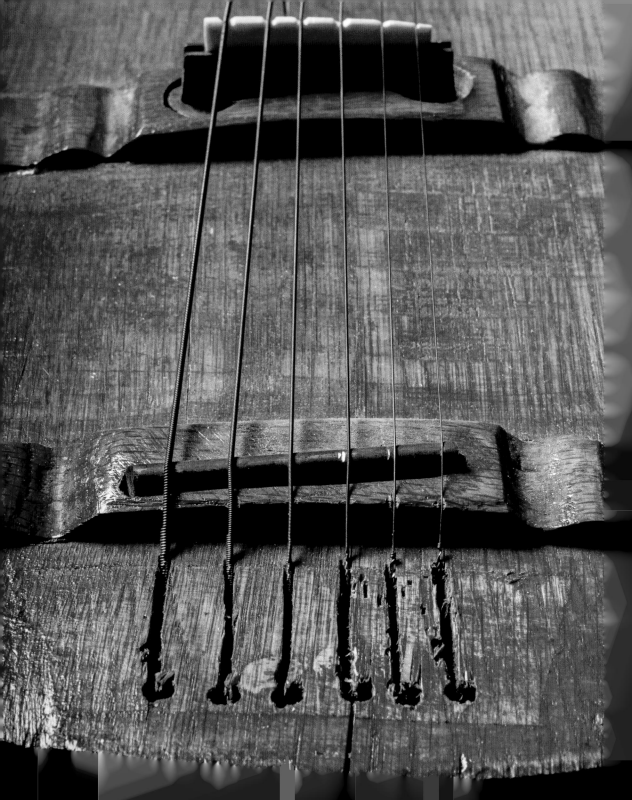

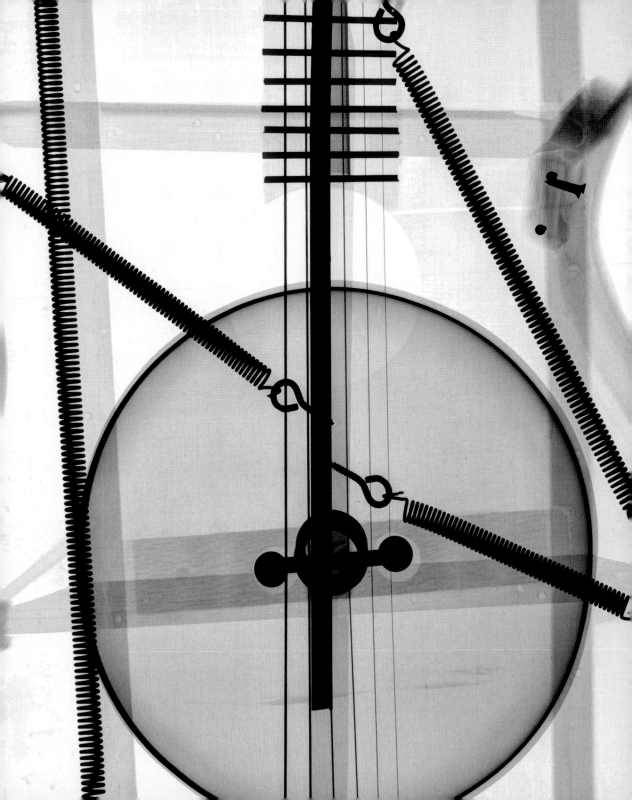

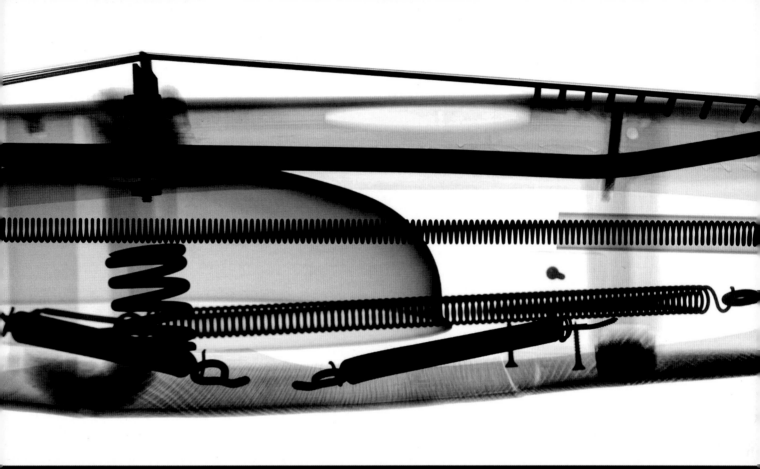

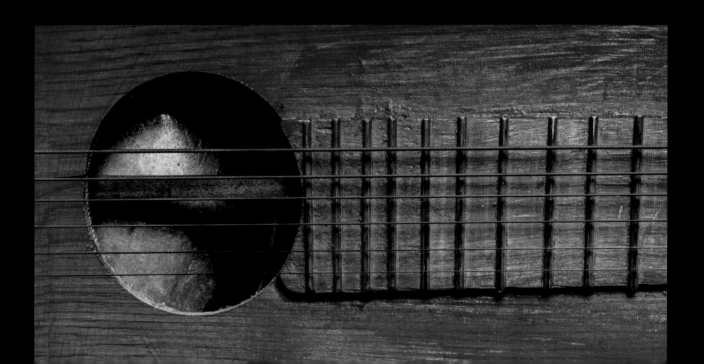

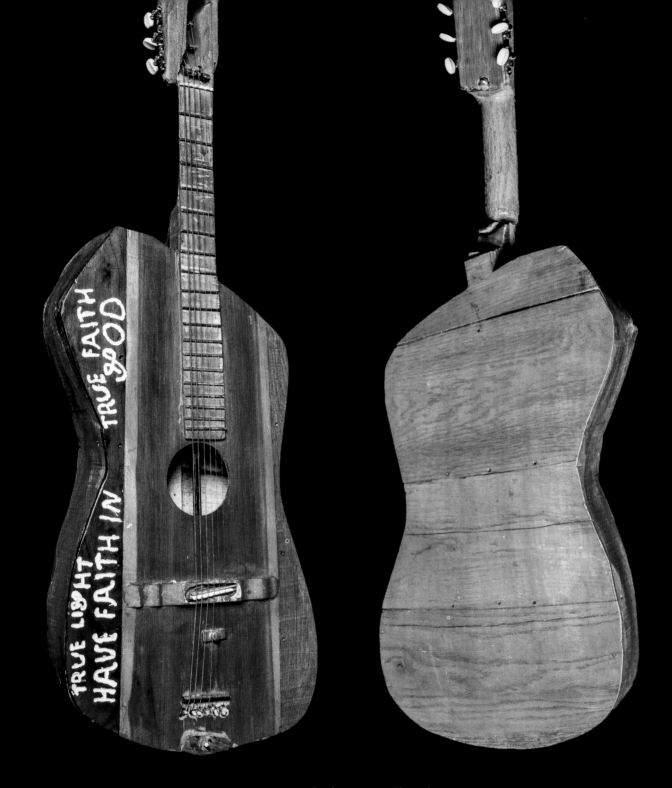

Guitar given to Shirley McCullough.

It's hard for me to fathom exactly what caused Ed to mount the steel tailpiece below the top. The bridge pins are actually inserted into the submerged tailpiece. Heavier than most, this one weighs in at 10.4 pounds. Top made of a handsome mix of walnut, eastern red

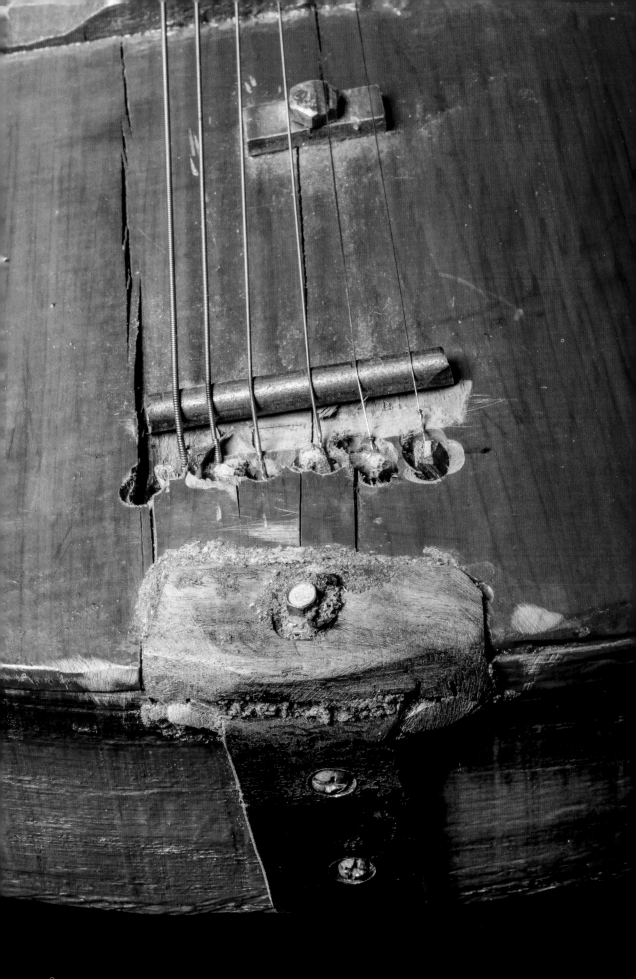

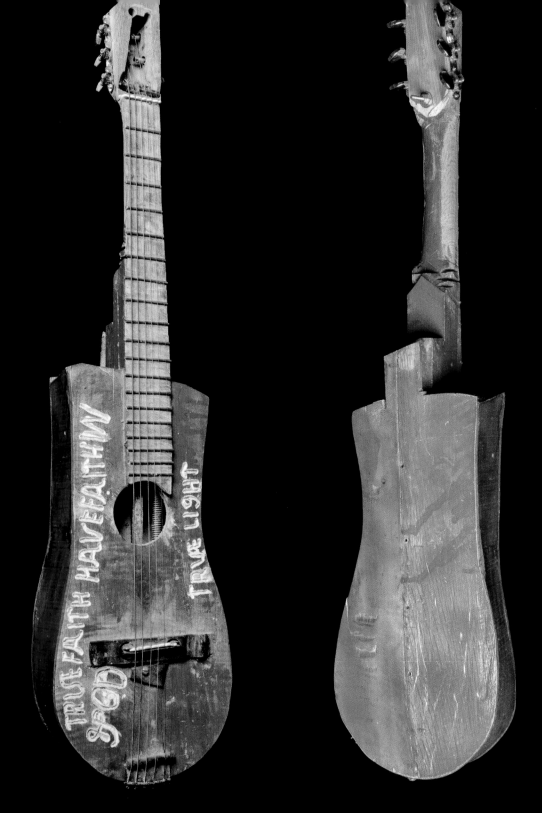

Guitar given to Joel Cover, Ed's grandson.

Diminutive proportions but surprisingly heavy for its size with stout saw blade and coil springs inside. Great sound for such a tiny thing. I love the jagged heel joint. Ed saw no need to refine such features. Constructed of white and black oak.

ED STILLEY'S LATE-PERIOD, CONTINUED

"Grandpa's guitars are unique and I'm happy I've got one of 'em!"

JOEL COVER

161

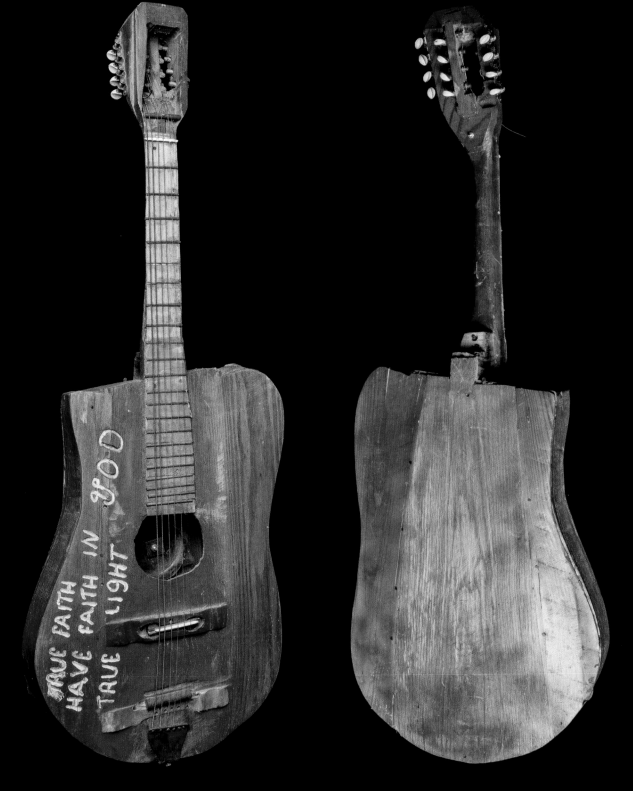

Twelve-string guitar owned by the Stilleys.

Illustrates Ed's uncanny ability to think outside the box. I imagine this is the only twelve string ever made with three rows of four tuners (as opposed to two rows of six). Chainsaw sprocket and a complex spring arrangement inside but no saw blade or pot lid. The string attachment seems to have gone through a couple of incarnations before Ed settled on a six-string steel tailpiece. Top is made of pine, and white oak.

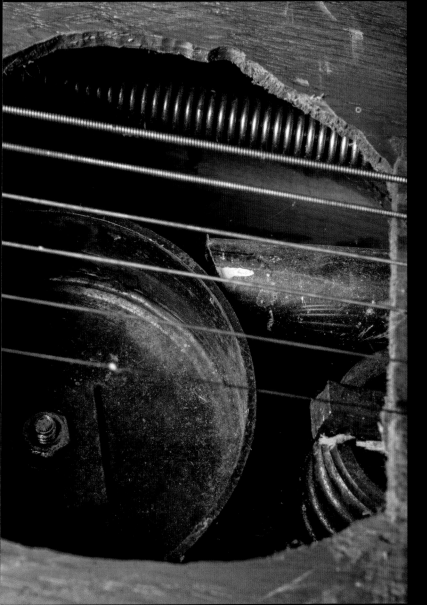
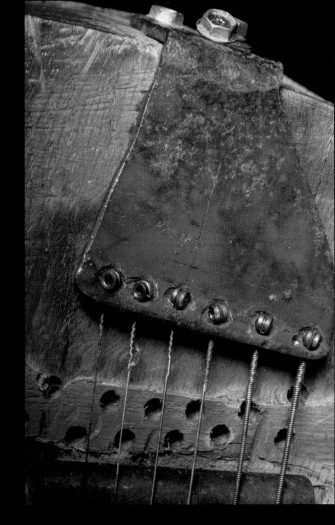

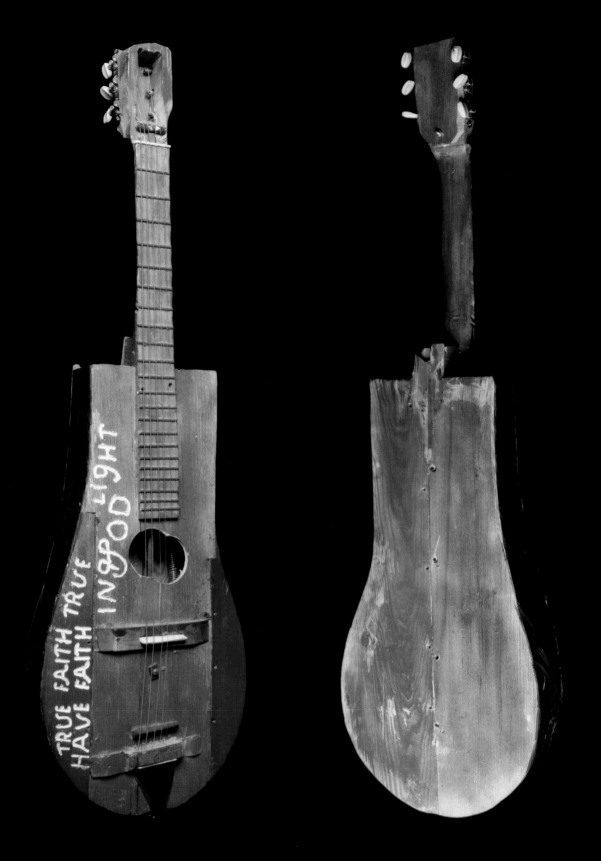

Guitar given to Samuel Robinson.

Sam was very young, maybe five years old, when he received this guitar. It's heavy for its size and is fitted with a steel tailpiece, typical of Ed's very late creations. Top is pine, oak, and eastern red cedar and the back is pine and basswood.

"I thought it was cool that 'Still on the Hill' played music at my school with some of Uncle Ed's 'music boxes.' It made me feel special that I had one of my own."

SAMUEL ROBINSON

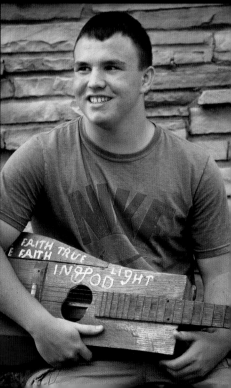

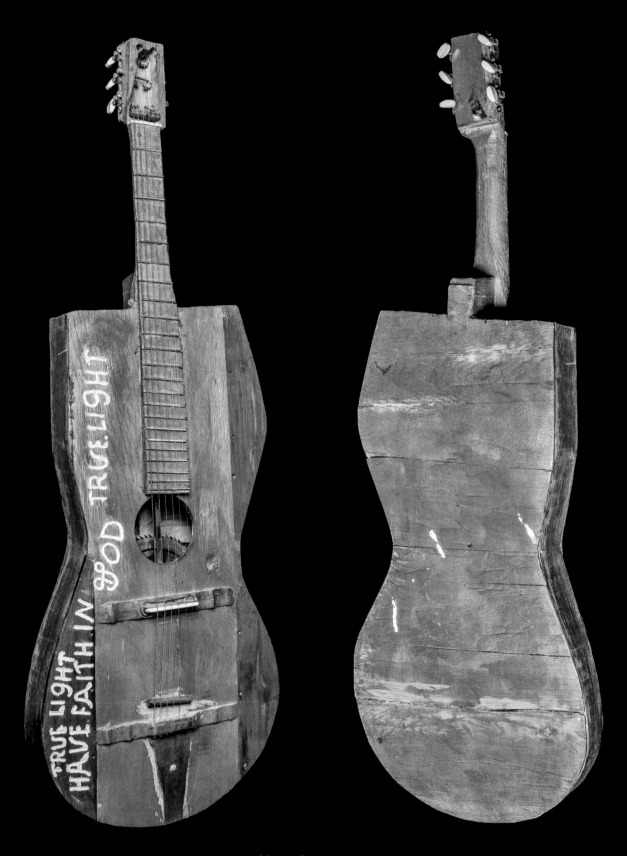

Guitar owned by Whitney Capps.

Big chunky instrument with an exceptionally long torso that extends halfway down the fingerboard. There's a saw blade, springs, and echo tube inside. This is the only instrument I've ever seen with a copper tailpiece. Top is made from oak, eastern red cedar, and walnut.

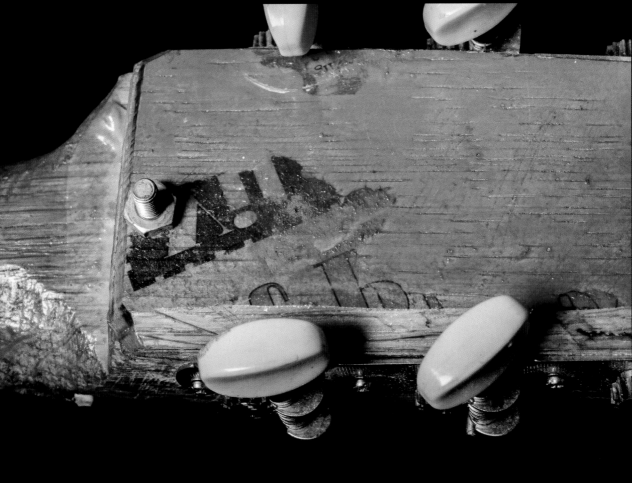

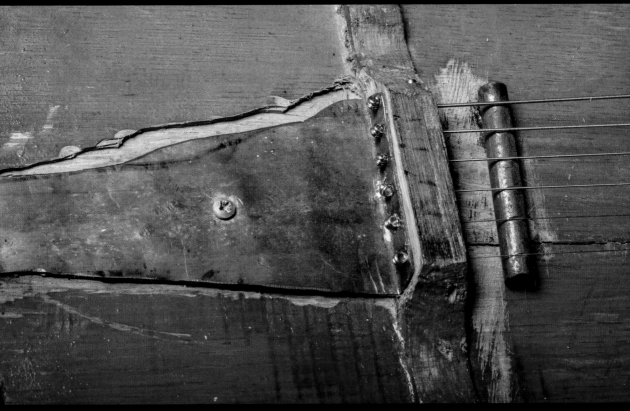

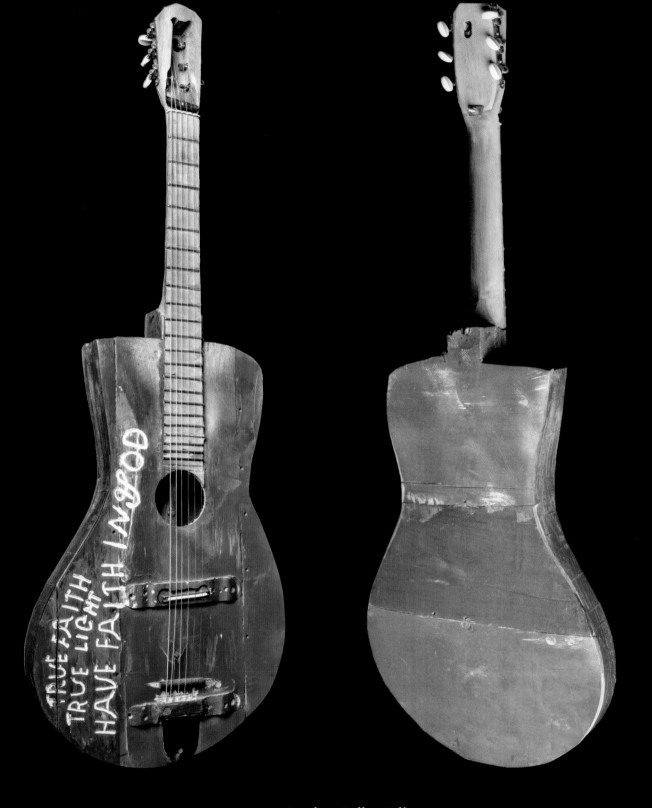

Guitar given to Stephen Stilley, Ed's son.

One of the best sounding guitars Ed built, and Stephen is a good player, so it is in good hands. Handsome shape includes all the innovations Ed utilized in his later period. Notice the access hole on the backside of the peghead. A nice touch! Saw blade, door springs, and an echo tube inside. Top is walnut and basswood.

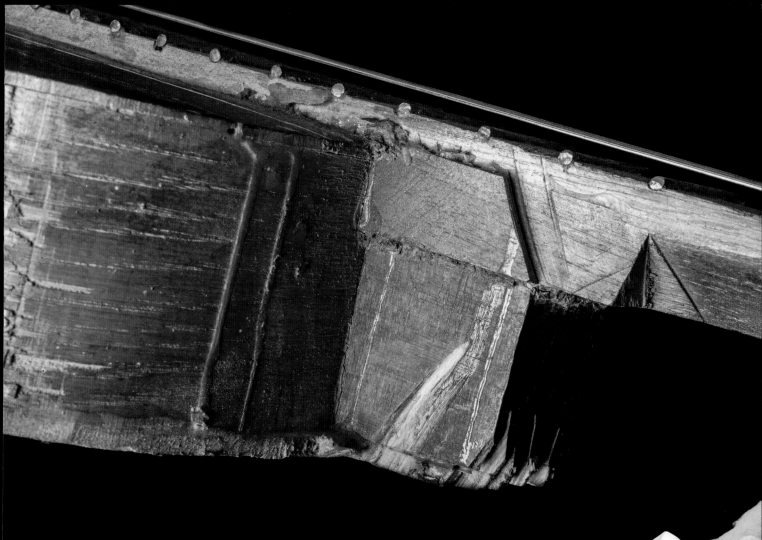

"*They're all so different, and yet they are so much the same. They're so much the same that you could not possibly see one of these and not know immediately that that's what it was.*"

STEPHEN STILLEY

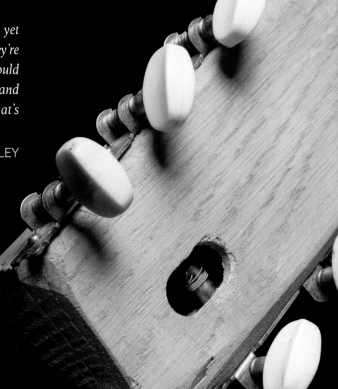

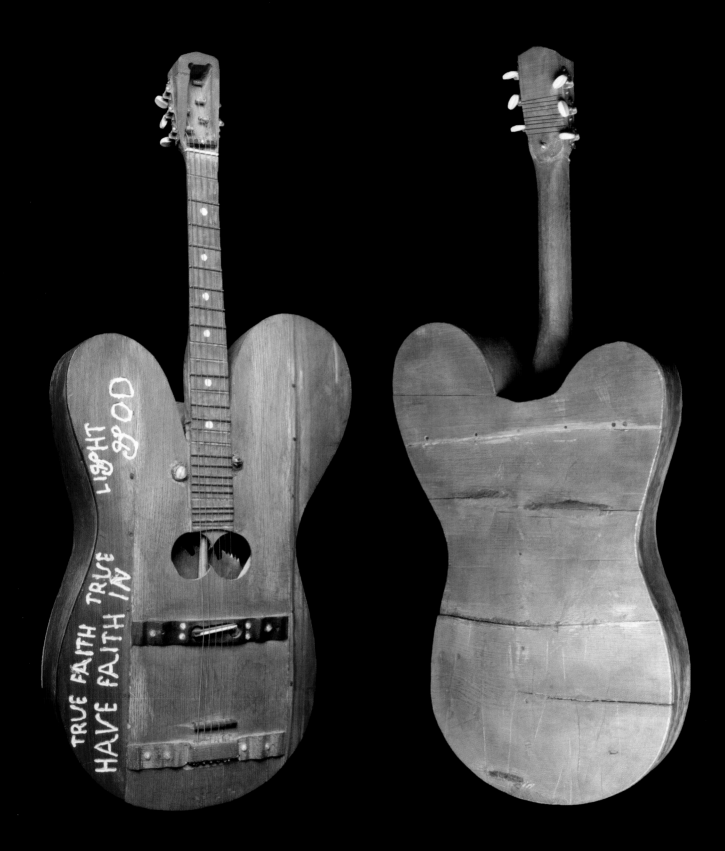

Guitar given to Bethany Miller.

Fine example of the butterfly family of Ed's guitars. A splendid creation with dramatic proportions and a fine sound. Saw blade, springs, and an echo tube reside inside. Marbles and tiny plastic jewels adorn the top of oak, walnut, and pine.

ED STILLEY'S LATE-PERIOD, CONTINUED

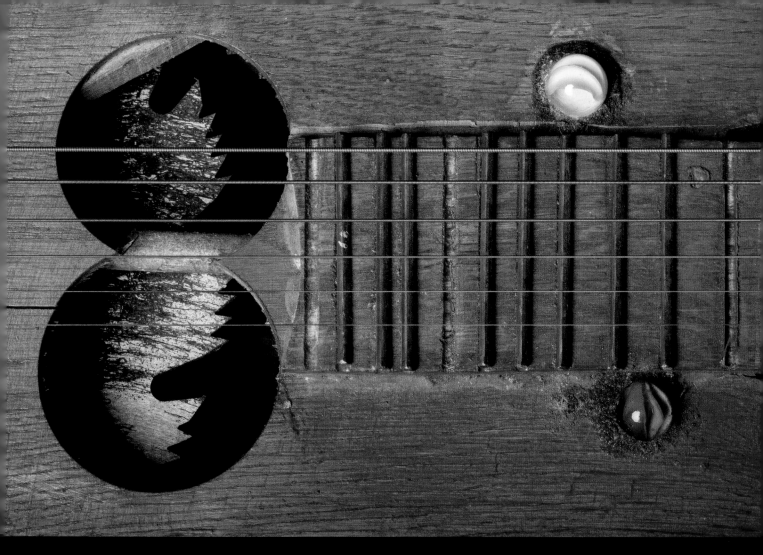

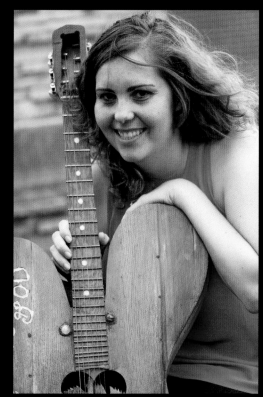

"As a young girl, the youngest of eight, I remember seeing all my siblings' instruments from Uncle Ed and thinking how neat and unique they were. I had been told for years that all the cousins got one from him, but the older I got, the more concerned I was that I'd been forgotten. The day Uncle Ed brought mine, I felt special, honored, and a bit silly that I had ever been worried."

BETHANY MILLER

There's a wonderful assortment of unfinished projects gathering dust in Ed's shop. Each one of these was well on its way to completion but got shelved for one reason or another. I'm quite fond of all of them and felt like they deserved a place in the book.

CHAPTER 16

Unfinished Work

Photograph by Russell Cothren.

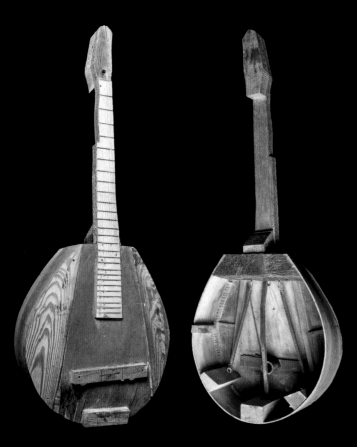

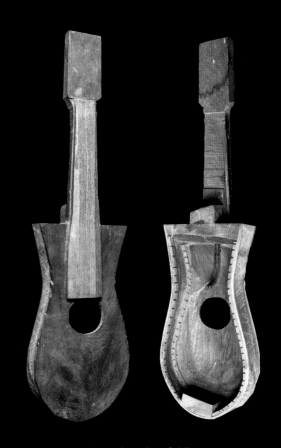

The only one of Ed's banjos I know of with a fifth-string notch—I feel certain that a saw blade was to be added to the metallic mix seen in the open back.

An early walnut fiddle.

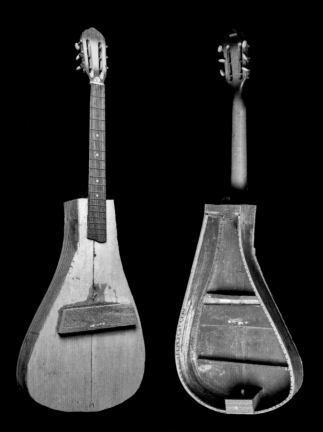

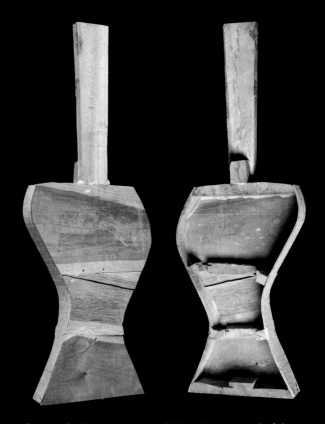

Guitar incorporating a factory-made neck.

Unfinished fiddle—Picasso would have been proud of this one.

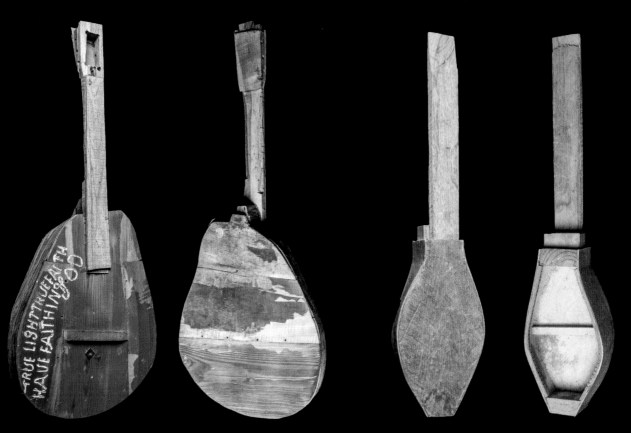

Nearly completed guitar.

Very early instrument.

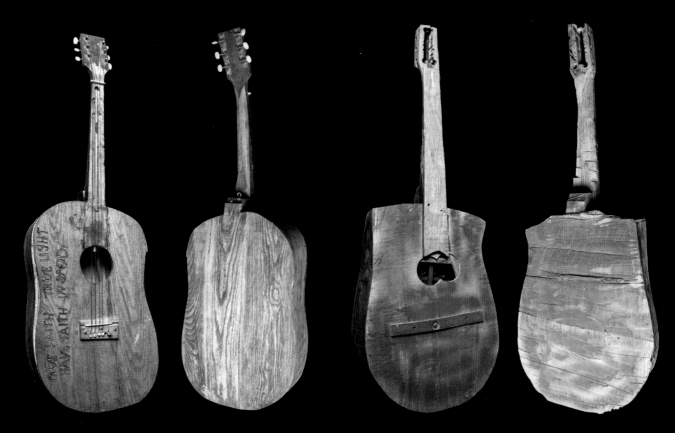

Early guitar with structural problems.

Elegant tulip shaped guitar.

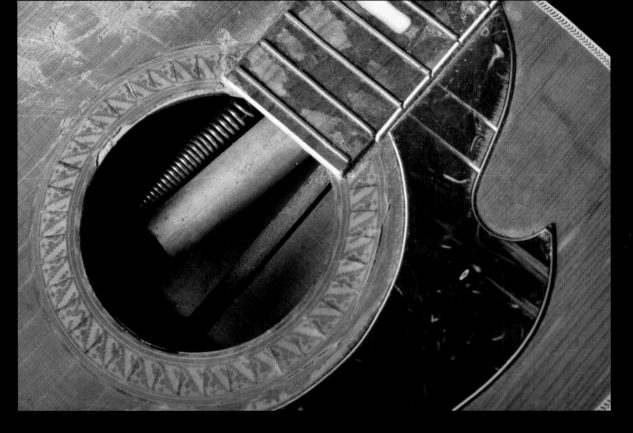

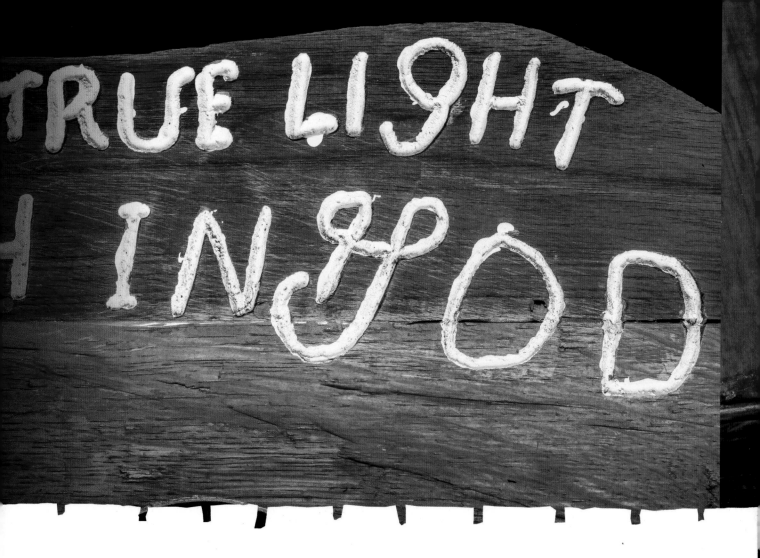

The Final Word

This remarkable man living in a remote holler of the Ozarks caught the eye of out-siders a number of times over the years. In his introduction to this book, Robert Cochran mentions that folklorist Max Hunter captured Ed Stilley singing and playing guitars way back in 1959. In the early 1970s, photographer Roger Minick was drawn to the Stilley family as quintessential representatives of a way of life that was fast disappearing. His book, *Hills of Home* was published almost a decade before Ed's journey as an instrument maker began.

Then in 1997, Flip Putthoff, a photojournalist for the *Rogers Morning News* was the first to document Ed Stilley building instruments at his Hogscald homestead. Four years later, David Rohr—great-grandson of Fannie Prickett who helped raise Ed—filmed a wonderful interview of Ed that includes him singing and playing. This may be the only video footage of Ed playing one of his guitars before arthritis made it impossible for him to play. Next, Russell Cothren photographed Ed at the tail end of his instrument making days. We were pleasantly surprised when we ran across a fine songwriter from Wichita Kansas, Bryan Masters, who had written a fine song inspired by Ed called "Made by Hand." And the list goes on . . .

Recently I noticed a "Tribute to Ed Stilley" when I was making an Internet search. I was astonished to find a photograph pop up of a modern replica of the first instrument

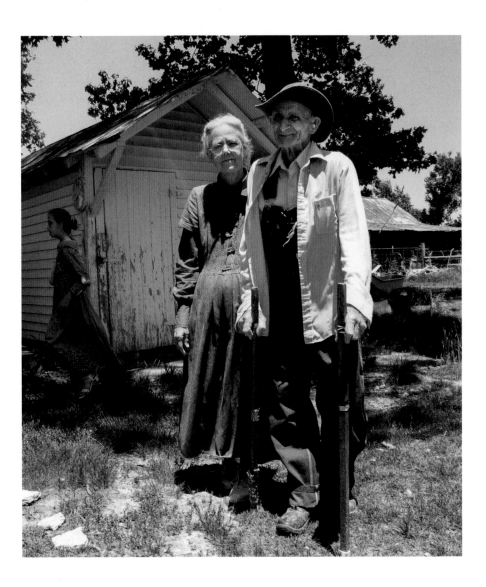

Ed and Eliza.

Ed ever made. Not an exact replica but the connection was unmistakable. I e-mailed the person who posted the photo and asked how he had met Ed. The reply caught me by surprise—"I've never met Ed. I've never been to America. I live in Belgium!" Kirk Termote had somehow stumbled upon a Flip Putthoff photo from our Still on the Hill website (stillonthehill.com) and was moved to build a replica as a tribute. A fine tribute indeed. I showed Ed the photo, and he was very pleased. He refers to Kirk as "that man across the water."

Finally, there is the current collaboration between Robert Cochran, my wife, Donna, and me. When Dr. Cochran saw *True Faith, True Light*, the exhibit of Ed's work that Donna and I curated at the Walton Arts Center in 2013, he recognized the need to document Ed's work and was instrumental in making it happen.

What is it about Ed Stilley that inspires a "man across the water" to put chisel to wood? Or a folklorist to put pen to paper? I sometimes wonder why I personally feel such a need to share Ed's work with the rest of the world. He certainly never made any attempts to promote himself. I'm certain it never occurred to Ed that what he was doing would someday be considered art. Ed teaches us about being an artist utterly free of the burden of ego.

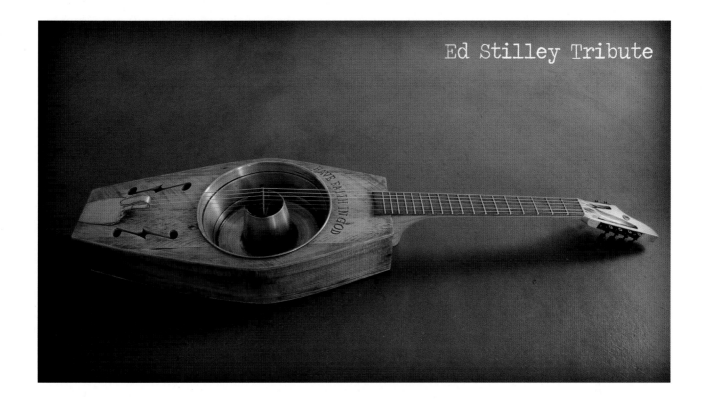

For Ed it was work. Work for the Lord. No different than guiding the plow behind his mule or building a fence. Ed is that man in Thomas Hart Benton's paintings, back arched over toward the earth. He worked hard. You can see it in his hands. He worked the land, and he made instruments in the same very same way. They will endure as great works of unintended art. Ed never meant to make art. His purpose was purely one of devotion to God. And in his pursuit of devotion, Ed made great art.

Kirk Termote's tribute to Ed Stilley. Photograph by Kirk Termote.

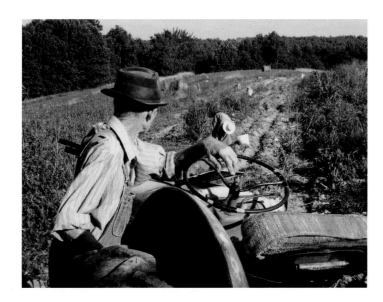

Ed on the land. Photograph by Samantha Parton.

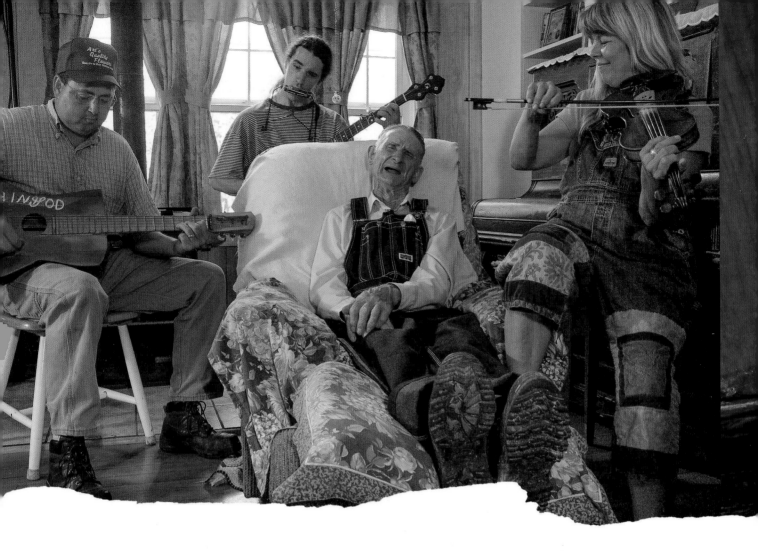

CHAPTER 18

Our Journey with the Stilleys

onna and I owe so much to Ed Stilley and his beautiful family. They have enriched our lives in many unexpected ways. The butterfly guitar he gave to me and the fiddle he gave to my wife, Donna have become cornerstones of our musical world. As the folk duo Still on the Hill, we've performed with these instruments for thousands of adults and children. We've written two songs about Ed—one for kids and one for adults—and perform them on Ed's instruments at almost every show. After each performance we invite our audience to come up one at a time to hold and strum the butterfly guitar. I never tire of watching people delight in this magnificent work of art. The hard part is getting it out of their hands for the next person in line!

I'll always be grateful to Tom and Nina Luther for introducing Donna and me to Ed in 1995. In 1982, at the tail end of the back-to-the-land movement in the Ozarks, the Luthers bought land up the hill from Ed's place to try their hand at farming. They both sensed that the locals in the holler were a bit wary of their presence at first—all except one, Ed Stilley. Ed treated them as good neighbors right from the start, helping them cut wood for their barn, bringing them homemade sorghum at Christmas and, of course, giving them one of his guitars. That guitar led to the making of this book. The Luthers eventually moved to Fayetteville, Arkansas, where Donna first saw the guitar proudly displayed in their

Donna and Kelly Mulhollan singing with the Stilley family.

house. Well aware of my lifelong interest in woodworking and my passion for folk art, she was certain that I'd be thrilled to see such a thing. She was right. When I laid eyes on that guitar, I knew that I simply must meet the man who made it.

Tom and Nina took us to meet Ed, and he was kind to us from the start. Despite my long hair and hippie-like appearance that might have put off some people, he treated us like family. In fact, it wasn't long before he actually let me take instruments home for weeks at a time. I desperately wanted one of my own but wouldn't dare ask. It felt like a violation of his intent to give them to children, and I knew there was a long list of kids waiting for their own instruments. I let myself be content with borrowing his guitars.

In 1997 I encouraged my friend, Flip Putthoff, a photojournalist for the *Rogers Morning News*, to do a story on Ed, and he graciously let us use his precious photographs in our book. I am so very thankful for these photographs that beautifully depict Ed in his prime when he was still building and playing at his homestead in Hogscald Holler.

Ed gave Donna a fiddle in 1999, a very sweet instrument with a chainsaw sprocket mounted inside. By 2003, I could see that Ed wasn't going to be able to keep building much longer. His fingers could no longer attend to such detailed work. After much struggle and introspection, I finally decided to ask Ed if he would give me a guitar. I explained that I'd be sharing his work with thousands of children when Donna and I entertain in school programs every year. In retrospect, I doubt all my chatter was necessary. It just so happened that at that very moment he was holding one of his greatest creations, the butterfly guitar. Ed simply said, "Well, you can have this one." That was one of the happiest days of my life.

As Ed's guitar-making days were winding down, I began to feel a great desire to share his important work with the world. Donna and I knew we had become privy to the work of one of the great folk artists of our time. I felt a responsibility to help make Ed's

Flip Putthoff, outdoor editor
for Northwest Arkansas Media.
Photograph by Alan Bland.

work available for the rest of the world to appreciate. Ed had no need or desire to promote himself—his motivation was purely spiritual. Still, it was clear to me that work of this caliber needed to be documented and shared.

The possibility of a creating a book with photographs documenting Ed's work started to haunt me, but hiring a professional photographer was beyond our budget. In spite of my lack of expertise, I naively decided I'd have to undertake the job myself. I began reading articles on photographing objects and lighting techniques. I bought a half-decent camera and a couple of light boxes, determined to figure out how to accomplish this task one way or another.

Thank goodness it didn't come to that! I did end up shooting a few of the instruments, but the photographs in this book are primarily the work of our good friend and collaborator, Kirk Lanier. His skill and his willingness to listen and respond to our input made him a dream to work with and his artistic eye is pure magic. We are indebted to Kirk for all the hours he contributed to the making of this book. Still, it is not possible to tell the whole story with an ordinary camera. Dr. Dennis Warren from Generations Chiropractic in Fayetteville, Arkansas, providing the X-ray images that reveal the inner workings of Ed's creations.

It turned out to be quite a difficult task to locate Ed's instruments. Years ago I had seen a notebook at the Stilley home with a waiting list of children's names. Ed tried his best to work his way down that list, and it seemed to me the perfect starting place in our quest. Unfortunately, the list had been lost. Ed and Eliza could only recall a handful of names to get us started. Donna and I had to become detectives of sorts to find the rest. In our search, we soon discovered that it was not only children who received the instruments. While children where certainly Ed's priority, it seems he gave them to many folks who crossed his path. One by one, we discovered the whereabouts of yet another instrument and

My wife, Donna, marvels as Dr. Warren processes an X-ray image of an Ed Stilley guitar.

began arranging field trips to document each one. It took a couple of years to get the job done. I remember the excitement I felt as we arrived at each home, not knowing what new treasure would be revealed. I recorded an interview with each owner in hopes of gleaning interesting stories concerning Ed. We found that some treasured their instruments, while others didn't understand the significance of the gift and had left it stashed in the barn. Either way, they all remember Ed with great fondness.

While I am no luthier, I have built and repaired various musical instruments over the years. Some of the instruments we uncovered in our search had a few problems that needed attending to. I've developed a fondness for every one of Ed's creations, and I simply can't bear to leave them in disrepair. I was pleased when Ed gave me his blessing to make repairs to his instruments when needed and even gave me the bone pieces and brazing rods to help me do it right. Usually it's simple things such as replacing missing frets and bridge work. I try my best not to change any aspect of his original design. My goal has been to leave every instrument I encounter in good working order. Most of the pieces I've seen are in pretty good shape, but unfortunately some have been terribly neglected. I've pulled pounds of dirt dauber nests out of a half-dozen instruments!

In October of 2013 Donna and I curated the first public exhibition of Ed's work at the Walton Arts Center in Fayetteville, Arkansas. The exhibit, *True Faith, True Light, Have Faith in God: The Folk Instruments of Ed Stilley,* was part of the Fayetteville Roots Festival. It included thirty of Ed's instruments, a display of tools and artifacts from his Hogscald workshop, and photographs by Tim Hawley including giant X-ray images. Ed made the trip to town for the opening and was greeted by hundreds of admirers. Surrounded by his wife, Eliza, and children and grandchildren, he gave us a spontaneous "singin'" of gospel hymns. Everyone in the room was moved and joined in. Ed has never sought any recognition for what he does, but it was so very sweet to see him and to see the message that's so important to him appreciated.

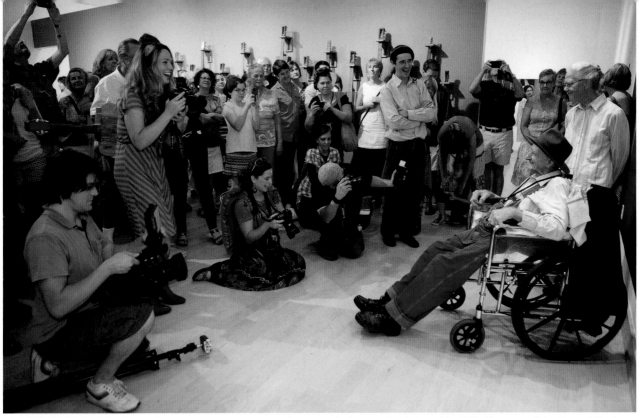

Admirers greet Ed at Walton Arts Center opening of *True Faith, True Light*, August 23, 2013. Photograph by Russell Cothren.

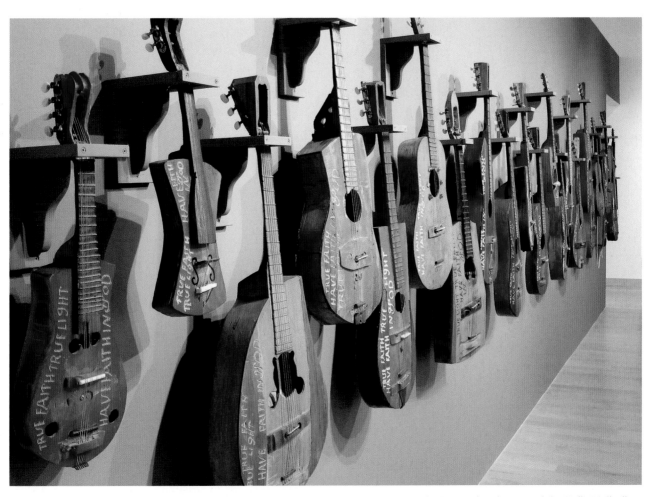

left: Wall with instruments, Walton Arts Center, *True Faith, True Light*. Photograph by Kelly Mulhollan.

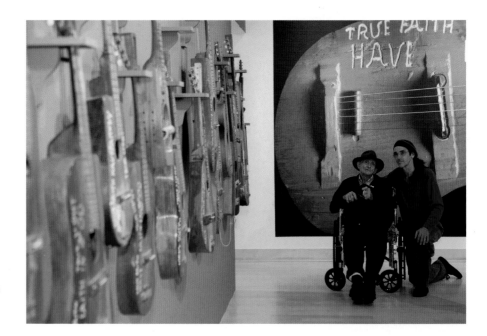

The exhibit made it clear that Donna and I are not alone in our appreciation of Ed's work. We observed countless people moved to tears by the instruments and the statement they make. The exhibit was the talk of town. Fortunately, it also caught the eye of the folklorist, Robert Cochran. Dr. Cochran immediately recognized the significance of what Ed has done and was key to making this book reality.

For eighteen years now the Stilleys have treated us like family. It's been a joy to watch the grandchildren grow. Many of the photos taken of them in this book were from several years ago, and now they are young adults. We are often asked to stay for supper and inevitably end up joining the family for some joyous gospel singing and playing. It's always

Why Ed does it!

fun to see what Eliza comes up with to feed Donna and me since we're vegetarians (likely the first she has ever encountered). Recently, she fried up some Hen of the Woods, a wild mushroom they had collected. It was delicious! Getting to know Ed and his family is a gift that continues to change our lives in wonderful and unexpected ways. Donna and I hope that this book gives you an opportunity to appreciate Ed's gift as well.

above left: Donna Mulhollan and the Stilley grandchildren—Donna takes a turn on stilts made from tree branches.

above right: Robert Cochran.

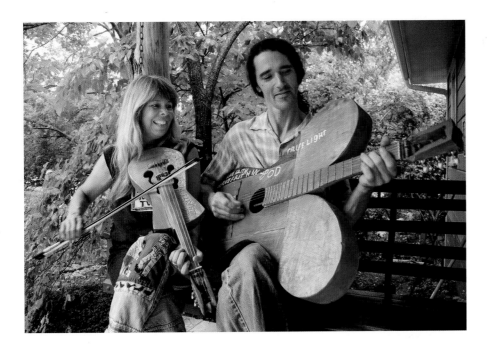

Kelly and Donna Mulhollan.

KELLY MULHOLLAN

Kelly Mulhollan has roots in the Ozarks that reach back five generations. He and his wife, Donna, compose the folk duo, Still on the Hill, and perform original songs from coast to coast and in Europe. With nine acclaimed CDs to their credit, two of which focus on Ozark people and places, they received the Governor's Folk Life Award in 2010 for their efforts to preserve Ozark traditions.

Beyond music, Mulhollan's diverse interests include collecting spherical objects and one-of-a-kind folk instruments, woodworking, and bird watching. In the early 1990s Kelly worked as the miller at the famous War Eagle Mill and rebuilt its historic undershot mill wheel.

Mulhollan encourages all of us to celebrate what makes our own region unique. He believes that Ed Stilley's story is good medicine for a culture struggling against homogenization. He offers this book as a way of sharing his love of the Ozarks with a wider community.

Sound files of many of the instruments featured in this book can be heard by visiting the author's website, stillonthehill.com/edstilley. Ed Stilley himself can be heard singing, playing, and preaching as well. There is no charge to listen to these sound files. Enjoy!

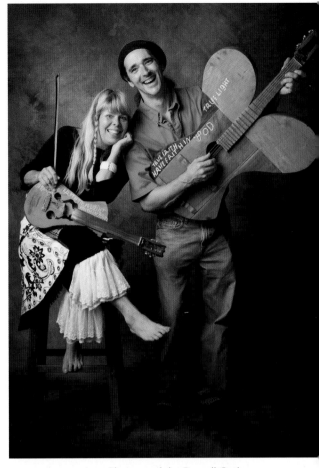

Photograph by Russell Cothren.

KIRK LANIER

After having a life-long career in music, moving to the Ozark hills in the early 1990s rekindled my second artistic love, photography. My wife and I bought a local art gallery known as Whimsicals in the heart of Fayetteville and quickly became connected with the amazing art and music community.

As a photographer, an ability to be almost invisible intrigues me, and it is in those invisible moments that I love to capture the essence and spirit reflected in the faces of people.

Ed Stilley is one of the most unique and fascinating individuals I have had the pleasure of photographing. His distinctive and irreplaceable folk guitars, their character, color, and primitive innocence have been a joy to capture. I've been involved with this project since its inception, and it continues to be an honor and a privilege. Working on this project has provided the musician and photographer in me to merge, flourish, and grow.

Photograph by Kelly Mulhollan.

THE ARKANSAS CHARACTER

A series jointly sponsored by the Center for Arkansas and Regional Studies
in the University of Arkansas's Fulbright College of Arts and Sciences
and the David and Barbara Pryor Center for Arkansas Oral and Visual History.

SERIES EDITOR
Robert Cochran